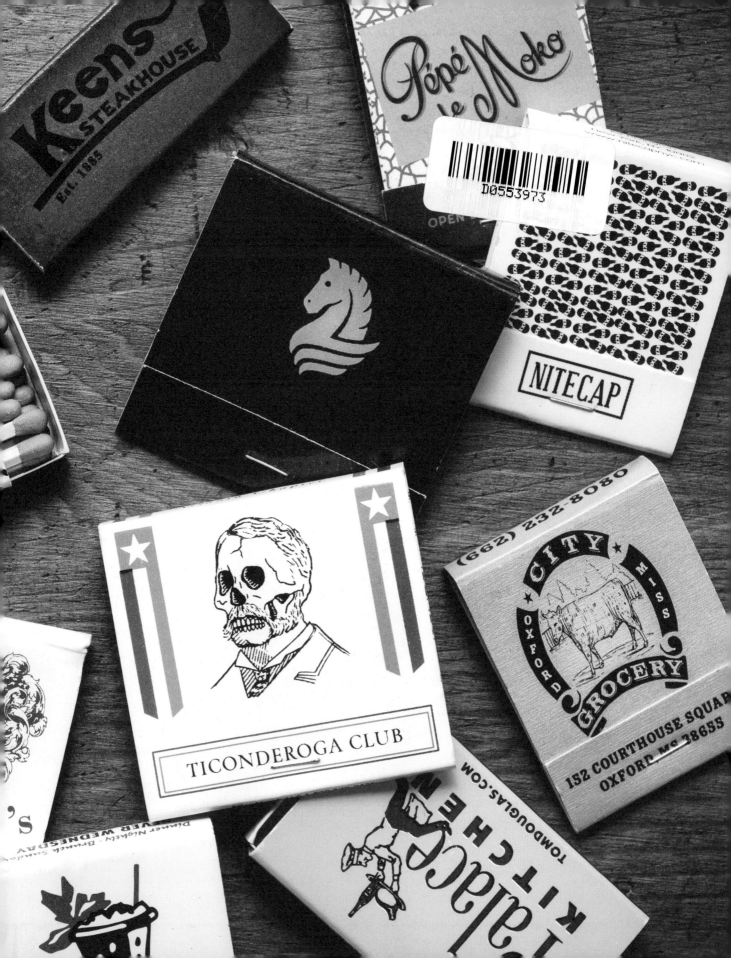

LAST CALL

Bartenders on Their Final Drink
and the Wisdom and Rituals of Closing Time

LAST CALL

Brad Thomas Parsons

Photographs by Ed Anderson

TEN SPEED PRESS
California | New York

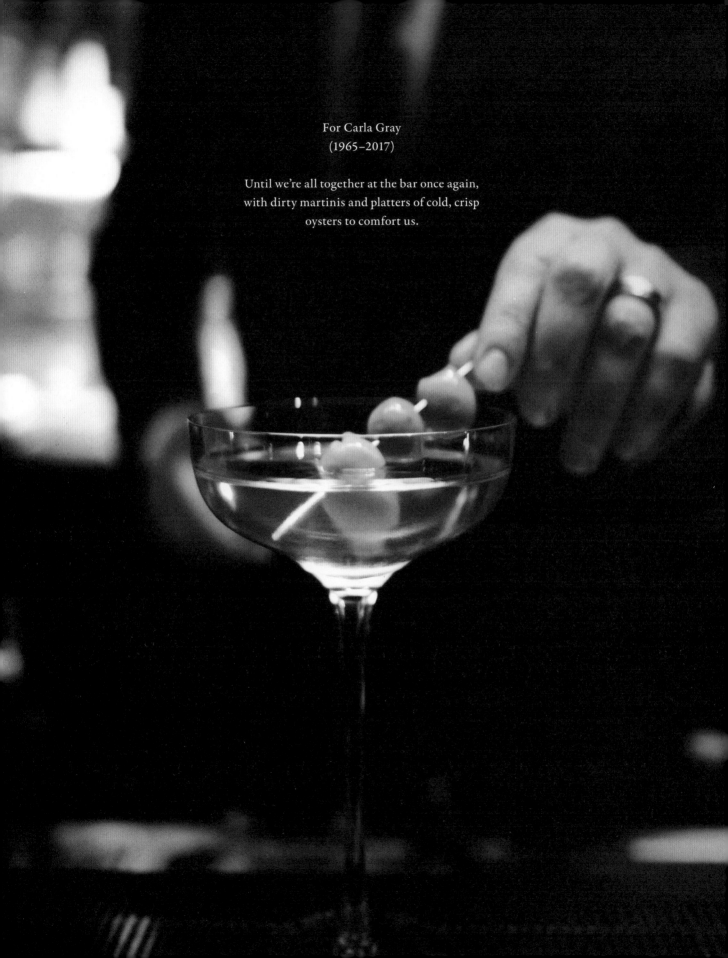

For Carla Gray
(1965–2017)

Until we're all together at the bar once again,
with dirty martinis and platters of cold, crisp
oysters to comfort us.

CONTENTS

FEATURED DRINKS

INTRODUCTION

On a winter night not too long ago, I was at Prime Meats, my favorite neighborhood local in Brooklyn. The evening started at the bar with a round of drinks before dinner, as a group of my friends who hadn't seen one another in a while gathered together, one by one. We moved to a large table in the back and then, after dinner, we posted up at the crowded bar for whiskey and amaro and one last round over long good-byes. While my friends bundled up and stepped outside into their waiting Ubers, I stuck around, seated at my usual corner stool at the bar. I ordered another drink, and just as an unexpected song on the radio can instantly turn you into a sentimental fool, I started feeling a little sorry for myself. All of my friends had someone waiting to welcome them when they got back to their apartments, yet I was alone. Lost in thought, I eventually finished my drink, tapped on the bar with my palm, and offered to settle up for the night. "I should get going so you guys can close up and go home." The bartender smiled and said, "Brad, I hate to break it to you, but we locked up two hours ago."

Suddenly I noticed the lights were much brighter, the last customers were long gone, and the music had transitioned from a prime-time mix of Led Zeppelin and *Beggars Banquet*–era Rolling Stones to the maudlin wails of Tom Waits, the ultimate barfly crooner. It had been years since I had shut down a bar. The last calls of my youth were typically announced with the clanging of a bell or a piercing whistle as the bartender shouted, "Last call! Last call for alcohol!" They were the band Semisonic's anthem "Closing Time" played out in real life: "You don't have to go home, but you can't stay here." But this was an adult last call—a much harsher look at reality. A walk across the stage when the houselights are on and the audience has exited the theater. It's just you, alone, staring at your own reflection in an empty bar, and it was a feeling I couldn't shake.

Like so many things in New York, the city is always changing, and too often not for the better. Prime Meats has since closed (and reopened as Franks Wine Bar), but so have countless bars and restaurants that have been somebody's regular. Bars are performance spaces, and some nights the featured show can be a comedy, drama, or tragedy. But more often than not, each night contains elements of all three. When you go to a bar, you're more than just a passive audience member. You're a featured player. Sometimes you're an extra who blends in with the scenery, and other times you're at the top of the call sheet and you have the most lines or a scene-stealing monologue. But ultimately you're part of an ensemble. And while each patron can affect the atmosphere with his or her own moods, motives, and hang-ups, it's ultimately the bartender who stands at center stage and his or her performance determines the pacing, mood, and well-being of everyone in the house.

As I approached my fiftieth birthday, my own mortality and sense of legacy weighed heavy on my mind, and the parallels between me and my own father, who died in 2008, and the journey of each of our lives spent alone in bars felt especially poignant. The words *last call* are particularly loaded, hanging in the air with the weight of finality. In countless interviews, chefs are often posed that parlor game question, What would be the last meal you'd want to eat before you die? But what does it look like when you pose that to a bartender? Is it truly the last drink you'd want to cross your lips before you die? Or would it be your favorite drink, the one you crave to drink in

solitude at the end of your shift? Or is it the signature drink you're best known for making? Or, to get a bit philosophical, is "last call" about remembering a moment in time or trying to regain something special that's now lost? Posing this question to bartenders around the country, I found their distilled answers also revealed secrets, rituals, and personal philosophies on display each night at their bars.

I spent months traveling around the country interviewing bartenders with Ed Anderson, who photographed our journey, shooting in more than eighty unique locations across twenty-three cities in thirteen states. I have a list of all the drinks consumed as well, though I probably shouldn't share that in case my doctor is reading this. But take my word that there were many draft beers, bottled beers, tallboy cans, shots, and cocktails drunk in the name of research. We didn't hit every state, and we probably missed your hometown or your favorite bar, and I'm sorry about that. I quickly discovered that an entire book could be written about almost every city we visited, as each bartender sent us to another great spot just down the street or across town. But hopefully some of the places are unexpected or unfamiliar to you, and you'll be inspired to visit and post up at the bar and say hello.

Music plays a pivotal role in setting the mood and the overall experience of going out to bars, and its presence is felt throughout *Last Call*. The organization of the book itself is set up like a very personal mix-tape, the kind I used to devote hours to making to share with someone special, revealing little pieces of my soul in a ninety-minute soundtrack of my life. Each featured bar in the book, whether it's an interview, essay, or just a photo, varies in tone and style, and while you can dip in and out as you please, taking on this bar crawl of a book from start to finish is recommended. You'll find cocktail recipes throughout, but sometimes it's about knocking back a beer and a shot and no one needs a recipe for that. And in case you're curious, it would have to be a tie between "Bohemian Rhapsody" and "Purple Rain" for most popular last call song played at bars.

When the last call question is lobbed back in my direction, I'm still unsure of my own answer. I can't help but think of Tom Sawyer looking in on his own funeral. If I had the chance to peer down on the room, I hope I would see my friends and family together at one of my favorite bars or restaurants, raising their glasses. Ultimately, sipping a pour of vintage amaro (please don't ask me to pick a favorite) seems an appropriate and fitting way to settle my affairs. But so does a crisp pilsner with an Underberg chaser. Or possibly one last Prime Meats old-fashioned spiked with Damon Boelte's (page 72) housemade pear bitters. And how I love the Negroni in all its variations: a classic made with gin, a Boulevardier spiked with bourbon, or (probably my favorite) a refreshing and celebratory Sbagliato topped off with Prosecco. And thinking about one final drink, I can't help but wish for the chance to have one more Miller Lite with my father, who died over a decade ago. But maybe that's what's waiting for me on the other side.

BTP

NITECAP

New York, New York | Lauren Corriveau, Natasha David

*"Gimme that night fever, night fever
We know how to show it"*
—Bee Gees, "Night Fever"

If you're at the Lower East Side bar Nitecap at closing time on a Saturday night, the disco ball will be spinning its final revolutions and you might find yourself sitting at the bar between a chef from a nearby restaurant and a neighborhood bartender stopping in for a drink before calling it a night. The room is chill with a fun, friendly vibe—so friendly that some couples settle into a booth for a solid make-out session. "There's *a lot* of kissing in booths at that hour," says Nitecap bar director Lauren Corriveau.

She may be biased, but Corriveau can attest to the magical vibe that goes down on a typical night at the intimate basement bar. Her first and only time visiting Nitecap before joining the team was on a midweek date that lit the spark for her desire to be a part of this special place. "The music was fun, but you could really hear each other. The lighting was sweet and a little sexy. Then suddenly the entire bar erupts in a sing-along to Michael Jackson's 'Man in the Mirror.' The bartender put on the disco ball, and it was just a special moment in this tiny little space."

Through a twist of fate, Corriveau was introduced to Jeremy Oertel, Nitecap owner Natasha David's husband, who was managing the Williamsburg bar Donna and who hired Corriveau part-time while she still held down a job in the fashion world. "Jeremy said, 'I just hired this girl and I think you'd really like her, and I think you're going to steal her from me,'" recalls David. "I was looking for a bartender and I went to Donna to spy on her. I asked her to make me a drink, and when I left I said, 'Jeremy, she's mine.'" After David offered her a job at Nitecap, Corriveau gave two weeks' notice at her day job, though her colleagues thought she was crazy when she explained she was leaving to bartend full-time. "These were fashion girls," says Corriveau, "so I had to put it into context for them. Natasha David is the Beyoncé of bartending."

But almost two years after joining Nitecap, the restaurant above the bar from which the bar rented suddenly went out of business without alerting its downstairs tenant. David, who was terrified she'd soon come to work to find the doors padlocked, knew she had to act fast. A plan was put into action to move the business two blocks down Rivington Street into an empty space owned by her partners that had been home to a grungy dive bar. They would have to leave their liquor inventory behind because it was tied to the license at their current address, but after an everything-must-go blowout for friends and regulars to drink down the inventory, David, who was six months pregnant, and Corriveau executed a strategic move that rivaled George Washington leading the Continental Army on a fog-covered nighttime retreat across the East River from Brooklyn Heights to Manhattan during the 1776 Battle of Brooklyn. They spent the next twenty-four hours making round-trips between the bars, transporting as much of the equipment as they could salvage to the new address. They opened ten days later, memorializing the date as Nitecap Independence Day.

Lauren Corriveau and Natasha David

Nitecap's beloved playlists live on at the new address, leaning heavily on disco, funk, 1990s throwbacks, and a heavy rotation of Madonna, Prince, Evelyn "Champagne" King, and Cyndi Lauper in the mix. And although the last call song of the night varies, it's likely to be from the Celine Dion, Whitney Houston, or Spice Girls songbooks, preferably something that everyone in the bar knows the words to. "The idea behind our last call music is that, yes, we're going to shift gears and play something really kind of ridiculous as a last song," says David. "But I don't want it to be that song that comes on and everyone thinks, Oh, they really want us to leave. The tone has definitely changed, but we still want to send you off in the happiest, funniest way we possibly can. We want to tickle you."

But when the music is over and it's time to talk about what they would want to have as their final drinks, both women consider the white wine spritzer, the often-maligned mixed drink from the 1980s that they've both been on a mission to redeem, as the perfect end-of-night sipper, but then change their minds. "If this was going to be my last drink on Earth, it would have to be a margarita on the rocks," says David. "When I was pregnant, that's the drink I was really thinking about every day." And she insists on a salted rim: "Lots of salt. Like a salt lick. The more salt, the better."

"I think last call always means an end," says Corriveau, "but I like to think that my last-call-before-I-die drink is yet to come." But when pressed for a final answer, she settles on a bitter highball of Suze, the gentian-based liqueur from France, and tonic. The relatively low percentage of alcohol in Suze is part of the reason she's drawn to it, but she's also delighted by its complexity. "Suze is all things for me. It's floral and funky and musty while also being bright and bitter."

When Corriveau was working at Donna, she and fellow bartender Amy Koffsky created a 50/50 shot of Suze and Amaro Lucano they dubbed the Susan Lucci after their favorite soap opera queen ("Oh, the drama!"). "In the end, a Suze and tonic is a refreshing way to settle down after a long day while still being a perfectly weird drink," suggests Corriveau. "I used to do a lemon twist, but lately I'll just add a lemon wedge to squeeze in for extra brightness," she says, trying to illuminate a dark situation with a ray of light, just like the Nitecap disco ball.

SUZE AND TONIC *Makes 1 Drink (pictured at right)*

2 ounces Suze Tonic water Garnish: lemon twist or lemon wedge	Add Suze to a chilled collins glass filled with ice. Top with tonic water. Give it a quick stir and garnish with the lemon twist or lemon wedge.

SUSAN LUCCI *Makes 1 Drink*

¾ ounce Suze ¾ ounce Amaro Lucano	Combine the Suze and Amaro Lucano in a shot glass or rocks glass. Knock it back.

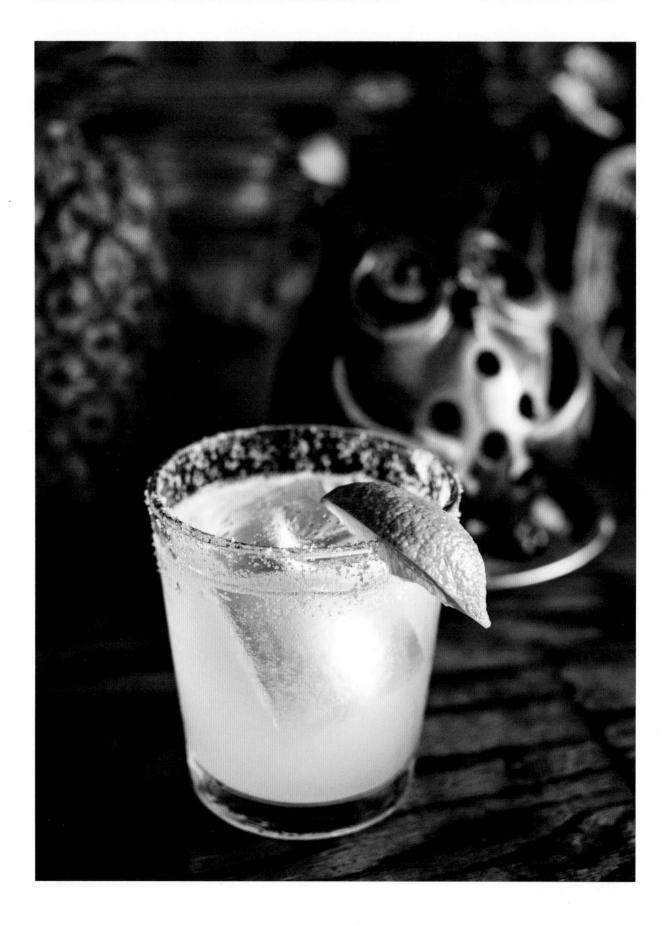

MARGARITA *Makes 1 Drink*

Lime wedge (for rimming)
Kosher salt (for rimming)
2 ounces blanco tequila
 (preferably Siete Leguas
 blanco or El Tesoro platinum)
1 ounce Cointreau
¾ ounce fresh lime juice
Garnish: lime wedge

Cut a small notch in the center of the lime wedge and run it around the rim of a chilled old-fashioned glass, gently squeezing the lime as you go. Pour a small pile of kosher salt onto a plate just wider than the diameter of the glass. Tip the lime-slicked glass onto its side, parallel to the plate, and gently roll the outside edge of half of the glass in the salt, coating it with a ¼-inch-thick layer. Fill the glass with ice.

Combine the tequila, Cointreau, and lime juice in a cocktail shaker filled with ice. Shake until chilled and strain into the salt-rimmed old-fashioned glass. Garnish with the lime wedge.

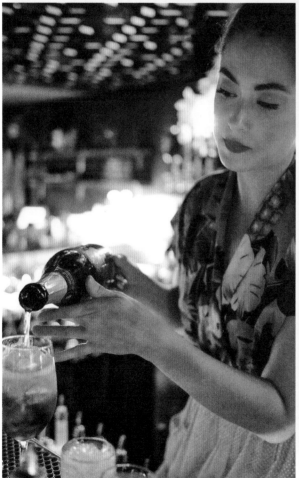

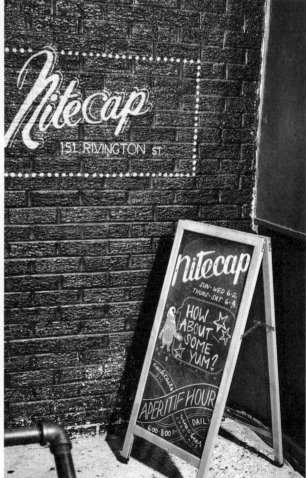

Sunny's. Brooklyn, New York. »

HARVARD & STONE

Los Angeles, California | Aaron Polsky

"Well, I just got into town about an hour ago
Took a look around, see which way the wind blow"
—The Doors, "L.A. Woman"

Tall, lean, and lanky, with a thick mane of curly hair and wearing a distressed denim vest and aviator shades, you'd be forgiven for mistaking Aaron Polsky for a rock star, especially when he's walking with purpose down Hollywood Boulevard through Thai Town on his way to Harvard & Stone, where he's the bar manager. But there's no denying the magnetic charisma and high-energy performance that's on display when he's holding court behind the bar. Before heading to Los Angeles in 2015, Polsky lived in New York City most of his adult life, moving there for college when he was eighteen. Like many students, he procured a fake ID to drink underage at dive bars, but when he started sneaking into prominent cocktail bars, he was blown away by the experience and was instantly hooked. He landed a job as a host at Sasha Petraske's influential bar Milk & Honey the week of his twenty-first birthday, and from there tended bar at White Star and Amor y Amargo. But he's found his home at Harvard & Stone.

"Harvard & Stone is a pretty unique place that satisfies a lot of different needs," says Polsky. "It's a high-volume cocktail bar. It's a neighborhood bar. It's also a music venue, with live shows every night." There's honky-tonk on Sundays, and on Friday and Saturday nights, a trio of burlesque dancers performs on the second-floor catwalk before descending a pole to dance on stage and atop the bar. Polsky tends to miss out on their synchronized aerial routines, however, due to being head down, focusing on knocking out drinks from his station. In the back of Harvard & Stone is the R&D Room, a snug little bar where visiting bartenders pull guest shifts on Monday nights, with the staff taking turns the rest of the week workshopping new drinks. Polsky estimates more than twelve thousand new drinks have come out of the back room. "Overall, I want people to party and have fun, and I hate any sort of exclusivity," he says. "I hate places with a velvet rope. I can't stand places whose focus is to make people feel wealthy and exclusionary rather than just enjoying something creative and exciting."

What was the most important thing Sasha Petraske taught you about bartending?
There are a lot of valuable things Sasha taught me, so I don't want to make this like the *most* important thing he ever told me. But he said the one thing that takes a good bartender to very-great-bartender territory is to taste every drink you make and to drink cocktails when you go out. He always told me, don't waste your nights out drinking beers and shots. That wasn't a tough sell for me because I love drinking cocktails. But as years pass, you get into the habit of going out and doing shots and beers. Recently, I've tried to re-center and drink with purpose as opposed to just drinking all the time. At London Cocktail Week, I made a conscious decision to try drinks only at the cocktail bars I'd been wanting to try, and to drink those cocktails but not take the shots and not mindlessly drink a bunch of wine at dinner. That all comes back to Sasha. It's definitely a valuable lesson.

How would you describe your bartending style?

Professionally I come from a background of seasonality and paying attention to ingredients. I like to use culinary ingredients. I like to use Asian ingredients. Exotic citrus. Sichuan peppercorns. I love using Korean ingredients. I like layering lots of flavors. At the end of the day, when you make a dish you have a number of discreet ingredients. You can pick those things out. In a cocktail, it's all mixed together, so you have to layer it and have people perceive it, you know? Ideally, it has to be greater than the sum of its parts.

What is the hardest part about being a bartender?

One of the biggest downsides is that you're dealing with an addictive substance that's free and accessible. And it's easy to leave it unchecked, to spiral. And sometimes you lose your patience with people. Sometimes you sit down and try to focus on delivering high-level service, but it can be unrealistic when music is blaring and drunk people are yelling at you. You often disappoint people who don't really understand your lifestyle. That's sort of the way it works. And it's unfortunate that they're disappointed. But at the same time, I don't take it too much to heart because I don't expect those people to come out on a Monday night for my birthday party. They have to wake up at 6:00 a.m. for their office job, and that's fine.

What's last call like at Harvard & Stone?

We start putting the lights up from the back to the front around 1:45 a.m. We say, "Guys, Harvard & Stone is closed. If you have a tab at the front bar, please, close it now." Then one of our managers starts walking around saying, "Free tacos outside, free tacos outside." [Spoiler alert: There are no free tacos outside.] Sometimes we'll go out and get Korean food. Sometimes if it's been a hardcore night, we'll go and drink at one of our houses, then go to the Drawing Room, which opens at 6:00 a.m. and has no windows. But that's very rare. I've come to a point where I value sleep over drinking past 2:00 a.m.

What is the last thing you'd want to drink before you die?

My college roommate got me a cocktail book with one thousand drink recipes, one of those thick paperbacks, like a Danielle Steel novel, and that's where I learned about the Manhattan. It's probably the first cocktail I ordered at this West Village dive bar when I was underage. The bartender would free-pour probably six ounces of Maker's into one of those stemless martini glasses with the bulbous base. I don't remember if there was vermouth. Definitely no bitters. He'd shake and strain it and finish it with a cherry. Yesterday I was at an airport lounge and I ordered a Manhattan, and she made it on the rocks with Jack and Martini & Rossi and bitters and one of those bright red cherries and it was pretty fine. You know how we say a Negroni is impossible to fuck up? If you put all three ingredients of a Manhattan in there, it hits the spot.

One of my favorite bars to go to has always been PDT. And when it had bottles of rare stuff, I started ordering Saz' 18 [Sazerac 18-year-old rye whiskey, which, in case you're wondering, will set you back over $1,000 a bottle] Manhattans from Jeff Bell once in a while to treat myself. Jeff knew that was my jam, and it was a fun thing to do, but I was young and horrible and would go in right before last call when it's time to shut down and put everything away. Looking back

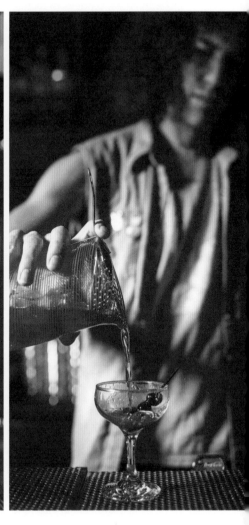

at it makes me cringe, but now we joke about it. Santi, one of my best friends, works the door at PDT, and we've known each other for the past thirteen years. I hope if I was dying, she'd be there. I want my friends from here and New York and all the people I love. I'd want them there drinking with me. I hope we'd be taking a bunch of shots, too.

And for the garnish, give me three cherries. Might as well; I'm dying, right?

MANHATTAN *Makes 1 Drink (pictured on page 16)*

2 ounces rye whiskey (preferably 18-year-old Sazerac) 1 ounce Cocchi Vermouth di Torino 1 dash Angostura bitters Garnish: 3 Luxardo cherries	Combine the whiskey, vermouth, and bitters in a mixing glass filled with ice. Stir until chilled and strain into a chilled coupe glass. Garnish with the cherries on a pick.

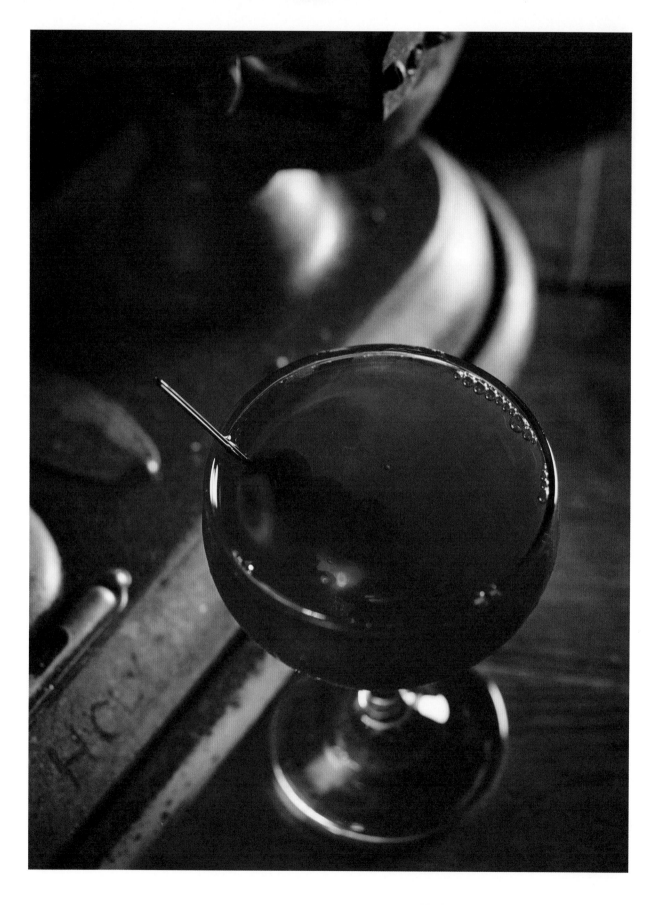

Mt. Royal Tavern. Baltimore, Maryland. »

William Elliott

What makes the drinks at Maison Premiere so special?

More than creating, archiving, and tweaking drinks, I pay a lot of attention to investing in classics and creating our version of classic cocktails. The first sip has to be super impactful. I know that sounds kind of obvious, but we rely on some tricks to maximize flavor, from splitting citrus juices to the kind of sugar we use and how we use it. A little thing such as adding orange flower water to a whiskey sour can make that first sip so memorable, and ultimately develops a profile that tastes like Maison Premiere. Our absinthe colada, sherry cobbler, and Jungle Bird are favorites here. Bold flavors are really key.

What's last call like at Maison Premiere?

Most of the time we play New Orleans blues and jazz, but late at night we transition to early-to-mid-1960s psychedelica. Nothing too overt, just unusual stuff that slips through the cracks that might make you feel a little weird listening to it. It definitely sounds like something you'd hear after midnight or 1:00 a.m. There is this one record, *U.F.O.* by Jim Sullivan, that's in heavy rotation. He was driving to Nashville from LA and disappeared in the desert in the Southwest and never returned. It's amazing: folk driven, slightly psychedelic. Usually when we put that on, the hardest part of the night is over. At that point, we've moved on to a more chill bar crowd. Once we close, I definitely switch it to something more up-tempo and aggressive to get my blood flowing. Closing down a bar at 4:00 a.m. is an athletic mission. I like to move fast. I like to be efficient. I always try to challenge myself to get a certain amount of stuff done before pouring that first beer. I know that sometimes when you sit down and have that first beer, you're not getting back up.

What is the last thing you'd want to drink before you die?

I don't go out to cocktail bars very much. I'm not necessarily proud of that. I like to know what's going on in our industry, but I'm also fully immersed in three restaurants. When I go out, I like to detach from cocktails, and honestly, they get me drunk too fast.

That said, if I was feeling really successful about my night, or in this case my life, my last drink would be a well-made French 75 with Cognac and great Champagne. My knee-jerk reaction when people ask me what I like to drink is Champagne. A French 75 to me, especially with great Cognac, is one of my favorite cocktails in life. It's also in keeping with the context of the space of Maison Premiere. If we have a special soul sister, it's Arnaud's French 75 Bar [the iconic, historic bar in the French Quarter of New Orleans]. Without a doubt, my favorite experience with the drink has always involved Chris Hannah when he was at Arnaud's French 75 Bar. The combination of the louche New Orleans weather and his perfect recipe never ceases to impress. It makes perfect sense. Nothing speaks to celebration, commemoration, and luxury more than Cognac and Champagne.

FRENCH 75 *Makes 1 Drink*

1 ounce Cognac (preferably
 Gourry de Chadeville)
¼ ounce simple syrup
 (1:1 sugar:water)
¼ ounce fresh lemon juice
Champagne (preferably
 Bourgeois-Diaz), chilled
Garnish: lemon twist

Combine the Cognac, simple syrup, and lemon juice in a cocktail shaker filled with ice. Shake until chilled and strain into a chilled flute. Top with Champagne. Garnish with the lemon twist.

Guido Martelli

PALIZZI SOCIAL CLUB

Philadelphia, Pennsylvania | Guido Martelli

"That's life (that's life), I tell ya, I can't deny it
I thought of quitting, baby
But my heart just ain't gonna buy it"
—Frank Sinatra, "That's Life"

"If the neon is on, we're open" is the phrase that pays at Philadelphia's Palizzi Social Club. But first you have to get past Guido Martelli, whose shadowed face greets you through a slot in the door, asking to see your membership card. Once through the red-neon glow of the vestibule, the thick curtains part and you step into a small room with a checkerboard-tiled floor, colorful vinyl swivel stools, a few simple tables, and a vintage cigarette machine. Framed photos of past members and the club's original charter hang on the wall, and, of course, there's a portrait of a young Frank Sinatra gazing over the proceedings. It's a transitory space, like an old-school Italian American take on the otherworldly Red Room in *Twin Peaks*, but instead of a dancing, backward-speaking dwarf, there's Ralph the accordion player leading the room in "That's Amore" and bowls of crab spaghetti and olive oil–washed martinis.

Located in a South Philly row house, the one-hundred-year-old private club was founded in 1918 by a small group of immigrants from Vasto, Italy, and was named after their town's most famous resident, Italian painter Filippo Palizzi. A members-only club open only to men from Vasto, it was where expats could hang out, have a sandwich, buy cigarettes, and speak in their native language. There was a small kitchen and a bar, with a pool table in the basement and a meeting room and a couple of bedrooms upstairs. As the membership died out over the years, the charter was amended to open up the books to those who were born in Italy and later to American-born sons of 100 percent Italian heritage.

With an aging membership base and people moving out of the neighborhood, things slowed down. Chef Joey Baldino grew up five blocks from the club, and his uncle Ernest Mezzaroba was a longtime member and began serving as club president in the 1980s. Mezzaroba eventually convinced Baldino to take over the club, and he was installed as its new president. After making some needed renovations, including adding a full kitchen, the new-look version of the Palizzi Social Club opened on February 17, 2017, with Baldino's English bulldog, Cesar, as Honorary Member #001.

Memberships to the private club, now open to both men and women, were made available for an annual $20 fee, and Guido Martelli was the guy working the door. "I joke that having the name Guido Martelli was good enough for Joey, but long story short, eighteen months later, I'm still here. It was awesome to work the door the first six months we were open. I met everybody. That's my handwriting on those original cards." (I can vouch for that. I treat my Palizzi membership card like it's my Social Security card or driver's license.) Its cash-only, no-photography, and strict "what happens at Palizzi stays at Palizzi" policy only added to the club's allure, and soon demand became so great that Palizzi stopped taking new members. When *Bon Appétit* named it one of the best new restaurants of the year in 2017, praising Baldino's take on

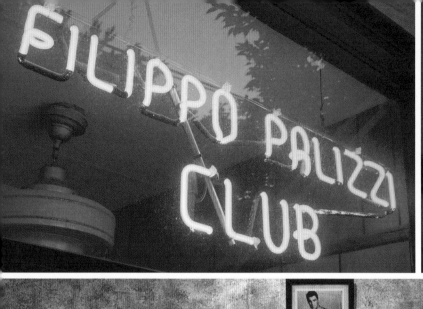

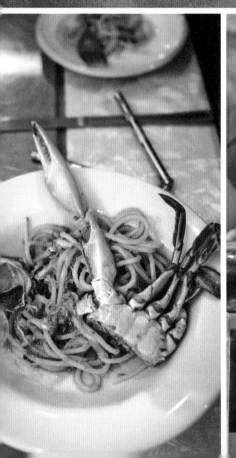
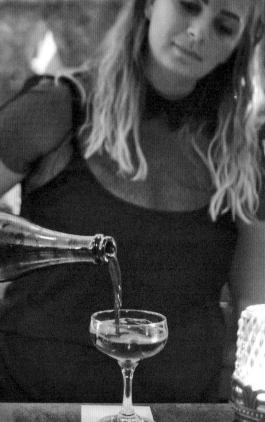

Italian American classics and the stellar bar program, people started lining up each night before the doors opened, with the line stretching seventy people deep one Sunday night.

Martelli is now the general manager and a key member of the small Palizzi team, working the door Thursdays and dividing the other nights between waiting tables and tending bar. "I want to know how to do everything here. Joey set forth a family environment, truly. It's a private club, and he wants everybody to feel like they're part of a club, especially the staff. The number-one benefit is as soon as you become a member, you're essentially a regular, right? You're a member of the club, and we don't take that lightly. Some people call it a shtick or a concept, but it's not. It's a private club in every sense of the word. Joey values Palizzi as being a place where people can relax and be part of the community, just as it was in the beginning."

Tell me about the delicate art of talking about a restaurant and bar that most people won't have the chance to actually visit.

We used to do ten to twenty new memberships every night at the door. That's when the lines started forming. We'd make them members, go through the rules, fill out their cards, and then they'd come in for dinner. Then we got booming and cut it back. Then all the big press hit and we had to close off new memberships. Sometimes it's hard. There's going to be people who feel left out. That just kind of happens. In six weeks, it went from doing well to being packed constantly. When we did close the memberships it was to respect the people who had been here for the first six months. It's gratifying that people still want to be members. Every now and then customers will come in because of *Bon Appétit,* and they're ready to rank you against the other places they've been as soon as they walk in. Sometimes they come in expecting fine dining, and we're not. It's simple food done well, and that can throw them for a loop. I've had people say, 'You better live up to this,' and I'm like, 'What can I get you to drink? How about a martini? And let's cool out and have a good time.'"

What do people like to drink at Palizzi?

Vincent Stipo set up the bar program here, and he did a great job because it's built on riffs on classics as well as originals. We have an amaretto sour called The Molino, and people love it. It's made with overproof rye and light on the amaretto, but it still gives people that familiar hit. The D'Amo, our take on an espresso martini, has brown butter–washed amaro, espresso, and clotted cream. And The DiCicco, an olive oil–washed Ketel One martini, is a top seller. But the number-one seller on our menu, always, is the Negroni.

Is Palizzi a restaurant with a cool bar, or a bar that happens to serve great food?

It's funny because Palizzi is a place where everybody enjoys themselves, from the older demographic that gets in line at six and comes right in for dinner to the late-night crew that's definitely industry heavy and thinks of it like a bar. We serve food until 1:00 a.m., so they can come in after work and get crab spaghetti at midnight. Those two groups may never cross paths but both enjoy the place and relax.

Do you have a shift drink tradition at Palizzi?

I always have a classic daiquiri as a shift drink. If I'm closing, I'll make one and set it on the backbar before I burn the ice. I close Sunday nights, and we're closed for three days in a row, so any open Prosecco and open lambrusco aren't going to make it. One time my barback poured lambrusco on top of my Prosecco, and now we drink it that way every Sunday—50/50 in a rocks glass. I don't really have a name for it, but "Night Moves" sounds about right, as it fuels us through the closing duties and we're usually playing classic rock at the end of the night. You're talking to people for nine hours when you're working, so it's refreshing while you're cleaning up. But a 50/50 shot of rye and Cynar and a cold Peroni hit the spot, too.

What's last call like at Palizzi?

Late night is definitely industry heavy—people who I describe as just getting their night started. Last call in Philly is at 2:00 a.m., but because we have a club license, we get that extra hour. That said, after we stop serving, we're not throwing you out at 3:05 a.m. We'll switch up the radio from Frank Sinatra to yacht rock. It gets a little more rambunctious for sure. A half hour after we make the last round of drinks, I'll bring the lights up halfway and turn down the music. We're not really saying get out, but it's a nudge. At some point you kind of need to be more direct, so I'll fire up Frank Sinatra's "That's Life" quite loudly, and as it winds down, I take out my wine key, bang on the American Legion bell we've got behind the bar, and say, "Thanks guys, but it's time to go."

What is the last thing you'd want to drink before you die?

I'm a big proponent of a shot and a beer, but my dad drank an extra-dry gin martini my whole life. When we'd go out to dinner, you knew he was going to order one. And it was always with olives. My dad used to say, "I'll only have one martini," but at home he drinks this five-ounce martini. It's what we call "the XL," and it's almost cartoonish. I've had friends come over and say, "What is this thing?" They were definitely not measured out. He always liked Bombay Dry and used a dusty bottle of Martini & Rossi vermouth. My dad knows what he wants and wants it that way. When I got into cocktails in my early twenties, my brother, who also worked in restaurants, and I—in one of our proudest moments—turned our dad on to the classic spec with orange bitters and a twist. And now I'll come home and he's like, check out this new gin. He's building quite a collection. He's lapped me now. And now he knows that his vermouth needs to be refrigerated.

My one final drink would have to be an extra-dry martini. And if I could pick the time and place, it would be with my wife and my family—my father, my mother, and my younger brother—all together on the beach at the Jersey Shore.

NIGHT MOVES *Makes 1 Drink*

2 ounces lambrusco (chilled) 2 ounces Prosecco (chilled)	Combine the lambrusco and Prosecco in a rocks glass. Salute!

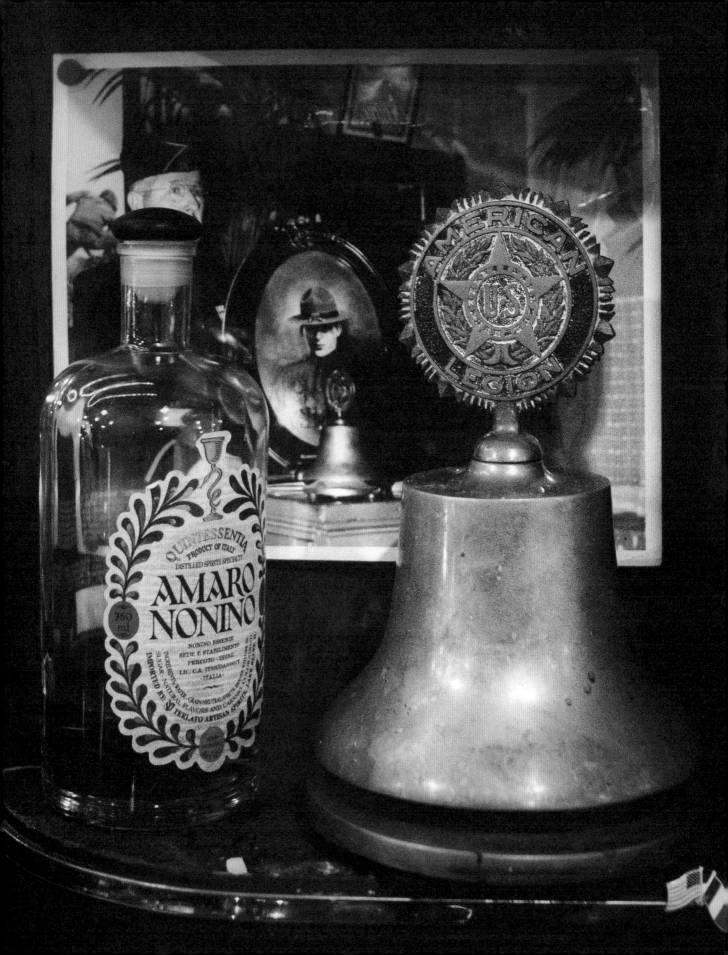

MARTINI (EXTRA DRY) *Makes 1 Drink*

2½ ounces London dry gin (preferably
 Bombay Dry Gin)
½ ounce dry vermouth (preferably
 Dolin Dry Vermouth de Chambéry)
2 dashes orange bitters
Garnish: lemon twist

Combine the gin, vermouth, and bitters
in a mixing glass filled with ice. Stir until
chilled and strain into a chilled coupe glass.
Garnish with the lemon twist.

NEW LUCK TOY

Seattle, Washington | Mark Fuller, Patric Gabre-Kidan, Brendan McAuliffe

"Hold your glass up, hold it in
Never betray the way you've always known it is"
—The Shins, "Caring Is Creepy"

You'd be forgiven if you walked into New Luck Toy with the intention of placing a takeout order for a beef and broccoli and egg roll combo. The retro metallic gold façade, bright neon sign, and pagoda-style roof all suggest a Chinese restaurant. Yet New Luck Toy is a bar that just happens to serve killer Chinese food. Opened in October 2016 by West Seattle chef Mark Fuller and coproprietor Patric Gabre-Kidan, who met years ago when they were working for Tom Douglas at the Dahlia Lounge, New Luck Toy is an homage to the West Seattle Chinese restaurant Luck Toy, which had closed after sixty years. "They had a good run," says Fuller, "but by the end, people weren't going there for the food. It was really about the bar and karaoke."

When you step inside, you can pull a deli counter–style numbered ticket to wait for an available table to open up. Or you can pass by a mirrored wall of more than one hundred gold *maneki-neko*, the popular Japanese "lucky cat" figurines, whose uplifted paws wave in unison, beckoning you past the karaoke room, under a canopy of red-and-gold Chinese paper lanterns, around the Skee-Ball set-up and *Family Guy* pinball machine and into the bar in the back, appointed with bamboo, beaded curtains, and built-in brown-leather swivel barstools. "What we started with was a 1960s/1970s–style Chinese restaurant design, inspired by Chinese American restaurants you would see in old movies," says Gabre-Kidan. Guests can load up on such menu choices as Salt & Pepper Spare Ribs, Chow Fun Mein, and General Oh Tso Good Fried Chicken, but the drinks that accompany the food take center stage. New Luck Toy's bar manager Brendan McAuliffe comes from a fine-dining background but loved the challenge of taking on a drink program whose primary ingredient had to be fun. That starts with how you order, ticking off your food and drink orders on a laminated menu with a Sharpie.

"My first thought was, Let's make tiki drinks. Strong flavors that play well with food," says McAuliffe. Plus, "It's eight months of gray in Seattle." One way to brighten an overcast day is through one of New Luck Toy's tropical-inspired slushies, like the "Lucky" Colada, a twist on a piña colada spiked with Frangelico, chocolate liqueur, and coconut water. There's also a Singapore Slingblade, a frozen take on the classic cocktail, along with a pink guava paloma, mai tai, and Boulevardier on tap.

When the doors open at 4:00 p.m., the seats around the bar fill with an older West Seattle crowd, and as the clock creeps toward the dinner rush, the playlist of the Isley Brothers and Earth, Wind & Fire shifts to a mix of Morrissey, Prince, and 1990s hip-hop. Although "Purple Rain" remains a go-to last call song in Seattle (and in bars around America), at New Luck Toy, McAuliffe likes to close out with Madonna's "Take a Bow," and as the opening line "Take a bow, the night is over" plays, the lights start to creep up. "Each night is completely different, but we have a rotating cast of about twenty-five regulars who come here every night on different days

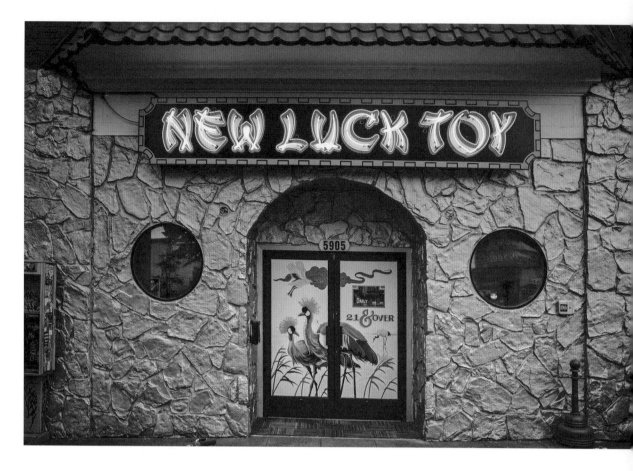

of the week," says McAuliffe. "Late night we have industry friends coming here after their shifts, people who try to scoot in to get food before the kitchen closes at 1:00 a.m."

When McAuliffe considers his one final drink, he turns to one of his favorite shift drinks, a glass of Fernet-Branca neat with a float of Averna. "To be completely honest, after running around for eleven hours and eating meals standing over a trash can, it may not be healthy, but it's super tasty to have a nice digestif to settle my stomach. If I were to drink tequila after work, I would just go home and want to drink more tequila. Fernet just makes me feel great, you know what I mean? It kind of softens your eyes a little bit. Gives you a touch of a buzz but also has a medicinal quality." He adds a splash of the sweeter Sicilian amaro Averna to round out the flavor of the bracing Fernet to make his last drink a more balanced sipper. "It calms me down. And a nice digestif lets me know that this is the end. It's time to wind down."

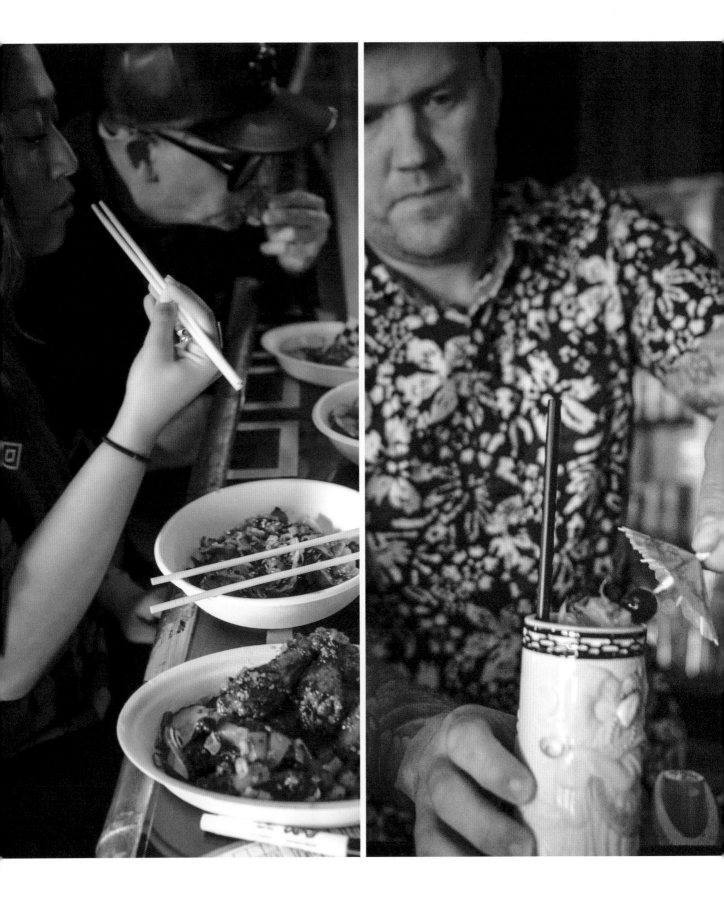

Old Town Bar. New York, New York. »

Dylan O'Brien

What advice would you give to a young bartender just starting out?

O'Brien: Taste as much as you can. Visit as many producers as you possibly can. Have as much information as possible about spirits, cocktails, formulas, and how cocktails work. That's the mechanical side. The other side is you have to enjoy people and enjoy finding the best way to get to a good interaction with someone.

Santer: I think for new bartenders—as it was for me—the tendency is to focus on the mechanics and the knowledge side of the job. But the best bartenders are aware of who's sitting in front of them, at what point in their day or night they are at, who's happy, who's not, who needs another drink. And they know everything behind them on that backbar as well. You have to be aware of everything.

What makes a great regular at your bar?

O'Brien: When it comes to regulars, I have a sense of responsibility for their lives, as you would for your friends or family. We have a guy who comes in here five days a week and he has the same thing every time. One time, he hadn't been here for a few days and all the staff was worried. Is he okay? Do we call him? Turns out he took a long vacation to Hawaii. I always love that about regulars. You're concerned about their welfare when you don't see them here because this is where they are. They're supposed to be here. In terms of being a good regular, as with anyone you see every day, it's like being a good roommate: knowing when to engage and when not to engage—for the bartender and for the regular. You do have a longer leash if you're a regular, but you still do have a leash. You're not a wild animal.

Santer: Regulars are our bread and butter obviously. When we first opened, we knew that to be successful we would need people to come here two, three, four times a week. We designed a bit of the program around that idea. How do we keep it going? How do we make it interesting? How do we make it consistent yet interesting for people? It's a weird line to walk. Regulars who are great really appreciate that. They've learned to trust us.

What drinks are you best known for?

Santer: The Revolver. I made this drink up a long time ago, in 2003 or 2004 at Bruno's in San Francisco. Despite the thousands of drinks we've made up since, it's the one I'm going to be remembered for. It's a Manhattan variation with Tia Maria, and a reaction to what was going on at the time. Everybody was making these bespoke ingredients, and there were all these drinks all over town that you could only get in that one place. I wanted to make a drink that anybody could make but that was still good. It was also when Bulleit bourbon launched, hence the name. I wanted to use a coffee liqueur, and I didn't want to use Kahlúa, and orange bitters at that time were *very* exotic. There was one store in town where you could get them. It's finished with a flaming garnish. The idea that the oil in citrus was flammable was also a revelation at the time.

O'Brien: I don't know that I'm known for anything because I've always actively avoided PR and all that stuff, but there's one drink that I always joke paid for this place. It's also made with Bulleit bourbon and is called the Recoil. Terrible name. Basically it's an elderflower whiskey buck. And at the time, we had the "novel" idea of serving the drink in pint Mason jars.

Jon Santer

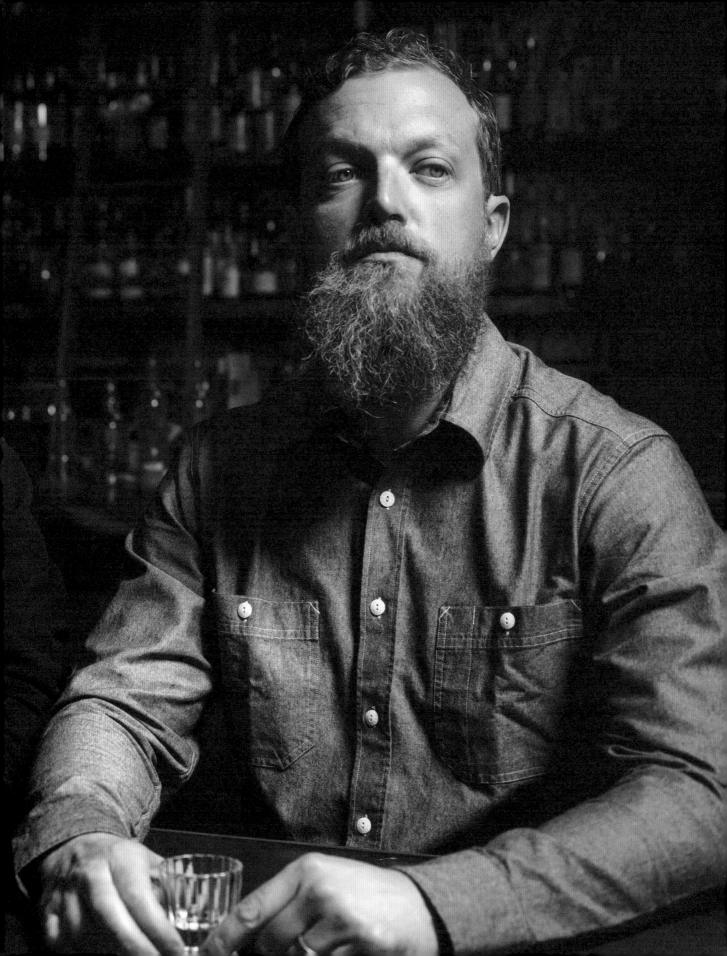

What is the last thing you'd want to drink before you die?

Santer: It would be Armagnac, specifically Domaine Boingnères 1986 Folle Blanche Bas, distilled in 1986, bottled in 2016. If I had to choose the best brown spirit on Earth, I think this is the one. I'm very self-conscious because it's not a cheap bottle and it's not something that I drink often. It's more special-occasion. But you're dying. Is there a more special occasion?

Many years ago, I went on a brandy trip in France in the dead of winter with some other bartenders. It was a really arduous journey, driving ten hours a day in a cold van starting in Paris during a snowstorm, north to Normandy, then all the way south through Cognac and into Gascony and eventually Armagnac. The last stop was where I first tasted it at the distillery, which is a family-owned operation. The woman who owns it is the granddaughter of the founder, and she's a force of nature. She doesn't make stuff to pay the bills—only the best shit you've ever tasted. I probably have a thousand bottles of booze at my house, even though I don't drink that much at home. But I dip into this particular bottle sometimes. When I'm a little bit lifted and have really good friends over, we break into it. I serve it neat, and we just sit around and make faces at it.

O'Brien: I would probably have to choose Del Maguey Tobala mezcal. When we got the keys to this place, it was the bottle we toasted with. At my wedding a couple years after that, I specifically handed a friend of mine two bottles and said anytime anyone needs this, you need to give it to them immediately—but especially to me, because I'm really nervous.

Mezcal generally is a very special spirit and stands out from most other spirits in terms of the raw material, how long it takes to come to maturity, and the production methods, which are ancient in most cases. I'm not a spiritual or religious person. I find that experiences and people are more meaningful to me. And the experiences I've had in Oaxaca have been very moving. I've sort of known Ron [Cooper, the importer of Del Maguey] casually for many years. As my palate developed and more quality mezcal became available, I got a passion for it. I'm inclined to sip on my mezcal neat. So much depth. So much character.

RECOIL *Makes 1 Drink*

2 ounces bourbon (preferably Bulleit) ¾ ounce St-Germain elderflower liqueur ½ ounce fresh lime juice Ginger beer (preferably Fever-Tree) Garnish: lime wheel	Combine the bourbon, elderflower liqueur, and lime juice in a cocktail shaker filled with ice. Shake until chilled and strain into a pint-size Mason jar filled with ice. Top with ginger beer. Garnish with the lime wheel.

REVOLVER *Makes 1 Drink*

2 ounces bourbon (preferably Bulleit) ½ ounce Tia Maria coffee liqueur 2 dashes orange bitters Garnish: flamed orange twist	Combine the bourbon, coffee liqueur, and bitters in a mixing glass filled with ice. Stir until chilled and strain into a chilled coupe glass. Garnish with the flamed orange twist.

Note: For a flamed orange twist, hold the orange peel between your thumb and index finger over the glass. With your other hand, light a match and then place it between the orange zest and the glass. Slowly press the edges of the zest together, folding it in half, to express the citrus oils, which will ignite in little sparks over the drink.

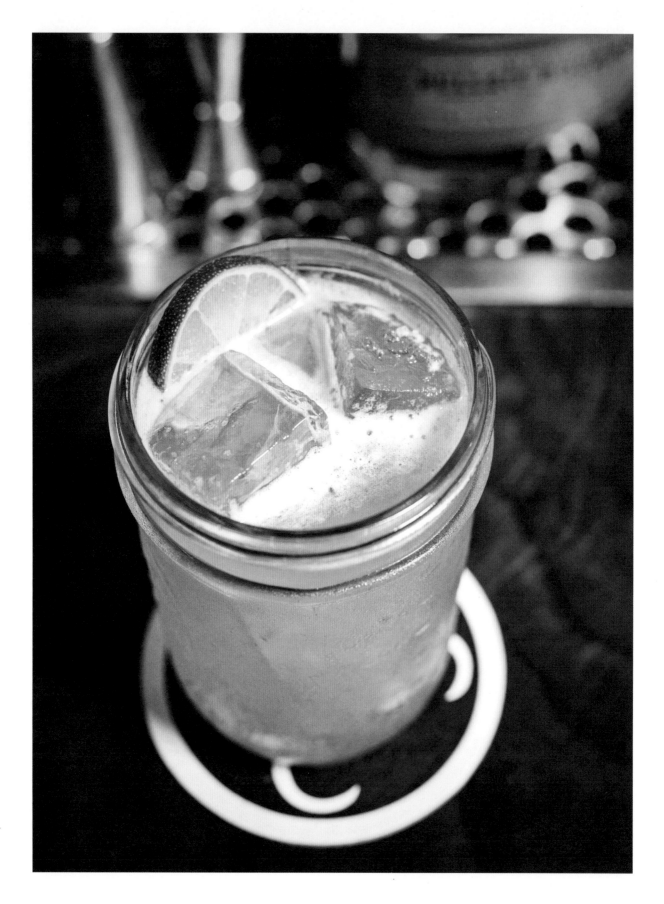

Recoil

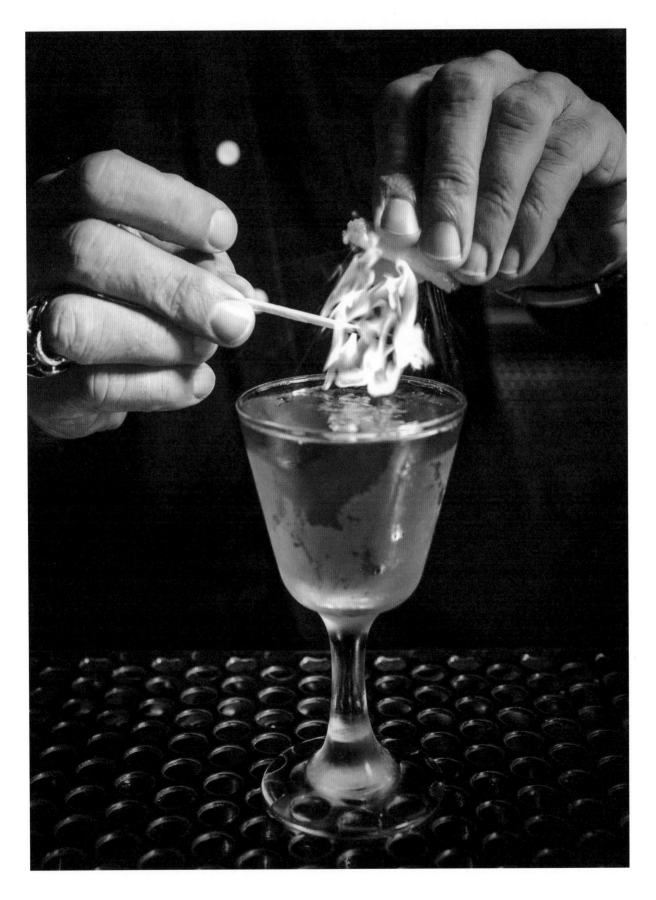

Revolver

Joseph Stinchcomb

SAINT LEO

Oxford, Mississippi | Joseph Stinchcomb

"When the lights shut off
And it's my turn to settle down...
Promise that you will sing about me"
—Kendrick Lamar, "Sing About Me, I'm Dying of Thirst"

Most of the bars surrounding the perimeter of the historic Square in Oxford, Mississippi, cater to the social lives of students attending Ole Miss just up the hill. There are holdouts, such as the upstairs bar at City Grocery (page 169), which draws an older crowd, and Saint Leo, an upscale Italian-inspired restaurant known for wood-fired Neapolitan-style pizza and inventive cocktails, with eclectic names taken from pop culture, hip-hop, and deep-cut cartoon characters, created by head bartender Joseph "Joe" Stinchcomb.

The kitchen at Saint Leo closes at 10:00 p.m., but drinks are served at the bar until the clock strikes 1:00 a.m., Oxford's official last call time. At this hour of the night, it's typically a mix of diners hanging out for a nightcap or friends of the bartenders popping in for a cocktail to make plans for hanging out after. I stopped in right before the kitchen closed on a slower night just as the remnants of a sudden summer thunderstorm passed through town. Before ditching his apron to join me for a bacon, sausage, and pork belly pizza, Stinchcomb made me The Clyde, a tequila cocktail rounded out with Pinot Noir, rooibos tea, lime, and Angostura bitters, named in honor of Clyde Goolsby, a well-known black bartender from Oxford who ran the Prince Albert Lounge at the Oxford Holiday Inn in the 1980s.

This was a drink left over from Stinchcomb's short-lived and controversial Black History Month menu that stirred up a heated dialogue that resonated miles beyond Oxford. There were five drinks in all: Blood on the Leaves, Bullock & Dabney, The Clyde, (I'm Not Your) Negroni, and Black Wall Street. "The wheels started turning," says Stinchcomb, on the creation of the menu. "What it means to be black. What it means to be black in Mississippi. What it means to black in the South. What it means to be black in America—and in the world as a whole." At first his regular customers applauded him for the tribute, even if many of them weren't aware of the deeper, often complicated meanings behind some of the drinks' names. Presented without context, you might not realize that Blood on the Leaves was a reference to Billie Holiday's 1939 recording of "Strange Fruit," a protest song about lynching. Or that Black Wall Street was a chilling reminder of the 1921 race riot in which a white mob razed the thriving black business district in the Greenwood community of Tulsa, Oklahoma, and killed hundreds of black residents. But once photos of Stinchcomb's menu began circulating on social media, the conversation around it was amplified beyond Oxford, with people calling in to complain and hundreds of online comments criticizing a white-owned restaurant for running an ill-conceived promotion. Many people outside of Oxford assumed Stinchcomb was white, and when they heard he was black, it became a case of *he should know better.*

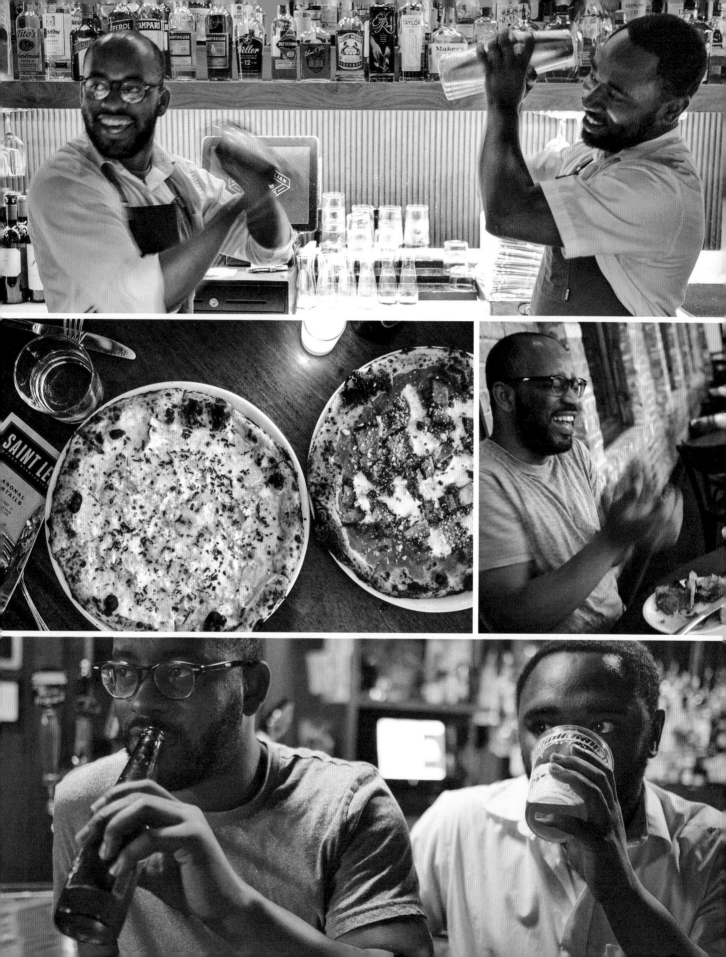

"People were upset, but it kept growing and growing into an amorphous ball of hate, with people arguing both sides of the issue," says Stinchcomb. "You read these stories and they're calling me Uncle Tom or traitor, and I'm like, Whoa man, you don't know what I go through every day behind the bar here. Even though I'm known around here, people still come up to me at the bar and say, 'Hey, boy,' to get my attention." The Black History Month promotion was removed less than two weeks into February, with a blank space left on the menu where the drinks had appeared. "All this hate and vitriol going back and forth about this piece of cotton paper. We just left it blank. It's almost like we whitewashed it," says Stinchcomb. He wishes he'd offered more context about each of the drinks on the menu.

Stinchcomb fixed himself a Last Word, the pre-Prohibition–era cocktail that was revived in 2004 thanks to bartender Murray Stenson (page 259), who put it on the menu at Seattle's Zig Zag Café. This is the last drink Stinchcomb would want to cross his lips before his eternal last call. When I asked him why, he pushes up the sleeve of his T-shirt to show off the tattoo of the Chartreuse logo on his right bicep. "For me, the Last Word is the alpha and the omega. It's the perfect cocktail. It's balanced, it's citrusy, it's tangy. You get those botanical notes from the gin." For his version, he deviates from the equal-parts formula to play up the herbaceous notes of his beloved green Chartreuse. "It's the perfect last call drink. It's what brought me into the industry, and I swear it's what's going to take me out."

This is the time of the night when Stinchcomb and his fellow bartender Delantric Hunt typically adjust the playlist from Anderson .Paak, Miguel, and Kendrick Lamar to a more late-night vibe. "We'll get a little more grimy. Lay down some Young Thug, some 2 Live Crew. Turn it up man, and let's get happy." After our late dinner, Stinchcomb busted out a suitcase bottle of Amaro d'Abruzzo, a gift brought back from Italy by one of his regulars, and poured a round while he laid out a rough draft of our plans for the rest of the night.

For our first stop, Stinchcomb wanted to hit up Snackbar, acclaimed Oxford chef John Currence's bistro located in a strip mall just over a half mile away, to catch up with bartender Ivy McLellan. At 11:30 p.m., we were nearly the only customers at the bar. McLellan stirred up a drink called Stop Your Nonsense & Drink Your Bourbon, made with bourbon, Cynar, and Angostura bitters, served over a giant ice cube flavored with strawberry and yerba mate. We hung out for just over a half hour, then knocked back shots of Fernet-Branca before hailing an Uber to The Blind Pig, a basement bar with twenty-three beers on tap that sits beneath Miss Behavin, a women's boutique just off the Square. "It's where everyone who works in restaurants goes," says Stinchcomb. As luck would have it, the young man driving the 2016 Chevy Silverado that pulled up was a *pizzaiolo* at Saint Leo ("Hey, I made your pizza earlier!") and ended up chauffeuring our expanding crew around for the rest of the night.

After closing down their respective bars, Hunt and McLellan joined us at "The Pig," as it's lovingly known among regulars. Multiple bottles of Bud, Miller High Life, and Dos Equis were passed around, and when shots of tequila, Jameson, and gin (Hunt: "Who drinks shots of gin?" McLellan: "Alcoholics.") made the rounds, I discovered I shared a mutual fear of horses with Stinchcomb (long story). I got ready to leave when the bartender called last call, but Hunt motioned for me to chill, and after a stream of college students exited the bar, he lit up a cigarette and asked for a small plastic cup of water to use as an ashtray. Stinchcomb pointed out the mixed bag of industry regulars—bartenders, baristas, servers—who were locked in with us, and

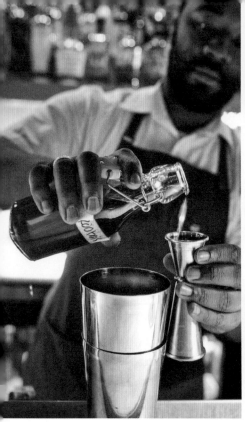

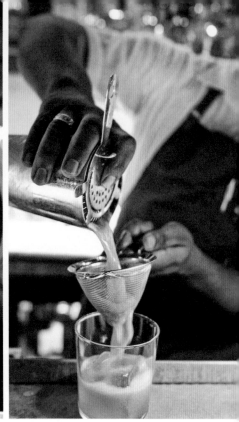

explained that the owners were typically cool with letting those in the know hang out for a bit past closing time. "I love it here at this time of the night," says Stinchcomb. "It's dank and dark." As it neared 2:30 a.m., we had reached our limit of beers and shots. Hunt implored us to "get out of here," and we all pitched in to bus our glasses and help put the stools up on the bar.

When you're in Oxford and you've had more than a few and are hungry at that hour of the night, you make your way to the Chevron service station on South Lamar for its famous fried chicken on a stick. The chicken was between batches, but Stinchcomb went back into the kitchen and somehow sweet-talked the kind woman working the fryer into making us a fresh order. While we waited under the fluorescent glow of the gas-pump lights, Hunt and Stinchcomb took selfies with a Lafayette County deputy sheriff on his coffee break while McLellan passed around bottles of ice-cold Gatorade and two bags of Funyuns. Around fifteen minutes later, we were all sitting on the flatbed of the Silverado pounding our Frost Riptide Rush–flavored Gatorade, ripping open packets of honey mustard sauce, and burning the roofs of our mouths, too hungry and impatient to let the chicken cool down.

Before we said our good-byes and made plans to meet up at Big Bad Breakfast in a few hours, there was one last stop to bookend our late-night crawl through Oxford: Saint Peter's Cemetery to pay our respects at William Faulkner's grave. We parked the truck and walked through the wet grass until we located the headstones of Faulkner and his wife, Estelle. The sky was filled with stars, and there were two sunflowers placed atop each grave along with dozens of scattered pennies. Talking about your theoretical final drink is much more than a parlor game when you're sitting in a graveyard staring mortality in the face. We didn't have any bourbon to pass around or leave behind for Faulkner, but after a long booze-fueled night full of laughs, stories, and chopping it up, we took a respectful pause and sat there in silence until the mosquitoes chased us away.

LAST WORD *Makes 1 Drink (pictured above)*

1 ounce green Chartreuse
¾ ounce gin (preferably London Dry
 style, like Beefeater or Tanqueray)
½ ounce maraschino liqueur
¾ ounce fresh lime juice

Combine the Chartreuse, gin, maraschino liqueur, and lime juice in a cocktail shaker filled with ice and shake until chilled. Strain into a chilled coupe glass.

THE CLYDE *Makes 1 Drink*

2 ounces blanco tequila
¾ ounce Rooibos Tea Syrup
 (recipe follows)
¾ ounce fresh lime juice
2 dashes Angostura bitters
Garnish: fresh mint sprig

Combine the tequila, tea syrup, lime juice, and bitters in a cocktail shaker filled with ice and shake until chilled. Strain into a chilled double old-fashioned glass over a large ice cube. Garnish with the mint sprig.

ROOIBOS TEA SYRUP *Makes 2 Cups*

Steep 6 rooibos tea bags in 1½ cups boiling water for 8 to 10 minutes. Discard the tea bags, add 1½ cups sugar, and stir until the sugar dissolves. Let cool completely and store in a tightly capped glass jar. The syrup will keep in the refrigerator for up to 1 month.

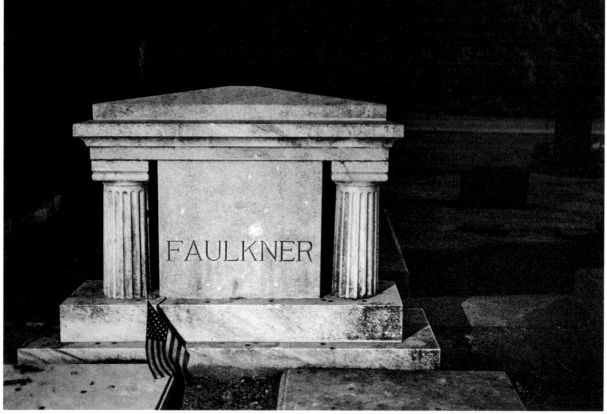

Greg Best

TICONDEROGA CLUB

Atlanta, Georgia | Greg Best

"Turn the light out, say goodnight
No thinking for a little while"
—The National, "Fake Empire"

When people ask Greg Best what Ticonderoga Club is all about, his answer is, "We're a restaurant with a lot of different influences from a lot of different timelines and a lot of different personal experiences. But at the end of the day, it's really good food, really good drink, and a really genuine sense of hospitality." Best opened the Atlanta bar in 2015 with a dream team of partners, including fellow bar management alums Paul Calvert and Regan Smith along with chef David Bies and designer Bart Sasso. "This bar was meant to be our Cheers. After various careers, some of us together, some of us separate but overlapping, we decided to break ranks and create kind of a Voltron of restaurant groups," he says, comparing their union to the five robotic lions that lock together to form Voltron, the super robot who stars in the 1980s Japanese anime series *Voltron: Defender of the Universe.*

Ticonderoga Club anchors the back corner of the popular Krog Street Market in the Inman Park neighborhood of Atlanta. Stepping through the doors, sitting at the bar, watching this wholly unique space in action, and experiencing the entire team's dedicated hospitality made me wish I was a regular. I'm certain I'd pop in a couple of nights a week for a glass of their Hootchy Cider Punch, a twist on the classic picon bière made with cider and Amer Ticon, the house blend of amaro, fortified wine, and orange bitters. The first thing I notice on my initial visit is that all the bottles, standard set dressing for most bars, are out of view of guests. The custom oak bar is on the small side but branded with iconography pulled from colonial flags and the tenets of the bar—audacity, integrity, camaraderie—spelled out in 24-karat gold leaf. "Like all old bars, we wanted to build a relic that would be here, or somewhere, long after all of us were dirt—whether it's still here operating or in a collector's house or in a museum."

Best admits that naming a bar in the heart of the South after a fort in the New York Adirondacks was intentional. All the owners are Yankee transplants, aside from the chef, and their vision for the space is filtered through a foggy colonial lens. "This place feels very much like a New England tavern, and we chose Ticonderoga Club because it's a referentially Yankee term," says Best. "It's also mysteriously recognizable when it comes to history. I think I've heard that name. . . . It's a pencil right? It's a fort? It's a cannon? There's that weird scratch at the back of your brain when you hear the word. And the last reason is it's incredibly disruptive to the Southern vernacular, an Iroquois term like that." Ticonderoga Club was built to look like it had been in business for a century or two, and frustrated with the cocktail scene's reliance on all things dark, bitter, and boozy, Best and his team turned to America's forefathers for inspiration when creating their cocktails, spotlighting fortified wine, sherry, Madeira, port, brandy, rum, and cider on their drinks list.

After sampling all those great cocktails, you'll likely need to make a pit stop at Ticondogera's bathroom. You'll be forgiven if you linger a bit longer than necessary, as this is one of the more eccentric water closets you'll encounter at a bar, complete with a somewhat creepy bird skeleton camped out in a gold cage and red wallpaper adorned with owls, toucans, badgers, koalas, raccoons, and armadillos. "The only thing we had planned to look and feel a certain way completely was the bathroom," says Best. "No one ever thinks about the bathroom. They're always lame, and they make you feel sad about your life and how many drinks you've had when you go in there to pee. So we wanted the bathroom to be an exhilarating place to be. The aesthetic is *Twin Peaks*' Dr. Jacoby mixed with a crazy Southern swamp aunt with an old, creaky, dilapidated plantation house that no one seems to know how it got in the family. It's by far the most Instagramed part of the bar."

Best can get a bit cerebral in his pursuits and even uses the end-of-night shift drink as a learning opportunity for both himself and his staff. "I won't allow myself to have the same drink because it keeps me myopic," Best says. "But if I've got a new bartender I'm working with hand in hand on training and on understanding balance in a cocktail and why that's so critical as opposed to the recipe, then that would be the one situation where I will ask that one bartender to make me a daiquiri. It makes them excited because they get to make a drink for the boss but also gives us a practical lesson. I'm conscious and highly aware that the barback working with me is coming up, and I've got to be setting examples. So I'm diligent in our closing conversations and how we clean the bar and talking about why this and why that. I'm always looking for one little snippet of information to share, whether it's the backstory of a cocktail or having a side-by-side tasting of two spirits."

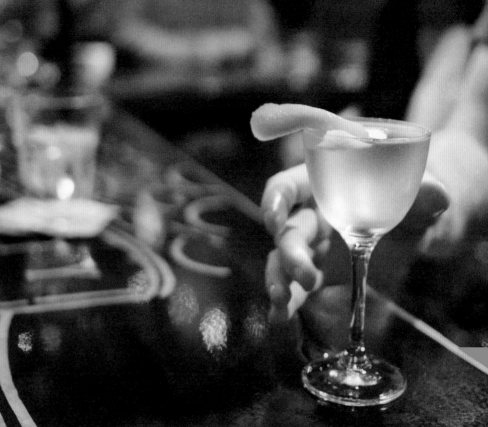

It doesn't surprise me that Best is a man who has already given his last drink on Earth some serious consideration. "It's pretty simple, right?" he says. "If I'm on death row, I really screwed something up. Chances are I'm not really worried about doing anything the right way anymore. I'm just looking for the pure revelry of my last food and drink experience and really kind of seeing through that opulent perspective.

"My last drink would be a pint glass of Sazerac, accompanying a large plate of country fried steak with white gravy and sliced tomatoes with mayonnaise. Because, why not? Let's go big." The idea of supersizing a Sazerac is something Best would never consider under normal circumstances, but that's what makes it special. He's sticking with rye and adding Angostura bitters in addition to the classic Peychaud's Bitters the drink calls for. "Rules are not my utmost concern here. Lemon peel in. I don't believe in expressing and discarding. If it's the end of the world or the end of my life, who wants to think that hard?"

The first Sazerac that Best remembers drinking was made for him in a Las Vegas bar by Italian bartender Francesco Lafranconi. "I was just being introduced to the part of bartending that drew me in the most, which are the stories and the history of it all. The idea that a drink that represents an entire place that you can never get made the same way in that place. You go to New Orleans to have a Sazerac and 90 percent of them suck. It really struck a chord with me. This really is old wizards and alchemy.

"The skull image that is all over Ticonderoga Club is kind of our strongest bit of iconography," says Best. "The idea is more Roman than Masonic. *Memento mori*. We're all mortal. We're all going to croak. Let's make the most of it and enjoy every moment."

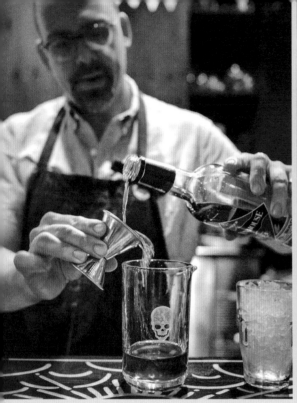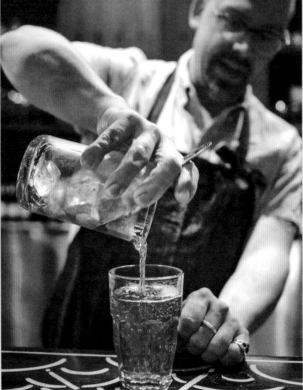

SAZERAC *Makes 1 Drink*

½ ounce absinthe or Herbsaint (for rinsing, or do as Best does and just leave it in there)

2 ounces rye whiskey (preferably barrel proof)

¼ ounce simple syrup (1:1 sugar:water)

2 dashes Peychaud's Bitters

2 dashes Angostura bitters

Garnish: lemon twist

Add the absinthe to a chilled old-fashioned glass. Roll the glass around to coat the interior of the glass and shake out any excess liquid. Combine the whiskey, simple syrup, and both bitters in a mixing glass filled with ice. Stir until chilled and strain into the prepared glass. Express and garnish with the lemon twist.

DEATH ROW SAZERAC *Makes 1 Drink*

1 ounce absinthe or Herbsaint (for rinsing, or do as Best does and just leave it in there)

4½ ounces rye whiskey (preferably barrel proof)

1 ounce simple syrup (1:1 sugar:water)

5 dashes Peychaud's Bitters

5 dashes Angostura bitters

Garnish: lemon twist

Add the absinthe to a chilled pint glass or other large glass. Roll the glass around to coat the interior of the glass and shake out any excess liquid. Combine the whiskey, simple syrup, and both bitters in a mixing glass filled with ice. Stir until chilled and strain into the prepared glass. Express and garnish with the lemon twist.

CLYDE COMMON AND PÉPÉ LE MOKO

Portland, Oregon | Jeffrey Morgenthaler

"Hey bartender, before you close
Pour us one more drink and a pitcher to go"
—Loretta Lynn, "Portland, Oregon"

I first met Jeffrey Morgenthaler on a late-fall night in 2011 when he was behind the bar at Clyde Common. He leaned in to take my order, and when I asked him if he was Jeffrey Morgenthaler, his response, with just a hint of a smile, was, "It depends on who's asking." Morgenthaler has been a bartender for more than twenty-three years, and while he has a reputation for being a bit salty and quite opinionated, the Eugene, Oregon, native is also one of the best bartenders around, not to mention one of the most generous and entertaining people in the bar industry. Throughout his career he's shared his recipes and techniques on his website, and with *The Bar Book* and *Drinking Distilled*, he's provided professional bartenders and cocktail enthusiasts alike with two essential books on bartending tools, technique, and philosophy.

As bar manager of Clyde Common and Pépé le Moko, both in the Ace Hotel in Portland, Oregon, he oversees two bars that he describes as being "complementary opposites of each other." Clyde Common is a big and bright high-volume restaurant with a bar that is built to serve a lot of people as quickly as possible. It's the perfect spot for a late-night bite and a drink. Around the corner and down a set of stairs is Pépé le Moko, an intimate basement bar with more focus on crafted cocktails but still set up with a sense of fun, as demonstrated by its most popular drink, an inventive take on the classic grasshopper. Along with the Barrel-Aged Negroni, Morgenthaler is best known for resuscitating the grasshopper and the amaretto sour by introducing contemporary techniques that strip them of their cloying 1970s reputations but keep the spirit of their original era alive.

You won't find Morgenthaler barhopping or grabbing a late-night burger after work. Instead, he is in his kitchen, where he's become a pretty obsessive and adventurous home cook. The last time I stopped by Clyde Common, I caught him at the tail end of his shift. He was sporting a white apron dotted with a pattern of bright red ladybugs and mushrooms, which of course had a story behind it. He was on a bartender road trip through Germany, and his hosts at Campari had created custom red T-shirts for everyone. "They ran a little snug, and after I went and ate my way through Germany, there was no way I was getting behind the bar in that tight T-shirt," says Morgenthaler. "So I found this cute little ladybug apron to wear instead, which just happened to be in Campari red. It was perfect!"

He lit up when he saw the box of fried chicken I brought him from an earlier stop at Reel M Inn, a Portland dive bar known for its killer fried chicken (before you even order a drink you're asked if you want chicken, as the wait time for the made-to-order chicken climbs throughout the night). After making me an amaretto sour, he closed out, but stopped by to say good-bye, balancing the fried chicken and a large package from Amazon in his arms. "I broke down and finally bought an Instant Pot," he said smiling, already plotting the late-night culinary adventures in store.

How would you describe your bartending philosophy?

I spent a lot of time in dive bars and clubs. I've never been the vest and bow-tie guy. I'm really loud and boisterous, and I make fun drinks that people like to drink. And that's about it. I don't do a lot of weird esoteric drinks that you have to really think about. I'm not the "brown, bitter, and stirred" guy at all. I'm the variation of a whiskey sour guy. We really like to have a good time behind the bar. For me that's one of the most important things. The bartenders are having fun. The guests are usually having fun. I always tell my bartenders if we have a bar full of people just sitting there sort of smelling their cocktails and taking pictures of them, we've failed. The goal is to have a bunch of people enjoying drinks and enjoying life and talking and getting to know one another and having a good time.

How did the Barrel-Aged Negroni, amaretto sour, and grasshopper become your signature drinks?

There's no real common thread among those. I just make a lot of drinks and those happened to resonate. Those were the ones that clicked the most with the press. They're the ones I'm known for outside of the bars. The amaretto sour in particular sums up my style, in that I'm a little bit irreverent. I put that out during a period when a lot of bartenders were falling all over themselves trying to summon the ghost of Jerry Thomas in their bar, which is not necessarily very fun. It kind of reminded me of a time when bartending and drinking were fun. What if we could have a drink that was really fun but not just like an amalgamation of obscure amari and mezcal and liqueurs. It sums up what I've always done: fun drinks that are really, really good. You can do both.

What makes a good regular?

People always want to know, How do I befriend the bartender? And it's like, well, the same way you become friends with anybody else. Have something in common or be able to talk to each other like civilized people and maybe something will click. Maybe it won't. There are certainly pointers I can give you, but what makes a good regular depends on the bartender. A lot of bartenders don't like somebody who comes in and gets sloppy drunk every night. Now we've got to worry about you. Nobody really wants to hang out with someone you have to worry about all the time. Some bartenders like a regular who will come in and talk about sports. I could give two shits about sports. I like a regular who wants to talk about music. Or cooking. Any of the things I'm interested in. There's no universal "good regular." I think a lot of us would rather have somebody who's pleasant to be around than somebody who throws a lot of money down.

Do you have any late-night, last call traditions?

God, I wish we had a last call ritual. I always loved those bars that do. There's a bar in Eugene I used to always go to that would play "Sweet Caroline" at last call. I've tried to get those things going, but they've never really clicked, unfortunately. My staff is a little boring. Nobody drinks behind the bar. No last call shots or anything. They call last call, clean up, and go home and go to bed. Most of them don't even have a shift drink after close. If they do, it's a short pour of cider.

My old bartender at Clyde and I have a lot in common. We both go home and cook super-elaborate meals until two or three in the morning. We'll text each other pictures of what we're making. Tons of braises. I make a lot of pasta. I've been super into pizza lately, working

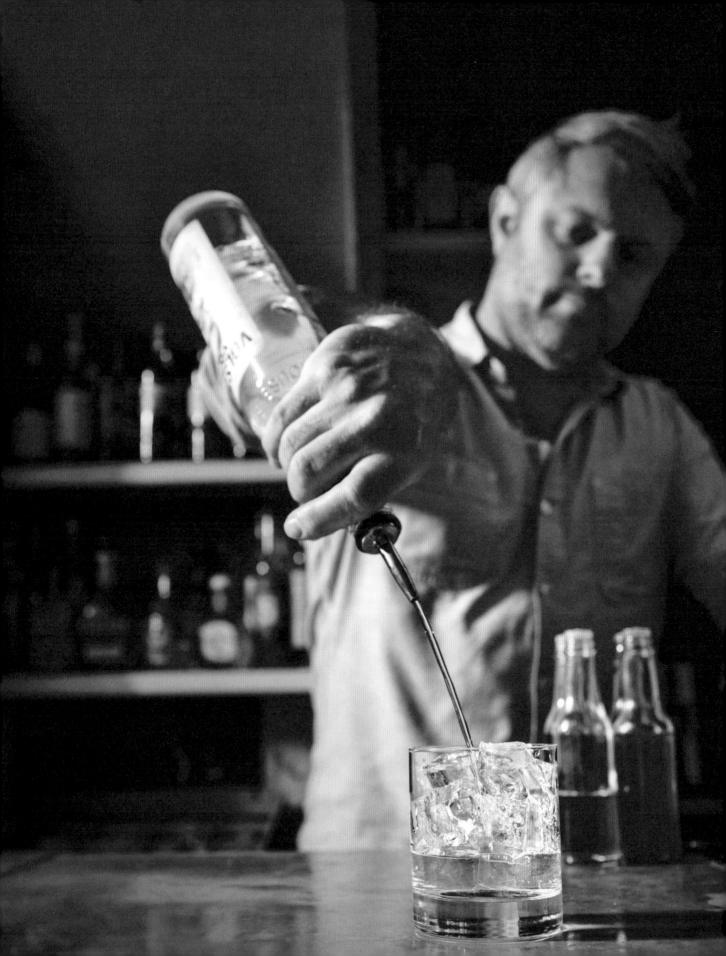

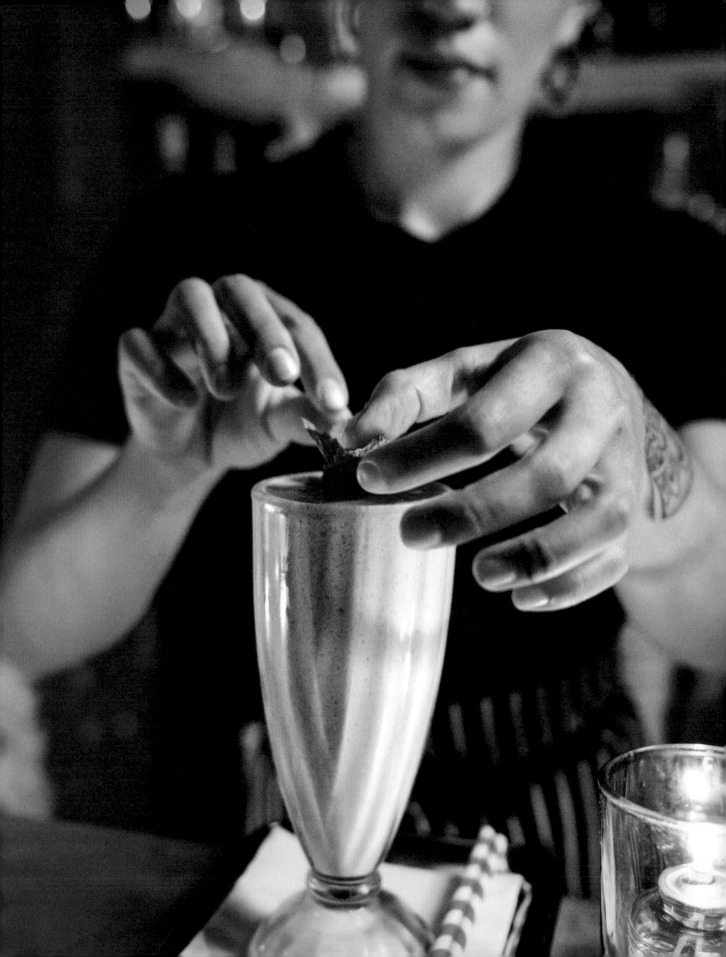

on perfecting my dough. I'm a big fan of our local guy Ken Forkish, who wrote a really fantastic book on pizza, *The Elements of Pizza*. Half the time I'm making recipes from David Lebovitz's cookbooks. *My Paris Kitchen* is my favorite book.

What is the last thing you'd want to drink before you die?

I'm going to give you the drink that we used to drink back in Eugene. I had finally worked my way up to fancy cocktail bars, and we were making Negronis and Manhattans, all these crazy drinks with so much flavor. At the end of the night, it was just well vodka on the rocks. Always. To this day, if I sat down in my own bar and said, "pour me a 'Jeff,' or pour me a 'Morgenthaler,' they would grab well vodka and pour it over ice. It's one of those things I don't want to have to think about too much. I don't want anything difficult to drink. I just want some cold alcohol. It's really refreshing. It's nice to have a good vodka on the rocks. You can kind of slug that down really quickly.

At that hour, we've usually already put all the shit away. There's no fucking way I'm going to bust out all the stuff that I just cleaned to make myself a Last Word. You know, squeezing fresh lime juice, doing jiggers, getting sticky Chartreuse all over everything. You can take the glass to the ice machine in back, fill up the glass with ice, and pour a bunch of well vodka on top of it. Let it sit for a couple of seconds and just enjoy it while you talk to your coworkers about the night. Don't get me wrong. A Beefeater martini with a twist is one of my favorite drinks. But at the very end of the night, when everything is clean and done and you are sitting down to count the money, just vodka on the rocks, man. It's so great.

GRASSHOPPER *Makes 1 Drink*

1½ ounces green crème de menthe 1½ ounces white crème de cacao 1 ounce half-and-half 1 teaspoon Fernet-Branca Pinch of sea salt ½ cup vanilla ice cream Garnish: fresh mint sprig	Combine the crème de menthe, crème de cacao, half-and-half, Fernet-Branca, salt, ice cream, and 1 cup crushed ice in a blender and blend on high speed until smooth. Pour into a tall chilled glass and garnish with the mint sprig.

Ezra Star

DRINK

Boston, Massachusetts | Ezra Star

"And if it's crowded, all the better
Because we know we're gonna be up late"
—LCD Soundsystem, "All My Friends"

Once you make it through the line and into Drink, the popular basement bar in Boston's Fort Point neighborhood, the first thing you may notice after you've been seated at one of the three bar stations is that you're not handed a leather-bound menu divided into multiple cocktail categories. In fact, there's no menu at all. Each cocktail served at Drink comes as a result of having a conversation with your bartender, who then prepares a cocktail that ideally matches your mood, situation, and taste—and is also delicious.

Drink's general manager Ezra Star has been bartending since she was eighteen and has been at Drink for nearly a decade. When Drink first opened, it was staffed by some of Boston's best bartenders, all of whom made amazing drinks and delivered great service, but all of whom also worked in their own particular style. "They were all doing their own thing and no one was training the next generation," says Star, who worked to develop a system in which it now takes a minimum of two years from getting hired to being a bartender. "Everybody starts at the bottom and works their way up. I don't hire people with a ton of experience now because I want them to make drinks the way we make drinks. I want them to approach guests the way we approach guests. The amount of knowledge and the ability to learn to work in the space here are just something you have to apply over time." Each of those seemingly off-the-cuff cocktails comes from a consolidated drinks list of approximately two thousand drinks that each bartender is trained to make—a remarkable endeavor for any bartender to be able to skillfully execute. "Once they've been here a couple of years, they start to be able to actually do it," says Star. "It takes another couple of years, I think, to master that. Our best bartenders have been around for at least four years."

Before service each night, Star practices the same preshift ritual, running up and down the stairs in the hallway entrance listening to music to get her energy up and her head in the right space for her long shift. "My mind-set is that every person who walks through the door is my regular, and it's just a matter of time for me to get to know them. I always start my shift with, What am I going to offer today?"

How do you approach each customer about their order in a bar with no menus?
There are certain stages in a bartender's career where their comfort level and knowledge are really obvious based on the questions they ask at the beginning when it's the bartender's choice. Once we've established with a guest that there are no menus at Drink, people that are new generally ask the bartender for spirit suggestions. I find that's really limiting. Our job as bartenders is to hold a tremendous amount of knowledge that we share with our guests. Not because the guest doesn't know, but because the guests don't have our language. When you have a guest who walks

in the door and says, "Can I have vodka cocktail, not too sweet?" it doesn't necessarily mean they specifically want vodka. It just means they want something refreshing and light, and they've had things in previous experiences that have been too sweet for them. The biggest goal is to win their trust. An experienced bartender doesn't necessarily need to win your trust by giving you exactly what you asked for. She knows how to understand what you're saying and give you what you're hoping for. There are a lot of ways to win over the trust of your guest. The way you stand. The way you hold yourself. Being confident. Nonverbal communication through eye contact and just listening. I'm listening to what the guests are actually saying, noticing how they're standing, and thinking about what the weather is like outside. Is it a cold day? If somebody wants something refreshing, it's going to be something different in the fall than in the spring.

What do you like about your regulars?

In my mind, a regular is somebody who is allowed to break the norms but does it with respect. Maybe they might have the ability to skip the line because they've been coming in for ten years every single Saturday and we know to expect them. They're not really breaking any rules; they're just so used to it and they're a part of what goes on here. I love that. On a busy night when you have people asking for a lot and going crazy wanting too much, your regular is there and you already know what to expect. We make seven hundred cocktails a night, and we're making a lot of decisions for people because they don't have a menu. Having somebody who knows what they want and is easy to take care of and understands they might not get a seat but we're going to take care of them the best we can—that's the best person in the world to have in the bar.

What's last call like at Drink?

Last call is really about winding down. Our version of last call is to get to know the people who have been sitting in front of us. It's the one time of night where we're able to look up and connect even more so with the people who have been there. We're connecting the entire night, but when we don't have to make drinks anymore, we're equals with those people sitting in front of us. It's one of my favorite times of the night. On some nights, people are really lingering for a while. I think it's a testament to us when guests are still hanging out an hour and a half after we've stopped serving.

We've got a lot of fun little things. We pass out beer for the staff at 1:00 a.m. every night. On Sunday nights, we have a midnight Sazerac toast to the end of the week. The team lines up and the person closing the night will cheer everybody going down the line and thank them for the week. We'll sit down and talk about something good that happened that night, something bad that happened, something ugly we need help from friends or coworkers to repair. We meet at the end of the night as a team and go in a circle and say these things. And we'll do a little shot to end the night.

What is the last thing you'd want to drink before you die?

One of my favorite drinks is from an 1891 book called *The Flowing Bowl* by William Schmidt, who called himself "The Only William." It's one of my favorite cocktail books. Some have to be tweaked a little bit, but they're incredible recipes. The drink is called Appetizer a la Italienne, which makes no sense. He gives it a French name, which is weird. I generally don't like Fernet, but I really like this drink. I like it a little sweeter at the end of the night, and I usually put it in

Damon Boelte

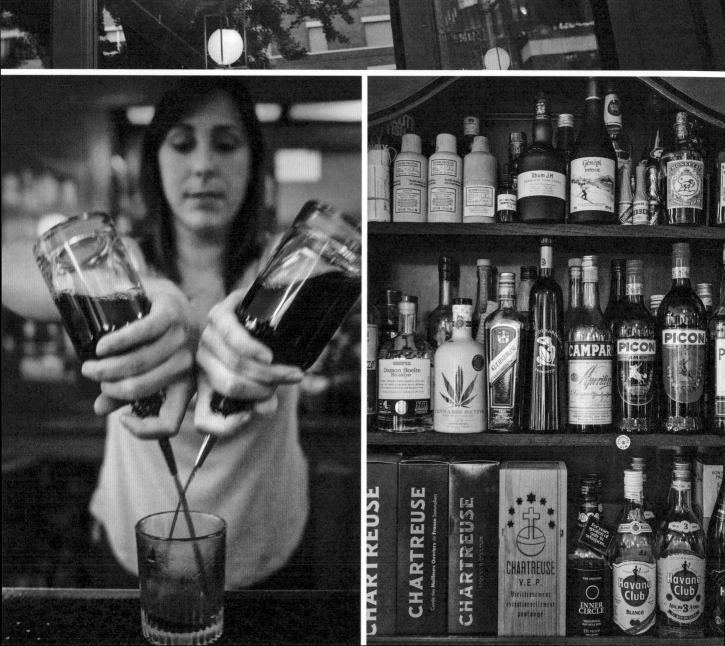

"There are many signed bottles in there, mostly inscribed by distillery owners, master distillers, and brand ambassadors," says Boelte. "But some of my favorite bottles aren't rare, just thoughtful gifts from friends. Two that I absolutely cherish are a bottle of Maker's Mark and a bottle of WhistlePig, both signed by the legendary Dave Pickerell." Pickerell, an influential master distiller nicknamed the "Johnny Appleseed of American whiskey" who was beloved in the spirits industry, died unexpectedly at the age of sixty-two on November 1, 2018. "Unlike a lot of my signed bottles from other master distillers, like Jim Rutledge from Four Roses' first run of single batch and Ralph Erenzo from Tuthilltown Spirits' Hudson Baby Bourbon first batch, that are sealed and will remain that way, Dave's bottles are open," says Boelte. "I loved sharing whiskey with him, and our conversations rarely focused on distillation. He was one of the kindest souls and probably the smartest person I've ever met, and I miss him terribly. His timeless whiskeys were designed to be enjoyed among the best with little ego, a true reflection of their creator."

Beyond the bottles, the Bosses' Cabinet is also a concept, and a way for Boelte and his team to tell a story each night through a featured Bosses' Cabinet cocktail. "It could be something as simple as a Negroni Sbagliato or a French 75," says Boelte. "Those are old tricks to us. We make those in our sleep. But it's a way to tell a story. Lately I like to dig in and find something that existed at a bar in New York that's no longer around. Gone but not forgotten. So long, not good-bye—that kind of vibe. It's a responsibility to keep the memory of these drinks alive."

Boelte goes big with the last call song of the night, typically firing up "Bohemian Rhapsody" or "Oklahoma!" "We end with a big, boisterous sing-along number and then it's like, that's it," he says. "Then after that we'll put on *Stardust* by Willie Nelson and chill out, or Tom Waits, which kind of freaks people out. It's a really great way to get people to leave the bar. Five percent of the people will be like, 'this is awesome, it's late at night, and I'm drinking whiskey listening to Tom Waits.' Then you've got the 95 percent who might be camping out on a date and just don't take social cues, like turning up the lights or putting stools up on the bar."

After a communal round of Hard Starts, he might stop by one of the only places still open in the neighborhood, such as The Brooklyn Inn or Bar Great Harry, which also happen to be two of his favorite bars. "I know some bartenders might feel a little perturbed when they see a group of bartenders or a staff rolling in when they were thinking they might close down a little early, but I'm like, we're going to be your easiest and most profitable customers of the night. We're going to come in and just want beers and shots and we're not staying all night. We want to decompress. We want to sit and chat for a bit. We're going to drink fast and we're going to tip like fucking Daddy Warbucks."

I would've gone all-in on a Hard Start being Boelte's request for a deathbed drink, but his answer surprises me. "I've got to say, iced tea. Just recipe-on-the-back-of-the-yellow-box Lipton iced tea." He gave up caffeine after it made him feel too jittery and dizzy (which is only amplified when that's the natural state of being when you're hustling and working in New York). "I miss it, man. So why not have one last jolt? I'd brew it in true Okie style, in a big jar on the porch, steeped with the light of the sun. I'd throw mint in there. Maybe an orange or lemon slice. I'd church it up a little." He goes on to explain to me what he means by "churching" something up. It's a concept he mastered working at Frankies, where the modular menu allowed for off-menu personalized modifications. "You can order the cavatelli, but if you're not into sausage, substitute broccoli rabe. Or you can do a Blanket Fort. That's layering an order of prosciutto over the cavatelli. The

plates are the same size, so you can just flip them on top of each other at the table. Throw some Burrata in there and you've got a Snow Capped Mountain. Take it to church, man. It's a religious experience." And that one final iced tea for Boelte would indeed be churched up, likely with a splash of Bénédictine. "I fucking love iced tea, man."

ICED TEA

Place 3 Lipton family-size tea bags or 9 Lipton regular-size tea bags in a clean gallon jar and fill with cold water. Cap loosely and place in the sunshine for 3 to 4 hours. Remove the tea bags. Refrigerate within 5 hours of brewing.

Serve in a tall glass over ice. "Church it up" with sugar or simple syrup and a splash of Bénédictine. Garnish with slices of orange and lemon and with fresh mint.

HARD START *Makes 1 Drink*

½ ounce Fernet-Branca ½ ounce Brancamenta	Combine the Fernet-Branca and Brancamenta in a shot glass or a chilled rocks glass. Knock it back. Boelte always keeps a pre-batched bottle of Hard Starts at his bar, in his home kitchen, for gifts, and for camping and beach trips.

Briana Volk and Andrew Volk

PORTLAND HUNT + ALPINE CLUB

Portland, Maine | Andrew Volk, Briana Volk

"And I've never seen anyone quite like you before
No, I've never met anyone quite like you before"
—New Order, "Temptation"

Andrew Volk went to college in Maine, then in 2005, he moved across the country to Portland, Oregon, to work at Clyde Common alongside Jeffrey Morgenthaler (page 61) just as the cocktail scene was taking off. He met his wife, Briana, who was then working in advertising, at the bar when he served her an old-fashioned. Once he realized this was her go-to order, he would make one as soon as she walked into Clyde Common. "This often meant that there was a drink ready for her by the time she got to a seat," says Andrew, "which gave me either the opportunity to spend a few more moments talking with her or to slide in front of whoever I was working beside and make her feel special and attended to. Knowing she had a drink that we both liked gave us plenty of common ground to build a relationship on."

After dating and eventually getting married, in 2011 they decided to switch coasts from Portland, Oregon, to Portland, Maine. "We both grew up in small towns and were looking for a place to establish roots," says Andrew. While the Portland, Maine, food scene was on the rise, cocktail bars were lacking, with most of the city's top bartenders working at restaurant bars. "After being here for a couple of months and trying to figure out what we're doing, we were out late sharing a whiskey and Briana said, 'We should be the ones to open a great bar in Portland. If we don't do this, somebody else is going to, and if somebody else does it, we'll kick ourselves every damn day.'"

That was the spark they needed to launch the Portland Hunt + Alpine Club in September 2013. Their "Maine meets Finland" concept for the bar was inspired by Briana's Finnish roots, and the similar climate and historical relationship to the sea both places share can be seen in many of the bar's signature cocktails, like the Norseman, a twist on the classic old-fashioned made with brown butter–washed aquavit. "Portland's a town that's changed a lot in the past six or seven years," says Andrew. "For a long time, it was very much a town you stopped in to fill up on gas and get a sandwich on your way to the coast. Now it's a destination unto itself, and that's a testament to the local restaurant industry and how it's grown."

Briana likes to describe Portland Hunt + Alpine Club as a Scandinavian cocktail bar that feels like a cozy lodge. "One of the things I kept coming back to is how great Scandinavian food and Finnish food are and how they go well with drinking," she says. "Brown breads, root vegetables, and pickled things go very well with heavy, bitter-forward cocktails and will stand up next to them." You would never know that the house favorite Swedish meatballs, green chile popcorn, house-made pretzels with hot mustard, and smorgasbord platters filled with fish, meat, cheese, and bread are coming out of a tiny kitchen with two induction burners and a quarter sheet pan–size oven.

Andrew explains that many New Englanders like things the way they like them and are sometimes reticent to try new things. "Threre's a sense in Maine that change doesn't need to happen quickly," he says, "and I totally understand that." When developing the cocktail program, he focused on clean, classically derived drinks to make things accessible to somebody coming in who may have never had a cocktail bar experience. "Very early on at Hunt, we had to make sure the staff understood, yeah, we can geek out about dilution ratios and residual sugar amounts in different vermouths and bring that to the guests who care about that, but there are going to be people who walk in and want a vodka soda and just want to fucking hang out," says Andrew.

"If you aren't integrating yourself in the community here, you're going to have a really tough time," he continues. "We've cultivated our local industry crowd, especially shifting from tourist season, with June and September being the shoulders of the season. We really have to balance doing great volume in the summer while still being present and making a connection with the locals, so they know we're here for them in the winter."

When I visited Portland Hunt + Alpine Club on a bitter-cold evening in December, decidedly the nontourist season, I met Andrew and Briana at the bar over a couple of cocktails and watched as the Portland Hunt + Alpine Club filled up over the passing hours, with the crowd eventually reaching capacity. After checking into my Airbnb and grabbing dinner in town at their sister restaurant, Little Giant, I returned to the bar around closing time for a nightcap, ordering an espresso martini made with Allen's Coffee Flavored Brandy, a Massachusetts-made brandy that's one of the top-selling spirits in Maine. Alone in the crowd, standing near the fifteen-foot windows overlooking the city park across the street, I was able to see the glow of the Christmas lights in the park through the condensation on the glass.

OLD-FASHIONED *Makes 1 Drink*

2 ounces rye whiskey (preferably
 Old Grand-Dad Bonded)
1 teaspoon rich simple syrup
 (2:1 sugar:water)
2 dashes Angostura bitters
Garnish: cocktail cherry and
 orange twist

Combine the whiskey, simple syrup, and bitters in a chilled double old-fashioned glass. Add a large ice cube and stir. Garnish with the cherry and orange twist.

TRIDENT *Makes 1 Drink (pictured on page 84)*

1 ounce aquavit (preferably
 House Spirits Krogstad)
1 ounce Cynar
1 ounce fino sherry
2 dashes peach bitters
Garnish: lemon twist

Combine the aquavit, Cynar, sherry, and bitters in a mixing glass filled with ice. Stir until chilled and strain into a chilled coupe glass. Garnish with the lemon twist.

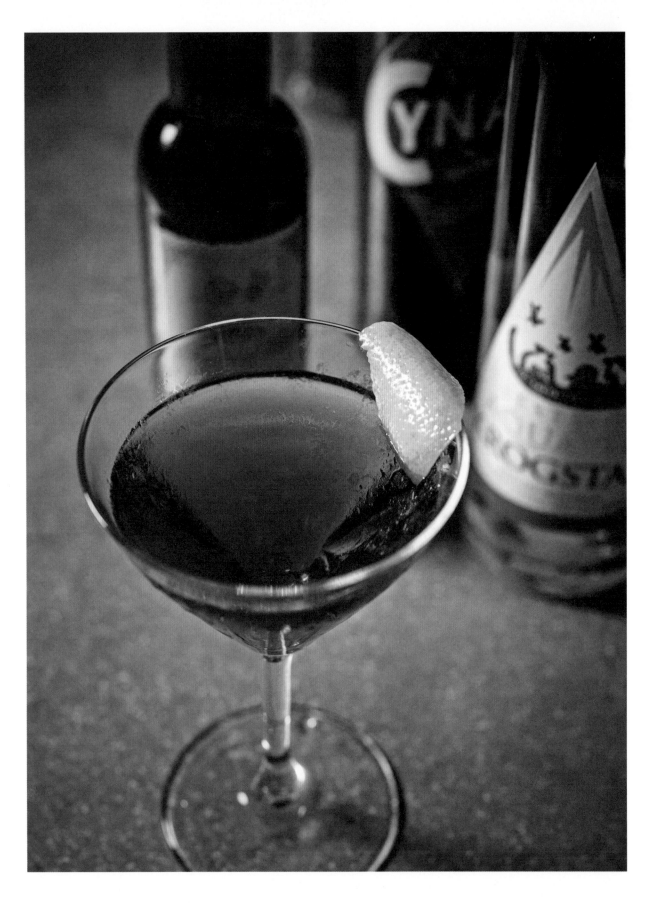

Brian Bartels

the crowd. We play Little Dragon a lot. I'll always happily put on the Rolling Stones's *Exile on Main St.*, and on the flip side, Liz Phair's *Exile in Guyville* is a fucking amazing album that I will always listen to. Old-school hip-hop for sure. I mix it up. Music is important to me. It's operating in the background, but conversation is the almighty goal. You still want people to be able to communicate.

Do you still love New York?

I've been here for thirteen years, and it's amazing how, through this industry, the city seems so small. Everything here feels like two degrees of separation because of the food and beverage industry. There's the age-old adage of nothing good happens after midnight, but in New York, I still wield the nostalgia of thinking in a romantic way that this is a place that doesn't sleep, and if you find something open anywhere at four in the morning, that's awesome.

What is your favorite thing about being a bartender?

The best thing is the camaraderie. I like the reliability of working a shift with somebody you can trust, and the tangible groove when everything about the night and service is firing on all cylinders. Camaraderie comes in many shapes and sizes. I celebrate when regulars come in and become an extension of your family. The genuine sense of being of service. The consistency of pouring a pint of beer is as important to me as a well-made cocktail. I love the occupancy of bartending, and working with my hands. I was probably a woodworker in another life—a carpenter maybe.

What is the last thing you'd want to drink before you die?

It would have to be a Mezcal Negroni. Simply put, the humbling trifecta of smoky mezcal, sweet vermouth, and bitter Campari tugs at my heartstrings. I celebrate how food and drink can catapult nostalgia, how each sip feels like a memory. I can't recall where I was when I first had a Mezcal Negroni, but I can speak for that little rascal of my former self and say he most definitely wanted to order another after his first sip.

It became my drink a few years ago, and nowadays it's an effortless late-night go-to for me. And when I get that first sip, everything makes sense. I can go to a dive bar and have some really shitty old-fashioneds, but I can go to a dive bar and pretty much always find a pretty consistent Negroni, especially in the past five years. There are so many characteristic layers to appreciate, and it reminds me I'm always respecting the balance of things; how life is a place I am always looking back at to appreciate who I have known and what we have experienced, where I currently exist and who is or isn't there to share it with, and looking forward to whatever's going to happen down the road. I don't like the expression, "Drink to forget." It bums me out when I see that sign in bars, even if it's meant as a joke. I'm too sentimental. We're too lucky to be here, alive, and actually know each other, even if it's for only a little bit of time, at the end of the day, over one drink.

And because I really always want more than one, I'm ashamed to admit I can drink them faster than Nolan Ryan could throw a baseball. Can I have one more?

MEZCAL NEGRONI *Makes 1 Drink*

1 ounce mezcal (preferably
 Del Maguey Vida)
1 ounce Campari
1 ounce sweet vermouth
Garnish: orange twist

Build the mezcal, Campari, and sweet vermouth in an
old-fashioned glass filled with ice and give it a healthy
10- to 15-second stir. Garnish with the orange twist.
Sip and smile and think of friends near and far.

Sunny's Bar. Brooklyn, New York. »

LOST LAKE

Chicago, Illinois | Shelby Allison, Paul McGee

"On an island in the sun
We'll be playing and having fun"
—Weezer, "Island in the Sun"

For some reason, I always tend to visit Chicago in the dead of winter. And to remedy the steady sting of the lake-effect winds on my face, I make it a priority to visit Lost Lake, the Logan Square neighborhood tiki bar tucked away behind an unassuming door like you'd find at a check-cashing store, for my own version of an island getaway. You can't see the outside street from the windows, which enhances the lost-in-time casino-like allure of the compact room that's adorned with a thatched ceiling, tropical-themed banana leaf–print wallpaper (the second biggest expense of the build out after all the booze), and a much-Instagramed neon sign spelling out "Lost Lake" in pink cursive script on the wall. I'll take my time perusing the menu, even though I know I'm going to order Bunny's Banana Daiquiri. One of Lost Lake's most popular cocktails, the blender drink is made with a blend of three rums and the secret house coconut liqueur and comes with a custom garnish of a whole banana passing for a dolphin with a cherry in its mouth leaping from the surface of the drink. "It's a serious cocktail that looks very silly," says Paul McGee, who co-owns Lost Lake with Shelby Allison. "There's a banana blended in the drink, so, with the garnish, you get two whole bananas per serving. Our Saturday prep person who prepares the dolphins makes one hundred of them, and we always end up having to make a few more during the shift."

Allison likes to describe their bar as a beautiful little hole in the wall. "We think we're like a rum bar that's masquerading as a tropical cocktail bar," says Allison. "We want to take the people who live in Chicago and who live through a seven-month-long winter on a mini tropical vacation by way of a wildly garnished cocktail." McGee, who has been bartending for thirty years, adds, "It's escapist without being over-the-top thematic. You come in here and it's warm and bright and cheery and friendly."

It might have to do with all the rum and the fact that I tend to run into every Chicago bartender I know hanging out there, but everyone always seems to be having a good time at Lost Lake, including the eclectic team behind the bar who are decked out in personalized tropical-inspired uniforms in an array of colorful, clashing patterns. (The staff is allowed to sit at the bar after their shift but, per Allison, must "de-tiki" to "preserve that feeling like you're in another world being served by people who live on this magical island.") They're dressed for comfort, and wildly conflicting patterns are encouraged. The only rule is flora and fauna patterns only; no idol motifs or surfboards allowed. "It needs to feel like a costume," says Allison. "You shouldn't feel comfortable walking to work in your work outfit." Hiring a hospitable and diverse bar staff is also a part of making guests feel comfortable at Lost Lake. "We have a lot of women, queer folks, people from the neighborhood working here," says Allison. "When people walk in, we hope they'll see themselves reflected in some way."

Last call at Lost Lake means slowly bringing up the lights and turning down the music. "We don't want to shock you out of your dream," says Allison. "Our drinks take a little while longer than most to enjoy, so we try to give people a good heads-up." When Allison's brother John worked at the bar, the last call ritual was a bit more dramatic and involved the mournful bellow of a conch shell. "I ordered a conch shell online," says Allison. "But it turns out they're pretty hard to blow. Not everyone has the lung capacity to give a nice clear horn blow. John was the one who could do it, but when he left, it kind of faded out with him." McGee smiles with the memory. "Oh, man, we've got to bring it back," he says. "I remember before John learned how to blow the conch, he would put it up to his mouth and mimic the noise."

When it comes to their final drinks, Allison will take a Negroni, thank you very much. "First of all, I love Negronis. I love bitter, I love vermouth, I love gin. And I love them together," she says. "Depending on how I'm feeling, I'll do either two ounces of gin, three-quarter Campari, three-quarter sweet vermouth, or stick with the classic equal parts, but always with Fords gin. It's my go-to cocktail to order out because—and this is also why it would be my last drink ever— it's really hard to fuck up. If I'm not going to have the chance to do it over, I know that that one is going to be fine. And I think that speaks to my control issues. I am a person who is deeply fatigued by cocktails in general, but I come back to Negronis because I think they're so beautiful and so crisp, and with each decision that you make—the bitter, the vermouth, the gin—you can do so much. That, to me, calls to what I love the most. It's really restrained and humble."

McGee sticks with rum, the spirit he's most passionate about, for his ultimate last-call drink, a Petit Punch, better known as Ti' Punch, an island drink that's popular in Martinique. "When you see rum, lime, and sugar together, you think, Oh, it's a daiquiri, but it's very much like an old-fashioned," says McGee. "In Martinique, you would typically get it with no ice, and a lot

of times in restaurants and bars, they just put the bottle down, and that bottle will be the house choice but always an *agricole blanc* that's 50 to 55 percent alcohol. They set the house bottle on the bar or table, bring cane sugar in packets or sometimes in a bowl with a demitasse spoon and some lime wedges, and you make your own. This style of service is referred to in French as *chacun prépare sa propre mort*, or roughly, 'prepare your own death.'"

McGee professes a love for Martinique rum, especially those made by Gregory Neisson, the distiller at Neisson and the grandson of the company founder. McGee has visited countless rum distilleries in his travels and has been to the Neisson distillery several times, where he has spent time with Neisson and his mother to witness firsthand their personalized, familial approach to making their *rhum agricole*. He can attest that this admirable perspective to distilling is the exception and not the rule, especially when it comes to rum. "With so many bottles to choose from, I gravitate toward spirits where there's a real person connected to the art form of creating what's in that bottle," says McGee. "The Ti' Punch takes me back to Martinique and reminds me of the beach and how close to the water the Neisson distillery is and of spending time there. As you get older you start thinking about your own mortality a little bit more."

NEGRONI *Makes 1 Drink (pictured on page 99)*

2 ounces Fords gin ¾ ounce Campari ¾ ounce Lustau vermut rojo Garnish: orange twist	Build the gin, Campari, and vermut rojo in an old-fashioned glass filled with ice and stir until chilled. Garnish with the orange twist.

TI' PUNCH *Makes 1 Drink*

1 quarter-size lime disk, make
 sure it includes a small amount
 of flesh

1 barspoon Martinique cane syrup

2 ounces Neisson L'Esprit rhum
 agricole blanc

Squeeze the lime disk over an old-fashioned glass and drop it into the glass. Add the cane syrup and, using a barspoon, press against the lime disk to release its oils and integrate them with the syrup. Add a large ice cube and pour in the rhum. Give it a quick stir to dilute and cool down.

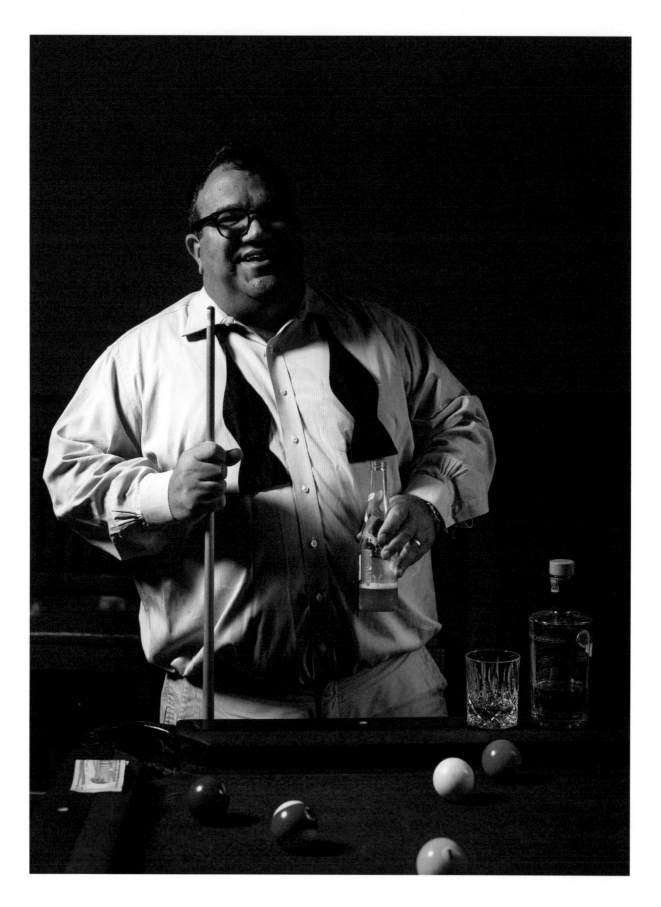

Gary Crunkleton

THE CRUNKLETON

Chapel Hill, North Carolina | Gary Crunkleton

"Goin' home, goin' home
By the waterside I will rest my bones"
—Grateful Dead, "Brokedown Palace"

Among Southern bartenders, Gary Crunkleton's reputation is larger-than-life. In fact, it veers toward American folklore proportions. The North Carolina native opened The Crunkleton in Chapel Hill in 2008, offering an elevated drinking experience that focused on classic cocktails and a deep spirits list that ran counter to the area bars, which mostly catered to the drinking habits of local college students. The first time I had the good fortune of meeting Gary was on a late-summer night at The Crunkleton (which, as a bar name, is impossible to say out loud without smiling). Crunkleton is built like the late Chris Farley, with a head of mussed-up hair and a hint of mischief always brewing just beneath the surface. As we were saying our good-byes, he sized me up and down, grabbed me by the shoulders, and said, "Brad, you and me, we're a couple of Clydesdales. And Clydesdales have got to stick together." He's truly one of the most generous, thoughtful, and downright hilarious souls I know, and I'm honored to call him a great friend.

The thirty-foot bar at The Crunkleton runs the length of the front room and has more than six hundred unique bottles on display on ten-foot-high bookshelves that reach toward the ceiling. Crunkleton credits the Grateful Dead for inspiration, modeling the backbar after his favorite band's legendary Wall of Sound speaker setup that spanned the entire backdrop of the stage during their 1974 tour. Assembling that many bottles in a control state was not an easy feat, and when Crunkleton wanted to expand his collection to offer rare and vintage spirits to his guests, he lobbied the state legislature. In 2015, North Carolina General Assembly House Bill 909 was passed—Crunkleton calls it the "Crunkleton bill"—allowing the "sale of antique spirituous liquor" in North Carolina bars, restaurants, and distilleries. "Owning a bar meant I would need to be there every day to serve guests. I thought it best to create a place full of things that I love in order to sustain my enthusiasm and appreciation for the place," he says. "I'm a big guy. I'm into sports. I look like a good old boy who lives in a trailer park and eats fish sticks, but that's not who I am. I created a place that's regal and rich and complex. I created a place about who I am, or who I esteem to be."

Crunkleton is the first to tell you that he gets easily distracted, and even though I've known him for years, it was difficult to pin him down to interview. But his good-natured charm is always on display. "I know you're a writer, Brad, and I buy a lot of books," he says. "But I'm going to tell you right now, I've only read two books cover to cover in my entire lifetime: the Bible and John Grisham's *A Time to Kill*." We talk on the phone and text each other quite often, but every time I tried to sit down to talk with him during my time in Chapel Hill, we'd last around twenty minutes before he'd get antsy, stand up, and say, "ready for lunch?" or "feel like dinner?" or "let's go for a drive." But just spending time riding shotgun in his Suburban as he drove me around the

University of North Carolina campus, stopping in for a slice of pizza at his favorite pizzeria, or catching up with our good friend Bill Smith at Crook's Corner for plates of pimento cheese and hot pepper jelly with crackers, cold fried chicken, and Atlantic beach pie revealed more to me about Crunkleton as a bar owner and father, but, more important, a friend.

Crunkleton started out making good money bartending, but as he was getting older, he wanted to settle down and establish permanent roots in Chapel Hill and meet someone to settle down with. His regular spot to try to meet women was an Italian restaurant on what he calls the "older side" of West Franklin (the undergrads run wild on the other side). "The problem with me is that when I was trying to feel sexy and cool and attractive and all that, there would be people in there eating pasta. So I'd have a glass of wine so I would look cool, but all the while I was thinking, man, that pasta looks good," says Crunkleton. "So I'd eat a bowl of pasta and feel bloated and full and not sexy and not appealing at all. I'd say to myself, Well, I had a great bowl of pasta but didn't meet anybody. I'll try tomorrow night."

Crunkleton eventually did meet his future wife, Megan, there, and they now have three sons, Montgomery, Hudson, and Beaufort. But his agonizing pasta travails gave him the idea for what would become The Crunkleton, a bar where adults could enjoy themselves and have great drinks and good conversation, but there would be no food to distract people. "I said, let's open a bar. It's the only thing I really know how to do that I'm good at. And I made it happen." It took about two years for people in Chapel Hill to understand that The Crunkleton was unlike any other bar in town. "We literally had to create a market—to create a culture," Crunkleton says. "And we did it through cocktails. There are people around here with discerning palates, and we transferred that to what they're drinking."

One of his favorite last-call stories at The Crunkleton is when he had a bar full of guests who were having so much fun they wouldn't leave, even chanting, "Hell no, we won't go," to make their intentions known. Worried that the local police would drive by and see people at the bar drinking after 2:30 a.m., Crunkleton jumped out from behind the bar, and started chanting in unison with the rowdy group. "The music I was playing was good for doing a conga line, so I started one and everyone got in line as we danced throughout the bar," Crunkleton says. After a couple of loops around the room, Crunkleton shouted, "Let's take this outside," and led the group out onto the street. "After the last person from the conga line was out the door and I had a good angle, I ran back inside the bar and locked the door," he says. "They were all unhappy being tricked like that, but they understood and laughed about it."

Despite running a place with more than six hundred bottles of spirits, including what he calls "some of the best whiskey ever made in America" with bottles dating back to 1906, you're most likely to find Crunkleton drinking a Miller High Life at the bar. "To me, this simple, inexpensive beer captures what the bar is all about," he says. "The Crunkleton is a place for everyone who strives to bring out the best in people. A guest can come in here for the first time and be intimidated by all the bottles, the fancy cocktails, the bartenders in bow ties, and the higher costs. The Crunkleton is not a common bar. But a simple bottle of beer can be the drink that shows guests what we are by showing them what we are not: pretentious, assuming, chichi, or jerks."

He tells me that the obvious problem with considering one's final drink is that one doesn't know when that last drink will come. But given that he knows himself pretty well, he tells me

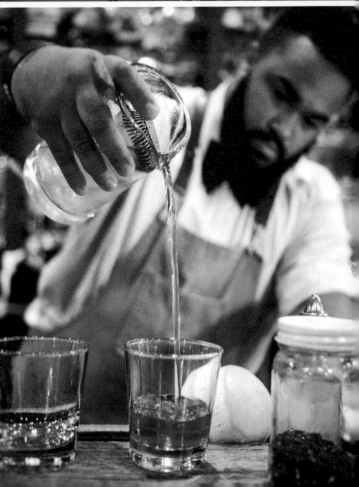

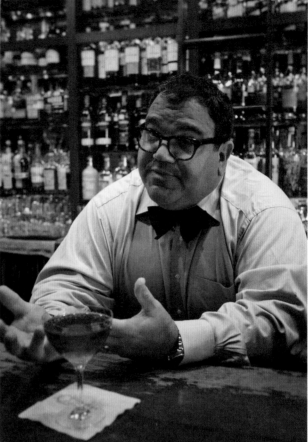

his last drink would indeed be a cold bottle of Miller High Life and a glass of rye whiskey, most likely Rittenhouse bonded rye. "I purposely do not pluralize the word *drink* despite there being two different drinks in front of me. For me, the beer and the whiskey represent one drink in two different vessels," Crunkleton says. "In a time when cocktails, mixing drinks, and knowing all about spirits are very *en vogue*, it is comforting for me to find enjoyment, satisfaction, and fulfillment in two simple things."

Standing by the pool table at the back of the room, Crunkleton seems at ease and takes a moment to look over the bar and soak in the space he created here in Chapel Hill. He brings up "Brokedown Palace," his favorite Grateful Dead song. "My guess is most people think that song is about dying, but not for me. Why wait to share all of life's wisdom on one's deathbed? Share it daily. Live life with meaning. Although the song appears on the surface to be about endings, it's really about new beginnings." He racks up the balls on the table, picks up a cue, and leans in for the break—but then pauses for one last thought. "I spent many days when I was younger turning drinking into a bad thing. Fortunately, I have found the grace that comes with an occasional drink," he says. "I hope that my final drink choice says that I am who I am, whatever that means. I try not to be anything more than who I am, and I hope that I am a caring, honest, loving, funny, authentic, and gracious man that relishes in the best life has to offer. For me, the simpleness of a cold bottled beer and a pour of whiskey is an appropriate gift for an honest day's work of doing good."

FRIDAY SATURDAY SUNDAY

Philadelphia, Pennsylvania | Paul MacDonald

"Lightning strikes maybe once, maybe twice
Oh and it lights up the night"
—Fleetwood Mac, "Gypsy"

The restaurant Friday Saturday Sunday first opened in 1973, and as one of the few upscale spots in Philadelphia's Rittenhouse neighborhood, it built a devoted following of regulars. It had an impressive run through 2015, when it closed and the business was sold to restaurant industry veterans Chad and Hanna Williams, who had never owned their own restaurant. One of their biggest changes was flipping the former layout, moving the bar downstairs and the restaurant to the second floor. The old neighborhood regulars approved of the update to their beloved restaurant, and a new crowd of diners and drinkers flocked to the place.

On a trip to Philadelphia in 2017, nearly every bartender I talked to told me of the talents of Friday Saturday Sunday bartender Paul MacDonald, and after I finally got a seat at his busy bar, I was so enamored of MacDonald's genuine hospitality and watching him turn out a diverse range of inventive cocktails that I canceled my dinner reservations at another restaurant and stayed put for the remainder of the night. MacDonald thrives on being a restaurant bartender and takes inspiration from the kitchen for ingredients as well as service, offering guests a spirited amuse-bouche or intermezzo cocktail, like his clarified milk punch made with Ovaltine, and developing culinary-inspired herbal infusions and a savory syrup made with smoked eggplant. "The drink program is definitely eclectic. We change one or two drinks at a time here and there, but it's more of an evolution than a seasonal flip," says MacDonald. "I try to get a feel of what people are up to—where they're coming from, where they're going. Give them the right drink for that. The cocktail bar is really the only setting in which you can do that."

The last time I was there, I went in for a nightcap and ended up closing down the bar with shots of Laird's Bonded apple brandy with MacDonald and bartender Madison Reynolds. America's oldest distiller, Laird & Company was founded in Scobeyville, New Jersey, in 1780 and still holds License No. 1 issued by the US Department of the Treasury. Like many bartenders, MacDonald is obsessed with the brand, especially Laird's Straight Apple Brandy Bottled in Bond, and keeps a bottle topped with a special pourer shaped like a blackbird in a prime spot behind the bar. The bar emptied out, and after settling my tab, MacDonald came out from behind the bar and told me I was needed in the kitchen. When we stepped into the back, I got to partake in the kitchen crew's version of last call, where every Sunday, Chad and Hanna order in for the staff and a late-night spread of cheesesteaks and fries was laid out across the pass. While I may not have earned it from a hard night's work, I was honored to be a part of the Sunday-night ritual and joined in.

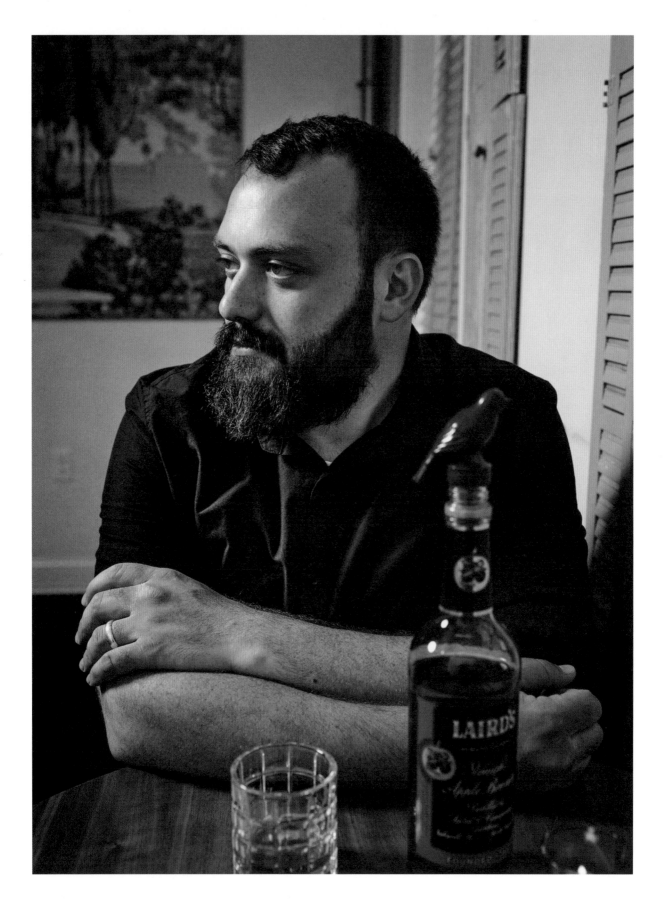

Paul MacDonald

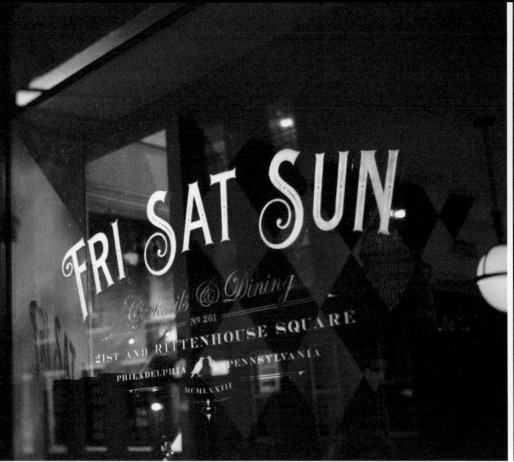

What do you like about being a restaurant bartender?

I like serving food, really good food, side by side with cocktails. It's about putting cocktails in context. I like a bar to be a place where people hang out for a long time. I like being able to serve dinner and intersperse drinks other than cocktails throughout and do beverage pairings. I like it to be a larger experience than just going out to a cocktail bar and drinking a few cocktails.

What's the drink you're most known for?

Probably the most popular cocktail that we've ever served went off our menu just a few months after we opened. It was on our original menu and was a wintertime drink called The Assassin's Handbook: Appleton signature blend rum, Cognac, mulled wine shrub, and Averna with a little bit of habañero tincture. It was hugely popular and *Philadelphia* magazine named it cocktail of the year. It might as well still be on the menu at this point, as we continue to make it constantly. It's possibly the drink I'm best known for creating, for better or for worse. At this point, it's a drink I just can't escape from.

How important is it to have regulars at your bar?

A reason that I love bartending is the variety—the fact that nothing is too routine. One way that manifests itself is in all the different types of regulars we have. We certainly have regulars who come in at the same time on the same day each week and order the same thing. We have regulars who come in every day at some point. We have one guy who hangs out four nights a week

at our bar and literally the only thing he ever drinks is Miller High Life. I've always worked hard to curate relationships with regulars, people who I've been able to take with me from bar to bar. I like it when people put in the effort to kind of be a part of the social scene at our bar—when they do the work to sew themselves into the fabric of the establishment. Whatever role they may be filling, whatever it is they like to do there.

How do you go about decompressing after closing time?

I'm not that much of a ritual person. I'm very weird about working with music. I'm very sensitive to background noise, and although I've gotten used to working in bars, I hate working to music. I would almost always rather work in silence. My only ritual is that as soon as everyone is out the door, it's music off, lights up.

I do have young kids, which put a damper on any possibility of me having a ritual of going out to eat or drink late night after work. That's not happening. Usually decompression is necessary, and I accomplish that by walking home. I live about two miles from where I work. No headphones. No music. Walking home late at night with cash tips in your pocket, you probably shouldn't be listening to music anyway. One of my favorite things about living in the city is the walkability of it. I walk miles and miles every day. If I stop somewhere for a drink, it's usually at Palizzi [see page 23] because they're actually on my way home. That's my go-to place. They stay open later than anyone else. And they're a few blocks from my house.

What is the last thing you'd want to drink before you die?

It's definitely not the drink I'm best known for. To be honest, it's probably not a cocktail of any kind. I would have to say Laird's Bonded. Neat. It's been the one constant of my bartending career so far. My opinion of it hasn't changed. My uses for it haven't changed. I've gone through brandy phases, and American whiskey phases, and scotch phases, and gin, and rum. But Laird's is the one thing that's kind of never gone out of fashion for me. It was one of the first things that got me interested in the cocktail world. I sip it. At the end of the night, I'll sip it. In the middle of the shift, I'll knock back a shot.

My first taste of Laird's, while I enjoyed it, was a somewhat anticlimactic experience. I'd heard it spoken of in almost mythical terms, and when I finally had my first opportunity to taste it, my mind-set was basically that of a person checking off a box on a list of goals, the way I approached a lot of experiences at that point in my life. As I delved deeper into the world of cocktails and learned about the history of the Laird's brand, I developed a much greater appreciation for the product. I have come to see it as an honor to have such ready access to a product whose background is so inextricably woven into the history and culture of our nation and the mid-Atlantic region. A liquor brand that survived the American Revolution, Prohibition, and the mass corporatization of the twentieth century; continues to be family-owned; and has never stopped making the same excellent product is truly an anomaly in this country, and I take it as a point of pride that it comes from my region. This product is meaningful to me because, in pouring it, I am carrying on a tradition that is bigger than me, my bar, and the whole of the modern cocktail world.

THE ASSASSIN'S HANDBOOK *Makes 1 Drink*

1 ounce Jamaican rum (preferably
 Appleton Signature Blend)
¾ ounce Cognac (preferably
 Gilles Brisson VS)
¾ ounce Mulled Wine Shrub
 (recipe follows)
½ ounce Averna
¼ ounce Habañero Tincture
 (recipe follows)
Garnish: orange twist

Combine the rum, Cognac, shrub, Averna, and tincture in a mixing glass filled with ice and stir until chilled. Strain into a double old-fashioned glass over a large ice cube. Garnish with the orange twist.

MULLED WINE SHRUB *Makes about 3 Cups*

1 cup granulated sugar
1 cup Demerara sugar
1 cinnamon stick, splintered
1 nutmeg, roughly cut
1 teaspoon whole cloves
1 teaspoon allspice berries
1 teaspoon juniper berries
1 star anise pod
Peel of 1 orange, cut into
 wide strips
2 cups red wine vinegar

Combine both sugars, the cinnamon, nutmeg, cloves, allspice, juniper, star anise, and orange peel in a bowl and muddle lightly. Cover and let sit at room temperature overnight. The oils from the orange peel will be absorbed into the sugar. The next day, transfer the mixture to a saucepan, add the vinegar, and bring to a boil over high heat. Lower the heat to a simmer and simmer briefly, just until cinnamon and allspice aromas are prominent. Monitor the pan closely to make sure the clove doesn't overpower the blend. Remove from the heat and strain through a fine-mesh strainer into a heatproof jar. Let cool, cap tightly, and refrigerate. It will keep for up to 1 month.

HABAÑERO TINCTURE *Makes about 1½ Cups*

8 habañero chiles, thinly sliced,
 with seeds and stems
½ (375-milliliter) bottle
 80-proof vodka

Combine the chiles and vodka in a glass jar, cap tightly, and let steep at room temperature for 24 hours. Scoop out and discard the solids, then strain through a Chemex or paper coffee filter into a clean jar. Cap and store at room temperature. It will last indefinitely.

ROB ROY

Seattle, Washington | Anu Apte-Elford, Chris Elford

"Don't you know promises were never meant to keep?
Just like the night, they dissolve off in sleep"
—Rolling Stones, "Emotional Rescue"

Located in the heart of Seattle's Belltown neighborhood, Rob Roy attracts an eclectic mix of the postwork happy-hour crowd, drawing tech bros, cocktail geeks, and bar and restaurant industry regulars alike. It's a cocktail den where you're made to feel welcome whether you're drinking a Rainier tallboy or a barrel-aged Martinez with your bowl of complimentary Goldfish. The clubby midcentury rec-room vibe is tricked out with a diamond-tuck leather-padded wall, stacked flagstone behind the bar, and a floor-to-ceiling shelving unit filled with books, records, a turntable, and a reel-to-reel player. In the men's bathroom, colorful citrus wheels fill the urinals, and instead of the usual uninspired "call me," the graffiti on the walls include cocktail recipes from bartenders passing through.

Chris Elford first met Anu Apte when he as working at Amor y Amargo in New York and she stopped by the bar with her then boyfriend. "I remember there was a handsome man making us cocktails at Amor y Amargo when I was there," she says. "Sother [Teague, proprietor of Amor y Amargo] was the hospitable one who probably overserved us, but Chris made a lasting impression." They later hit it off at Camp Runamok, an annual summer camp for bartenders in Lebanon Junction, Kentucky, and after a long-distance relationship, Elford made the move to Seattle, where they became partners in marriage and business. In addition to Rob Roy, Apte-Elford and Elford co-own the nearby spots No Anchor, a beer bar and restaurant, and Navy Strength, a "proto tiki bar" inspired by travel and drinks from around the world.

How would you describe Rob Roy?

Apte-Elford: It's a classic cocktail bar. We still focus on making classics but throw in some house originals. It's laid-back and causal. You can come in and have an intimate date. We have a lot of first dates here. It's really sexy at night, really dark and glamorous. But it's also a place where people know they can roll in with twenty friends, get a classic cocktail, and sit down and kind of party in that front area, the den. It kind of hits on every mark. It was really important for me to have a bar that could accommodate anything within reason.

What's one of your favorite elements of the bar?

Apte-Elford: The wall of sound is definitely one of my favorite parts of the bar. I love talking about it. Everything is in working condition. The reel-to-reel, eight-track, the record player, the old speakers. I'm just missing a cassette player. Analog Tuesday is still a thing we do each week. And the bathrooms with the recipes on the wall. I started it in the men's room since I thought women might actually want to see themselves in the mirrors, but then I was like, screw that. There are so many talented women bartenders, and I want them to put their recipes on the walls, too.

What's closing time like at Rob Roy?

Apte-Elford: Monday through Wednesday it's pretty subdued. A lot of industry comes in when they get off work, mostly sitting at the bar top and couches. But on weekends we normally have to do a loud last call. Personally, I don't like the loud last call. I like to talk to everybody individually and slowly start turning up the lights. But it can be 2:00 a.m. and people are still partying in here even if they have nothing in their hands. It's a comfortable space, so people tend to want to stay. Then we'll have to guide people out. Friday and Saturday sometimes turns into a dance party. Sometimes I'm the one who starts it. Every bartender does have a signature last call or closing song. For me it's "Fly Away" by the Alessi Brothers because I want people to fly away. But I also really love the song. It's mellow and soothing and just gets people to wander out slowly.

How do you go about decompressing after a long shift?

Elford: While I'm closing the bar, when I'm done talking to people, I just feel so exhausted. I don't think there's any other profession where you're just constantly describing what you're doing. Every dish that I drop off, I'm describing all the elements of it. Every drink I drop off, I'm explaining what it is and why it's that way. Do that for twelve hours, and it's tiring. At the end of a shift while I'm cleaning up, I turn up the lights and put on a stand-up album and just listen to someone else talk. It's nice to get enjoyment out of not talking and letting someone else do all the work in a way. I also like to run late at night.

Apte-Elford: Like Forrest Gump—away from work, in the opposite direction.

What is the last thing you'd want to drink before you die?

Apte-Elford: I'm trying to find the perfect work and life balance, so a 50/50 seems perfect. At the end of a long workday, it's important to balance it out with fun and a good drink. I didn't get to the 50/50 martini with all the garnishes until a few years ago. I truly don't think I've ever had a bad one. Not that I can remember anyway. I will, however, only order a martini at places where I see that the vermouth is properly stored. I've never really thought about mortality in connection with a last drink, but sometimes being forced to call it a night because of last call feels like dying when all you want to do is stay out and party. Now that I'm thinking about it, if I knew I was a few hours away from dying, I'd either have the bartender line up some martinis, or I'd order one made in a swimming pool and go swimming in it. I just love how classic, beautiful, and minimalistic this drink is. It sums up how I want to be in life.

Elford: The Sazerac and the daiquiri have been my favorite all-time drinks since I got into cocktails. I started drinking a Sazerac with a daiquiri back because I was working at restaurant jobs where I was getting off early enough to get a drink at someone else's bar but not late enough to have more than one. It was a way for me to have my two favorite things and call it a night. I think these two cocktails are up there at the top as the pinnacle of cocktails. Why mess with perfection? I even got a tattoo of a Sazerac in New Orleans almost a decade ago. I think about mortality increasingly. I think about legacy, not in the sense of making a name for myself but more in a sense of wanting to add goodness to the world. These were two of the first drinks I learned how to make, and there's an element of closing the circle by going back to where I started. Resetting to zero.

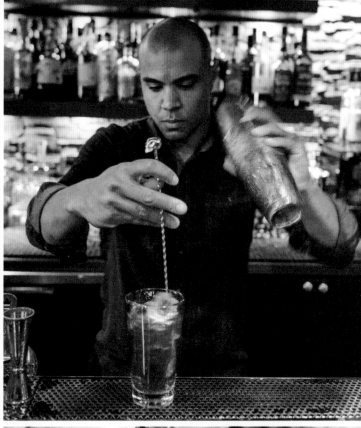

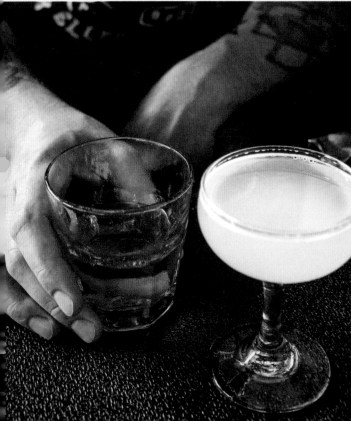

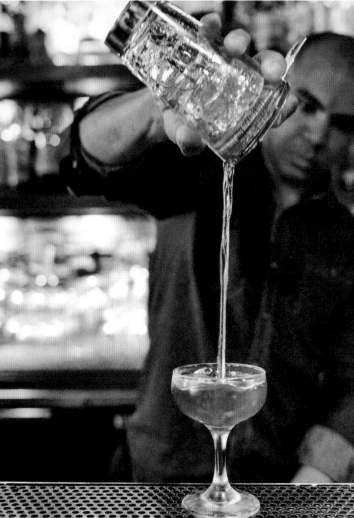

MARTINI (50/50 WITH ALL THE GARNISHES)

Makes 1 Drink (pictured at right)

1½ ounces gin (preferably London Dry or Plymouth)

1½ ounces dry vermouth (preferably Noilly Pratt for London Dry or Dolin for Plymouth)

Garnish: lemon twist, olive, cocktail onion

Combine the gin and vermouth in a mixing glass filled with ice. Stir until chilled and strain into a chilled coupe glass. Garnish with the lemon twist and a pick speared with the olive and onion.

SAZERAC *Makes 1 Drink*

Splash of absinthe (for rinsing)

2 ounces high-proof rye whiskey (preferably Wild Turkey 101)

1 barspoon rich simple syrup (2:1 sugar:water)

2 or 3 dashes Peychaud's Bitters

Garnish: lemon twist

Add the absinthe to a chilled old-fashioned glass. Roll the glass around to coat the interior of the glass and shake out any excess liquid. Combine the whiskey, simple syrup, and bitters in a mixing glass filled with ice. Stir until chilled and strain into the prepared glass. When it comes to the dilemma of express and discard or leave in the lemon peel, Elford is a "leave in" guy, so garnish with a neatly manicured lemon twist.

DAIQUIRI *Makes 1 Drink*

2 ounces white rum (preferably Banks 5 Island)

¾ fresh lime juice

½ ounce rich simple syrup (2:1 sugar:water)

Combine the rum, lime juice, and simple syrup in a shaker filled with ice. Per Elford, "shake the hell out of it" until chilled and strain into a chilled coupe glass.

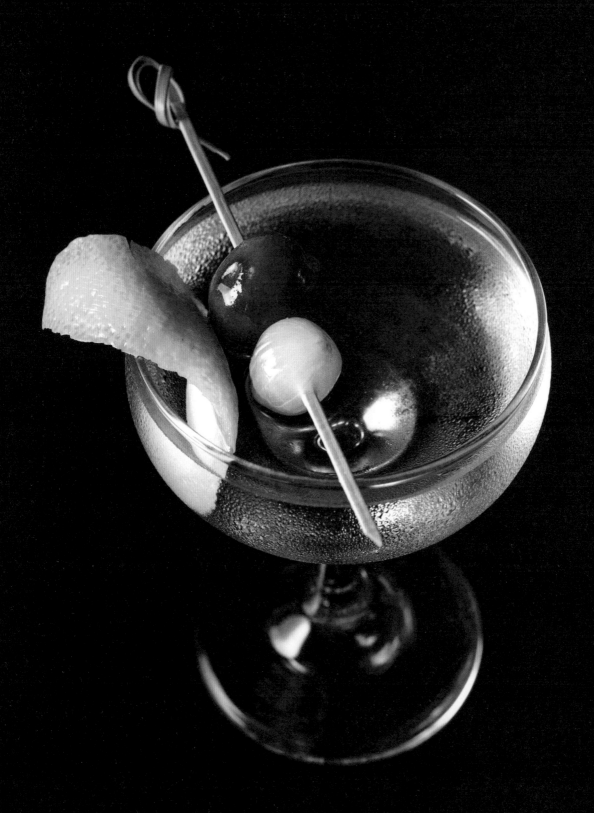

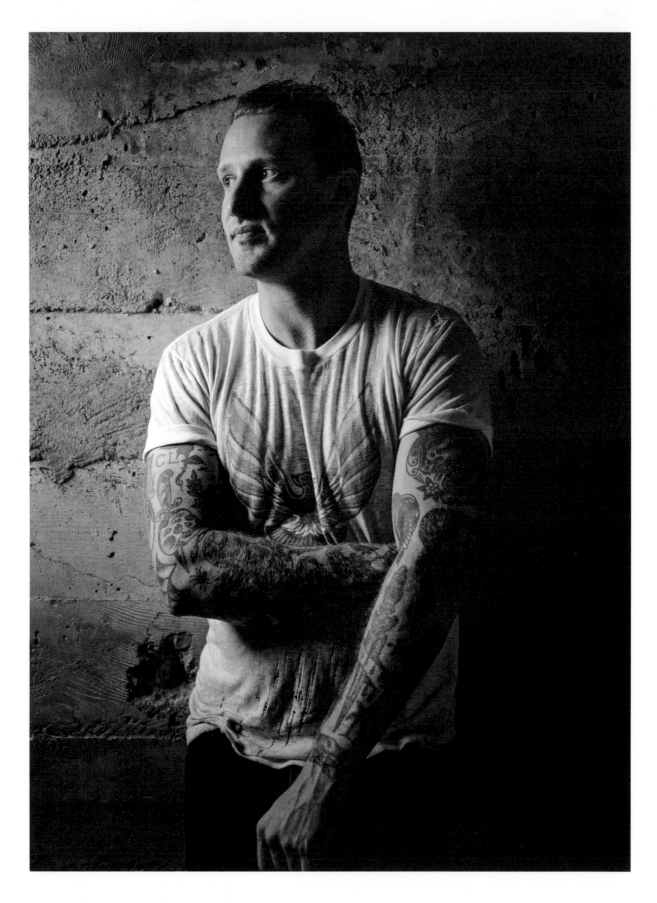

Josh Jancewicz

TRICK DOG

San Francisco, California | Josh Jancewicz

"Thrown like a star in my vast sleep
I opened my eyes to take a peek"
—Donovan, "Hurdy Gurdy Man"

After six years on the road touring America and Europe playing lead guitar and bass in a series of punk and rock bands, Josh Jancewicz knew that the best way to make money when he wasn't touring was to tend bar. After visiting a friend in San Francisco, he fell in love with the city, broke up with his girlfriend, sold everything he owned, and hopped on a plane to SFO.

He was introduced to Trick Dog co-owner Josh Harris while the bar, located in a converted warehouse, was still being built out, but that didn't stop Jancewicz from rolling up his sleeves and digging in, working construction every day for three months to help get the bar ready for launch. On their first day of business, the remaining construction equipment was thrown into the back of a truck fifteen minutes before they opened the doors. They were jamming their first night and have been packed every night ever since, instantly becoming one of the most popular bars in San Francisco. "This bar is intended to be a neighborhood bar," says Jancewicz, who worked his way up from barback to bartender to bar manager. "At one point in the day, every day, we always know one person in the bar who's here all the time. There's something special about that."

Along with great drinks and a lively late-night scene, Trick Dog is known for its eclectic themed menus, which are updated every six months. This isn't merely adapting to seasonal ingredients, but a complete overhaul that essentially reinvents the bar twice a year, with bartenders conceiving and learning to make and perfect more than a dozen original cocktails. The bar opened with a vibrant Pantone-themed menu, with drinks inspired by vibrant color swatches. Other menus have been modeled after a Chinese restaurant menu, a collection of 45 rpm vinyl records, a trifold tourist map of San Francisco, a children's book, a zodiac-themed horoscope, a vintage cookbook with drink recipes inspired by local chefs, and classic tattoos. To prevent guests with sticky fingers from walking out the door with these collectible menus, or to at least make them feel badly for doing so, the menus are now available for sale with a portion of the proceeds benefiting a local charity. Another Trick Dog tradition since Day One has been its last call song. No matter how many drinks you've had, once you hear Eddie Money's "Take Me Home Tonight," you know it's time to settle up and head out the door.

What do you love about being a bartender?

I don't know why everybody's not a bartender. I really don't. When you're working, it's the next closest thing to being a rock star. All these people and you're gauging the room and you're responsible for the overall vibe and feeling that you want. You put the music on that you think the room is going to react to and have fun. I can't believe that at some point everybody wouldn't want to do this. Having to deal with drunk people, really drunk people, can be a bit too much

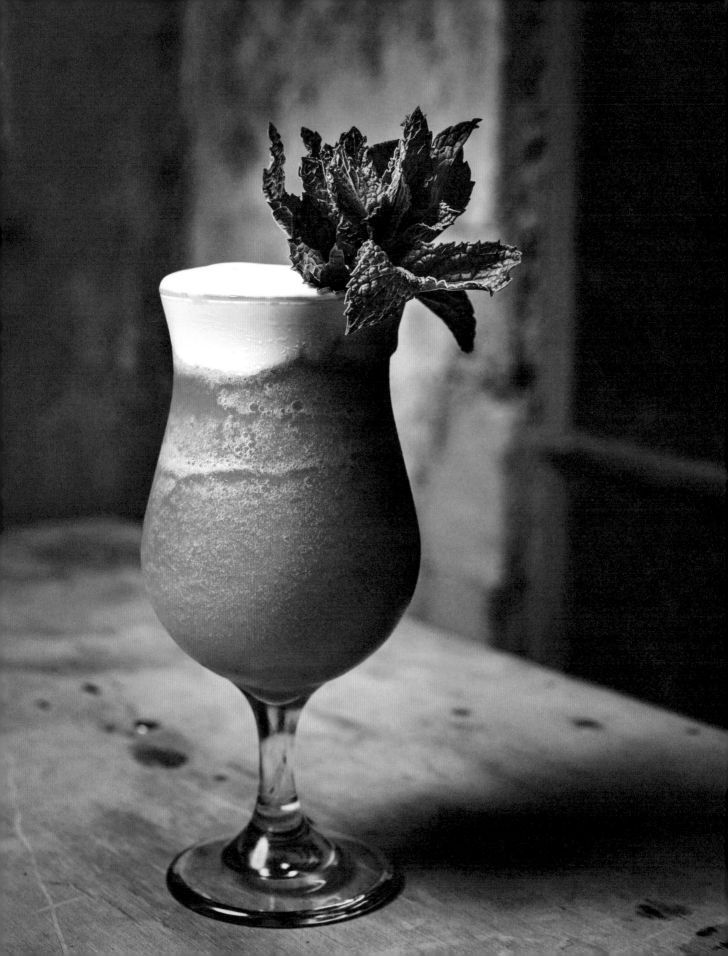

sometimes. If someone wanted to be a bartender, I would say just working at the right spot is more important than just getting in the industry. You don't want to learn bad habits early on. You want to work at a bar where you would want to hang out.

What's it like working in a fast-paced, high-volume bar?

I get asked what my favorite drink is on the menu four hundred times a day. For me, I think knowing the guests' expectations before they even know what they want is key. Not judging them, but just reading them. Do they want to talk to you about a drink? Do they want their drink as fast as possible? Sometimes I can tell if somebody's irritated from waiting to get in. Do you want a shot and a beer really quickly while you look over the menu? Ninety-nine percent of people order from the menu, so I'm kind of making these same twelve drinks over and over again. My favorite thing about bartending is I take pride in speed of service. When I see a regular walk in the door, I try to have their drink ready by the time they get up to the bar. They don't even have to say anything. When I go into a place, I wish somebody would do that for me. I drink tequila and beer. It's pretty easy. I wish it happened more often.

What is the last thing you'd want to drink before you die?

A frozen strawberry daiquiri. I'm from northeast Pennsylvania near Scranton—you've seen *The Office*, right?—and if you drank a pink drink like that, you would get picked on. But I don't care what people think of me. I don't think a drink reflects who you are as a person. Your actions do. I think that's coming from the punk rock side of the world where you don't care what people think of you. It wasn't intentional in this drink, but you drink a strawberry daiquiri when you're on vacation, you're on a beach, you're not where you normally would be. It's nice to go to somewhere where you normally go but feel like you're somewhere else. Something that reminds you of a better place. A better moment. Plus, I really like the sound of a blender.

STRAWBERRY DAIQUIRI *Makes 1 Drink*

2½ ounces white rum 1½ ounces strawberry puree 1 ounce rich simple syrup (2:1 sugar:water) 1 ounce fresh lime juice Garnish: 2 ounces heavy cream, 1 barspoon sugar, fresh mint sprig	To make whipped cream for the garnish, combine the cream and sugar in a cocktail shaker and dry shake for about 5 minutes, until whipped. Set aside. Combine the rum, strawberry puree, simple syrup, lime juice, 1 cup crushed ice, and 2 or 3 ice cubes in a blender and first pulse to break up the ice and then process until smooth. Pour into a chilled daiquiri glass and top with the whipped cream and the mint sprig.

THE LONG ISLAND BAR

Brooklyn, New York | Toby Cecchini

"I know when to go out
Know when to stay in"
—David Bowie, "Modern Love"

Toby Cecchini, a self-described "senior statesman" of the bar world, has been tending bar for thirty-one years. The Madison, Wisconsin, native was living in Paris but moved to New York to chase after a girlfriend. That didn't work out, but wandering the city streets ended up steering the direction of his career when he walked past the Odeon, the legendary Tribeca bistro whose neon sign illuminated the downtown scene in Lower Manhattan in the 1980s, drawing a cast of boldface regulars. "I had read *Bright Lights, Big City* when I was Paris," says Cecchini, of Jay McInerney's breakout 1984 debut novel that featured an illustration of the Odeon on the cover, "and was walking around New York kind of destitute when I looked up and there was the neon Odeon sign. I said to myself, Hey, that's the cover of that book. And I literally walked in and was greeted with, 'Yes, can I help you?' And I said, 'Yes, I would like a job I think.'"

Cecchini's legacy lives on at the Odeon due to creating a certain pink-hued cocktail that became a pop-culture phenomenon. He left to open the bar at Kin Khao, a hip Thai spot in Soho run by restaurateur Brad Kelley. He was bar manager there for eight years before leaving to open his own bar, Passerby, in the Meatpacking District (before it became Chelsea) in 1999, later chronicling those years in his book, *Cosmopolitan*. Passerby was open for nearly a decade but suddenly closed in 2008 when the landlord executed a demolition clause in the lease, sending Cecchini into a major funk. The team at Death & Co invited him to pick up some shifts to help inspire the young staff. "I thought, That's bullshit," says Cecchini. "I don't want to work at anyone else's bar. But if there was a bar I would want to step behind, it would be Death & Co. Working there got me out of my funk and made me aware that people are making cocktails and drinks in ways very different from me. I was very entrenched in my own thing. I thought I knew everything and that my way was the be all and end all. I started tending bar with kids much younger than I who were doing nutty cool stuff. You have to keep learning. You have to keep being curious. You can't just settle into your own hole. Working there snapped me out of the tailspin I was in."

Living in Brooklyn, Cecchini was one of the many people to walk past the long-shuttered Long Island Restaurant on the corner of Atlantic and Henry in Cobble Hill and shake his head in disbelief at the potential of the historic space and its art deco bar and glorious but long-dark neon sign. "I was one of those 13,685 people who would pass this place and think, I want to open this! This is so sad; it's going to be a bank or a nail salon or some horrible thing. The story went that three Spanish women owned it and they wouldn't talk to anybody. Every restaurateur in the city was trying to get in there. They'd been here for fifty-six years." After a chance encounter with David Alperin, the proprietor of the clothing store Goose Barnacle just up the street from Long Island Restaurant, Cecchini discovered that Alperin was the grandson of the bar's owner, Emma Sullivan, who had run the bar with her husband, Buddy, and her two

cousins, Pepita and Maruja. Alperin arranged a walk-through of the space with Cecchini. The bar seemed frozen in time, as if they had shut down and locked the doors after a long-ago last call. Sullivan lived nearby and after seeing activity at the bar from the window of her apartment, she came by to see what was going on. She sized up Cecchini and didn't believe he was a bartender—he was too professional-looking—until Cecchini showed her his calloused, banged-up hands, still rough from years behind the bar. Once he established his bona fides as a bartender, there was a spirited conversation and the impromptu interview turned into a handshake deal. Soon he and his business partner took over the lease and the neon sign was back on in 2013.

"My basic philosophy is that we have this amazing space," says Cecchini. "I want a really easygoing place where you walk in and think the food and drink are unnecessarily good. People are working super hard behind the scenes to make a very casual-looking place elevated." The neon sign that wraps around the outside of the corner building now casts its glow seven nights a week, serving as a beacon that draws a constant crowd of customers. Who knows, maybe it will land on the cover of a book some day and inspire a young bartender down on his luck to walk in and ask about a job.

What was it like tending bar at the Odeon?

The Odeon had been white-hot, but by the time I got there it had lost a lot of its shine. The owners were complaining about revenues being down even though everybody was there. I mean, Warhol and Basquiat were there nightly. I served Basquiat a steak the night he died, which he went into face-first and passed out. I read the next day that he was dead, and I was, like, yeah, not surprised actually. Madonna and Sandra Bernhard came in constantly. They were my lunch regulars. I was kind of terrified of them. They called me "boyfriend" and would snap their fingers at me. Madonna was kind of nice to me, but Sandra Bernhard was terrifying. Lou Reed was there. Sam Shepard was there all the time. De Niro and Harvey Keitel had a regular table. Letterman

was there. These were just regular regulars. And then you saw everybody else. That's just kind of where they went. It was a super scene. I waited on the Rolling Stones. It was, like, a $15,000 tab and Mick Jagger tipped me *$15*. I have loathed Mick Jagger ever since.

Can we talk about the cosmopolitan?

Yeah, it's all right. It is my albatross. But it is *my* albatross. I've had to make that clear.

I was working at the Odeon with a woman named Melissa Huffsmith who was in an all-girl punk band, and we worked Friday nights together. One night she said, "So I was out last night with these friends of mine from San Francisco who showed me this wild drink that I think is really cute. It's making the rounds in gay leather bars in San Francisco. It's called the cosmopolitan." So she showed me. Rail vodka with Rose's lime juice and Rose's grenadine. Up, in one of those V-shaped 1980s martini glasses that we had then. Shaken with a twist of lemon. I was, like, Huh, that's cute but absolutely disgusting. I liked the look of it, and so thought I'd set about to make it better.

At the time we were making house margaritas using fresh lime juice and Cointreau. There had been this brand-new, very exciting product from Absolut, Absolut Citron. It's such a laugh to think of it now, but back then we were like, "Dude, the flavor is *in* the vodka." We were so excited and buzzing around it, but nobody knew what to do with it. I was, like, I'll use that stuff, which makes no sense because you're putting lime juice in it anyway. I'll just do like we do with a margarita. Cointreau is very fancy. Fresh lime juice is cool. How do I make it red? We had that jug of cranberry sitting there to make Cape Codders. Ocean Spray Cranberry Juice Cocktail is very important. It changes it remarkably if it's not Absolut Citron, if it's not Cointreau, if it's not fresh lime juice, if it's not Ocean Spray Cranberry Juice Cocktail. As silly as it sounds, it tastes really different. That's the drink. I've tried to mess with it, and I can't honestly tell you I can make it better.

How did it become such an iconic cocktail?

What happened was I made this drink for the waitresses there, and in the ensuing weeks, it became our house drink. Then they started turning our regulars on to it. Which was weird when people such as artist Donald Sultan would be, like, "I'll have a cosmopolitan." I would be, like, "How do you know about this? That's *our* drink." Then it got really weird when people I didn't know started ordering it. Then it got crazy weird when I would be out and it had jumped to other bars near us downtown.

So then there was this diaspora. Within a few months, it was in other bars around town. Then after a year or a year and a half, it was all around New York. People were, like, "Dude, I heard you invented that fucking drink that's making everyone crazy." I just watched this happen and thought this is nuts. It was weird. New Yorkers just took it for granted. It was a New York drink then. It belonged to everyone. I didn't own a TV and people were, like, "Do you realize your drink is on this show all of a sudden that's blowing up?" I literally, to this day, have never seen an episode of *Sex and the City*. But it makes perfect sense. It had a character that had to be a very savvy, insider New Yorker, so what drink would she drink? I mean it's kind of a layup.

What's closing time like at Long Island Bar?

We go until midnight on weekdays and until two o'clock on the weekends. There's not much of a late night here. Last call is kind of funny because I maintain we don't have a last call. It's like the Hemingway short story "A Clean, Well-Lighted Place," where there are two waiters and the young one really wants to close things up so he can go and see his girl and and the old guy's, like, let people stay. And so the older guy lets the younger guy go. That's exactly me. There's no last call, man. If there are people here, just stay and let's hang. My bartenders are, like, "The hell with that. When you're not here we just call last call." We have a closing time, but if there are eight people across the bar, you just milk it until they kind of leave.

COSMOPOLITAN *Makes 1 Drink*

1½ ounces Absolut Citron vodka ¾ ounce Cointreau ¾ ounce fresh lime juice ¾ ounce Ocean Spray Cranberry Cocktail Garnish: lemon twist	Combine the vodka, Cointreau, lime juice, and cranberry cocktail in a cocktail shaker filled with ice. Shake until chilled and strain into a chilled coupe glass. Garnish with the lemon twist.

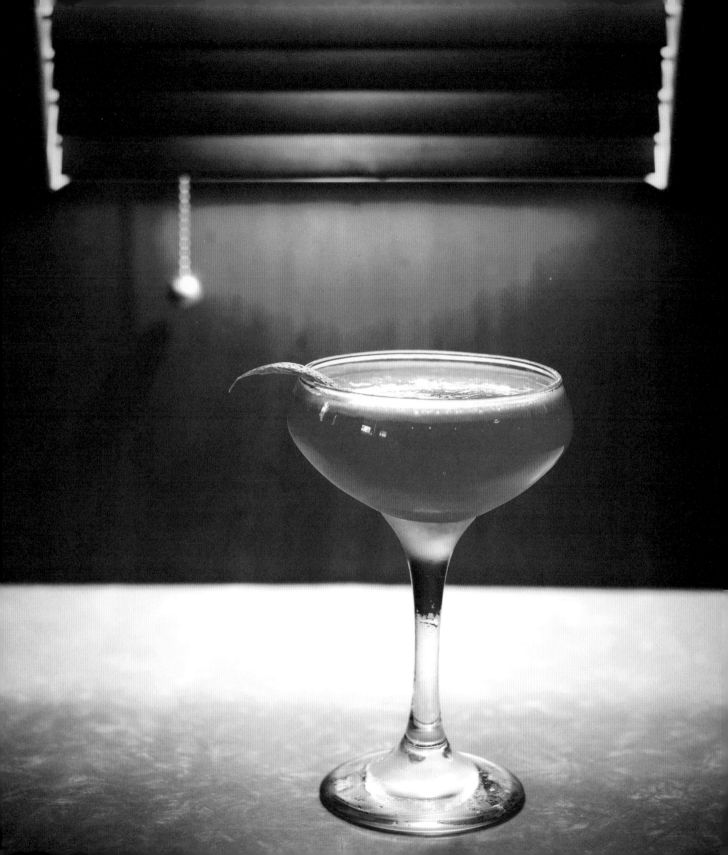

What is the last thing you'd want to drink before you die?

It's not the cosmopolitan. Once this woman came in and said, "I want something with whiskey and bitters." Oh, that's easy enough. "Not just bitters, but amaro. Do you know what amaro is?" Yes, I think I'm familiar with the concept, thank you. The particular thing I was messing around with at the time was the China-China from Bigallet, which I knew and loved. I had been playing with Suze on some things. Other than that, you've got sweet vermouth and whiskey, and that's a no-brainer. And then swapping in the China-China. That's just a take on the Manhattan. But put an equal part of Suze in there, and you've got something vinous. Something sweet. Something bitter. This woman loved it and said, "Oh my god, what do you call this?" I said, "Up to you." She said, "I call it The Erin." I thought, Oh no, don't tell me your name's Erin? That's the worst. I hate that. I'll come up with something else later. But of course I never did.

Look, if you're about to kick and you're looking back on your life, you want something to bring you back in—something that's going to take in all the facets. The Erin is a big drink that's just swirling with complexity, with all kinds of big flavors and aromatics. My father was a huge fan of brandy, and when he was on his deathbed, I brought him a 1951 Cognac from Delamain. The year he came to America from Italy was 1951. He was incredibly ill when we busted into it at his bedside with my sisters and my brothers gathered around, but he was so game about it. He took on this very strong spirit when he was so sick. I was very much brought back down to Earth by my father's death. It really brought it home. You know that people die, but when you see your father die in front of you, you understand that you're going to die. If I'm on my deathbed, I'm sure going to have something strong. You're looking back on your life, so I would want something strong, sweet, and bitter.

THE ERIN *Makes 1 Drink*

2 ounces New York Distilling Company Ragtime Rye ½ ounce Bigallet China-China Amer Liqueur ½ ounce Suze ½ ounce sweet vermouth (preferably equal parts Cinzano Rosso and Carpano Antica Formula) 5 dashes St. Elizabeth Allspice Dram Garnish: lemon twist and orange twist	Combine the rye, China-China, Suze, vermouth, and allspice dram in a mixing glass filled with ice. Stir until chilled and strain into a double old-fashioned glass over a large ice cube. Garnish with the lemon twist and orange twist.

Graham Miller

MUSSO & FRANK GRILL

Los Angles, California | Graham Miller

"He spent all night staring down at the lights on LA
Wondering if he could ever go home"
—Bob Seger, "Hollywood Nights"

"Right on time," says bartender Ken Donato, who's better known by his nickname, Sonny, as I made my way to a seat at the bar at the Musso & Frank Grill, the oldest restaurant in Hollywood. The woman next to me asked if it was my first time at Musso's, as it's known among regulars, and before I could reply, Sonny countered with, "Brad's been here before. He's a veteran degenerate." I've only been to the Musso & Frank Grill a handful of times, so I'm not going to kid myself and pretend I'm anything close to being a regular. Yet every time I step through the door of the Hollywood Boulevard restaurant and sit at the bar with a stiff gin martini served with its trademark sidecar on ice, I'm made to feel like Musso's is a second home.

Musso's first opened in 1919 and has been the hangout of actors, writers, and directors for generations, with such notable regulars as Frank Sinatra, Lauren Bacall, Orson Welles, Steve McQueen, William Faulkner, John Steinbeck, and Dashiell Hammett, to name just a handful. The dimly lit restaurant and bar are a step back in time, with lived-in red-leather booths and banquettes and a dark mahogany bar with a crystal cut-glass backbar. The waiters and bartenders wear iconic red-and-black bolero-cut jackets with crisp white shirts and black pants, with the bartenders sporting black neckties and the servers wearing black bow ties.

Although most people sneak a few candid snaps on their phone when they're at Musso's, the restaurant has a strict no-cameras policy to protect the privacy of its guests. "It's one of our very clear rules. And the rule is there to protect the discretion of our guests," says general manager Andrea Scuto. "We can talk about the past, but we'll never talk about current celebrities. This bar has seen every literary and movie star, and in part that's because when you come to the bar you don't feel like somebody is going to bother you." With that he points to specific seats down the bar, rattling off a library of literary all-stars ("That's Fitzgerald's seat. That's Bukowski's seat. That's Raymond Chandler's seat. Tennessee Williams sat here. Aldous Huxley over here.") who were a staple at Musso's. Whether you're on a barstool or settled into a booth, it's a thrill to watch the buzz of the room as the bartenders and waiters weave through the room and the front-of-house staff checks in on regular guests. "This bar has its own rhythm, and it seems like a rhythm that's been established for years and years," says Scuto. "The customer feels it. The bartender feels it. The waitstaff feels it. It's natural."

Graham Miller is thirty-seven years old, but at Musso's, that puts him among the youngest bartenders on the staff. "This place has career waiters and bartenders, and there are guys who've been here thirty to fifty years," says Miller, who started in the industry as a busboy at Chateau Marmont before talking the bar team there into giving him a shift. "I've been in this game fifteen years and am used to being one of the more seasoned guys in places I've worked. I come here and I'm one of the rookies, which is refreshing for me." Stepping into his role at such a historic setting

was thrilling for Miller, but he admits he was nervous. "There was a responsibility involved as a bartender and for the history and reputation of this restaurant," he says. "What puts this place on another level is when guests come here, they have an expectation in terms of service and the way they're treated, and the quality of the experience they're going to get. So you have to stay on your game."

Miller often works alongside head bartender Ron Sheriff and longtime bartender Sonny Donato, whom he describes as "masters at making the guests feel welcome." Sheriff tends to possess a more laconic and laid-back approach while Donato is a bit of a performer, busting out one-liners and working the row of customers at the bar like he's on the dais at a celebrity roast. "Every time someone comes in who I don't know, Sonny makes a concerted effort to introduce me: 'Hey, have you met Graham? He's the new guy.' Now I have my own set of regulars whom I know by their names and their drinks, which I have ready the minute they walk in. The regulars keep me on my toes."

I start with a gin martini, 50/50 with a lemon twist (Miller says 70 percent of the customers order a martini), and whenever Sonny wasn't taking care of other guests or telling a joke, I tried to get his attention to ask him what his last drink might be. He finally stood still and, as he twisted the cap back on a bottle of gin, I repeated my query. "Why would I want to have one last drink? It's always about what's the next drink going to be, right?" he says, stepping back into the stream of activity behind the bar. Miller gave my question a bit more consideration, and just as I was expecting him to say martini, he offered up a Manhattan. "I like drinks that are complex but also simple. I personally believe a really good cocktail can be done with three ingredients or fewer. You don't really need to go beyond that. The Manhattan is a very muscular, strong drink but with just enough sophistication to it."

I originally had dinner plans at another spot, but after my second martini at Musso's, the smell of chops and steaks coming off the one-hundred-year-old charcoal grill made me realize I didn't want a change of scenery. I ordered a wedge salad with blue cheese and bacon along with a bone-in rib-eye—charred, medium-rare—baked potato, and creamed spinach. There may have been another cocktail with dinner. As soon as the two seats next to me are vacated, Sonny swoops in and sets up a place setting and a small metal Reserved sign. "Wouldn't you like to know who's coming in next, Brad?" he says with a wink (and don't even think about asking me who it was; what happens at Musso's stays at Musso's). Later on, feeling a bit buzzed and very happy to be at Musso's, the bar was filling up to capacity, and it was my time to give up my prized seat and allow someone else the chance to soak up the spotlight at the bar. I hated to leave, but my night of time traveling through Tinseltown was up and the real world beckoned.

"Like Kerouac said, Brad, 'Everybody goes home in October,'" observed Sonny, shaking my hand good-bye. With no desire to call it a night just yet, I stepped outside among the garish gift shops and drink-special-touting bars lining Hollywood Boulevard and merged in with the steady flow of tourists shuffling along the sidewalk with their heads down, reading off the names on the stars on the Walk of Fame. The neon glow from the Musso & Frank Grill sign shined on my back, and would be there waiting for me the next time I was in town.

 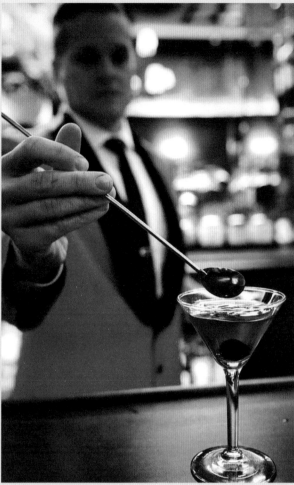

MANHATTAN *Makes 1 Drink (pictured on page 142)*

2 ounces rye whiskey
1 ounce sweet vermouth (preferably
 Carpano Antica Formula)
2 dashes Angostura bitters
Garnish: Luxardo cherry

Combine the whiskey, vermouth, and bitters in a mixing glass filled with ice. Stir until chilled and strain into a chilled cocktail glass. Garnish with the Luxardo cherry.

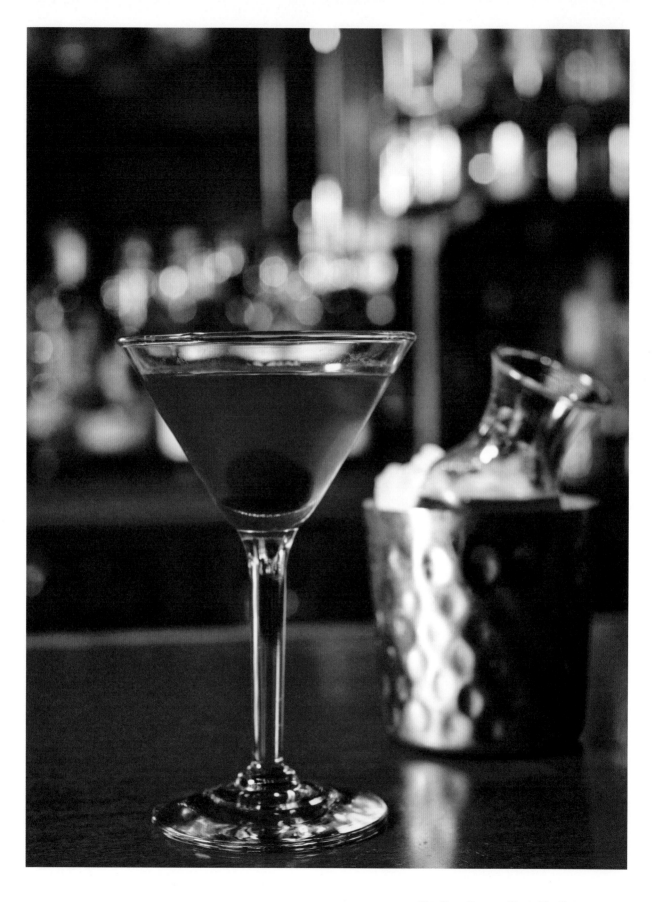

The Gray Canary. Memphis, Tennessee. »

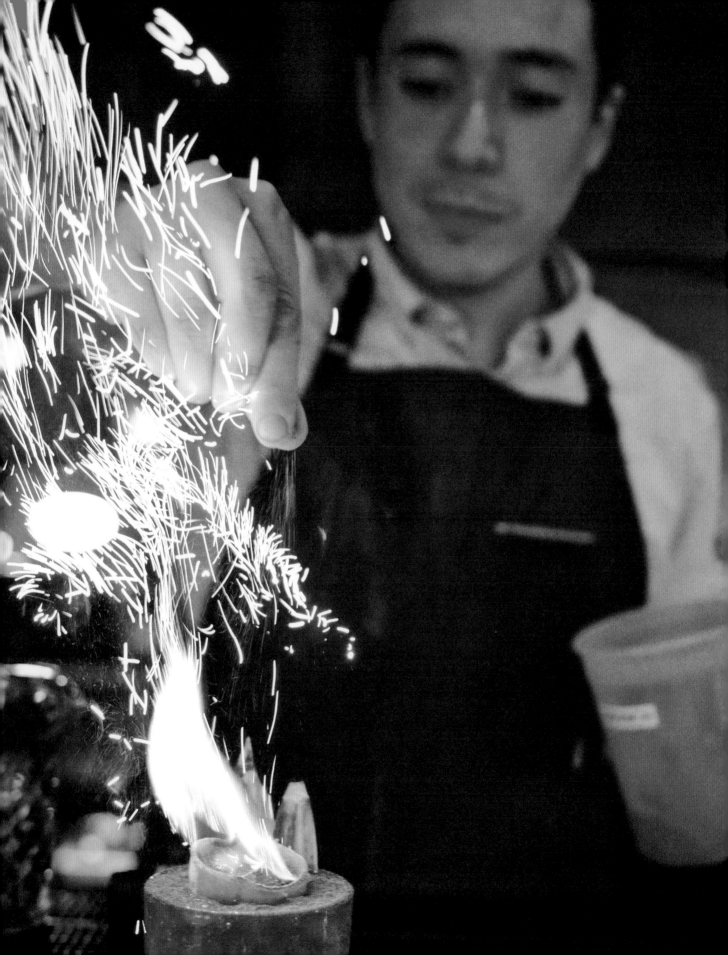

Brendan Finnerty

IDLE HOUR

Baltimore, Maryland | Brendan Finnerty

"Every day I bless the day that you got through to me
'Cause baby, I believe that you're a star"
—Hot Chocolate, "Every 1's a Winner"

The maroon-colored door of Idle Hour, a neighborhood corner bar in South Baltimore, is layered with a patina of dozens of stickers ("Patchouli Stinks," "Ithaca Is Gorges," "Choose Rockabilly," "Fuck 2016," "Do You Want New Wave or Do You Want the Truth?") slapped on by those who've come before me, and when I walk in, that awkward moment from the movies when the needle scratches across the record and silences everyone in the room seems to play out in real time. A cast of all-male regulars, whose median age is in the late fifties, look up in unison from their barstools to see who just walked into their bar. It seems fitting that I'm here on Open Vinyl Night, when anyone with a crate of records can take a spin at the turntables at the end of the bar for a brief set.

It's an intimate room, and I quickly spot at the bar Brendan Finnerty, who owns the place with his business partner, Randal Etheridge. My travels have taught me that neighborhood bars, especially those some might categorize on the dive spectrum, have their own unspoken codes of conduct, and after we shake hands but before we really get talking, Finnerty sizes me up. "How'd you hear about us?" he asks, less out of suspicion and more out of genuine curiosity. "There's not a lot written about us out there. Who hipped you to us?" He then motioned to the bartender, J.D., a glam rock–looking cat with a flip phone, who was wearing silver rings on each finger, a shirt unbuttoned to the middle of his chest, and a hint of black eyeliner. He came back with a bottle of green Chartreuse, the bar's spirit animal, and a round of shots was poured out. "Let's talk, but can we do a shot first?" When in Rome (or South Baltimore). . . . We raise our glasses as J.D. offers his standard house toast, words I'll hear repeated throughout the night with every shot poured: "Always merry and bright."

"I like to think Idle Hour is a very casual place," says Finnerty. "One of my favorite compliments we'll ever get is that people always feel comfortable here. If you come here, you can get your fancy mixology drinks to a degree. We have a drink list. We do barrel-aged stuff. We have a nice wine list. But we're best known for offering Chartreuse shots at a reasonable price. I just want people to come, feel comfortable, and hang out. These barstools are well worn." In 2014, Finnerty and Etheridge had to close the bar unexpectedly when a buckling wall behind the backbar presented major structural issues to the building. They assumed they'd have to close down for good, and the year and a half they were shut down only made the local community realize how much they missed their favorite neighborhood bar. Ultimately, supporters helped raise more than $50,000 to help with repairs and renovations, and the bar has been going strong ever since.

"This was a very working-class, blue-collar neighborhood," Finnerty says. "All the steel mills and docks were around here. It's changed dramatically from when we first started. You rarely saw kids walking up and down the street back then, and now at the end of the night when school is in session, there are about thirty thousand kids around here. It's changed, man."

Finnerty tells me that Idle Hour is the last stop of the night for many of their friends and regulars. "They rush here to get in before last call, which is 1:45 a.m., but sometimes we push it. It depends. If there's a ton of people in here on the weekend, we've got to get people out. But typically we have a hard stop at 2:00 a.m. Come on, you made me a promise, now it's time to go." The old-school regulars at the bar are often overcome with an influx of younger drinkers who flood the neighborhood, resulting in a distinctly different vibe on weekends compared to the more laid-back weeknights. "For the most part, I think this place self-regulates," says Finnerty. "We've been around for so long the reputation is out there. It's a great place not to get fucked up. It's one of those places, too, that if you do get fucked up, you might not know that everybody around here knows everybody. You might think you know somebody and it's all cool, but the rest of the bar will stand up and say, 'You've got to go.' It's a community."

A Baltimore dive bar seems like an unlikely spot to sell through cases of Chartreuse, the high-proof, aromatic liqueur made since 1737 by Carthusian monks in the French Alps from a proprietary recipe based on a sixteenth-century alchemist's formula for an herbal elixir. "At this point, we sell about a case a week. We go through more Chartreuse than we do vodka," says Finnerty. "People say, 'God, you look so young for forty-six.' It's because I'm pickled with Chartreuse. It's the Green, man." At one point, Idle Hour was the number-one account for Chartreuse sales in the entire United States, battling Boston and Chicago for the top spot. They're still one of the better sellers of the historic brand on the East Coast and sit comfortably in the top ten for national sales. One of the secrets for its Chartreuse success is that its customers typically knock it back as a shot, rather than in a cocktail or as a more discreet sipper. "I know,

we're terrible, we shoot it," says Finnerty, who does encourage first-timers to sip it neat on its own. The evidence of this devotion to Charteuse is the display of spent bottles atop the shelves of the bar, serving as markers of hazy memories of nights well spent. In recent years, many bartenders and sommeliers have become enamored of Chartreuse, running up the price tag of rare and vintage bottlings and geeking out over vertical flights through the decades of production. But while Idle Hour is fixated on the emerald-green elixir, all pretensions are left at the door. "We started out doing $3 shots of Chartreuse like a bunch of idiots. Had we been a little bit smarter about things, it would've been wise of us to pull a bottle or two over the years. It's one of these spirits where every batch is a little bit different."

Due to the inordinate amount of Chartreuse sold at Idle Hour, the bar popped up on the radar of Jean-Marc Roget, the president of Chartreuse, who informed the local distributor that he wanted to come and visit the bar. "I remember to this day we thought we were hot shit," says Finnerty. "He was in DC, and he came up here and the reps took him to all the fancy places. But he wanted to come to Idle Hour to see what was going on. He had his fancy dinner and came here later that night. He rolled in, impeccably dressed, and asked how this small bar in Baltimore was selling so much Chartreuse. Shots, we told him, pouring one out [they do a strong pour]. Knock it back." You would think the distinguished keeper of this centuries-old spirit would balk at the sight of his elegant herbal liqueur being tossed back with abandon, but he was won over by the South Baltimore charm on display at Idle Hour and ended up spending the rest of his evening at the bar. "He bought the whole bar drinks and promised he'd take us to France to show us the full operation. And on our ten-year anniversary, he took us to France for ten days."

It should come as no surprise then that a shot of green Chartreuse would be Finnerty's choice for his one final drink. He'd take it with a no-nonsense American beer, like Schaefer, as a nod the blue-collar history of the neighborhood. "My partner, Randal, was introduced to Chartreuse through his closest friend, Dave, who was a pilot in the Marines and became hooked on it. Sadly, not too many years later, Dave died in a training accident, and I know Randal thinks of him often when toasting with the Green. We never intended to make it the bar shot, but with only a handful of initial introductions, its popularity grew exponentially."

Drinking Chartreuse at Idle Hour is something the bar is known for and so deeply ingrained in tradition that when Finnerty and Etheridge go to other Baltimore bars, they are almost always immediately offered a shot of green Chartreuse. "I try not to think about my own mortality too much," says Finnerty. "I know that it could happen at any minute—we are in Baltimore after all. But I don't dwell on it. Chartreuse slows you down and warms and loosens you up. If you spend an entire evening sipping on the Green, you find yourself a little bit lighter and a little bit brighter. You tend to float. If I'm to enter the afterlife, what better way than that? I want to float right into that next chapter!" Finnerty contemplates the glass of Chartreuse in front of him and takes a sip of beer. "But if death is imminent, a shot of green Chartreuse backed by a cold can of Schaefer is the perfect companion. The Chartreuse relaxes your body, providing a serene physical state. Its complexity demands contemplation. Death may only come once, but you might as well be there to enjoy it."

DINO'S TOMATO PIE

Seattle, Washington | Jabriel Donohue

"Although we've come to the end of the road
Still I can't let go"
—Boyz II Men, "End of the Road"

The red neon sign in the front window of Dino's glows with Hot Pizza and Open Late, and what could be wrong with either of those promises? Dino's Tomato Pie was opened in 2016 in an old cash-checking business on the corner of Denny and Olive in Seattle's Capitol Hill neighborhood by *pizzaiolo* Brandon Pettit, who is also the owner of the Ballard pizzeria Delancey and its neighboring cocktail bar, Essex. But unlike the wood-fired pies and cozy setting of Delancey, Dino's, with its 1990s-inspired website, dark wood interior, and TVs hanging over the bar, is a decidedly East Coast–style pizzeria, heavily influenced by the pizza taverns of Pettit's time growing up in New Jersey.

"We're a pizza parlor," says Dino's bar manager Jabriel Donohue. "We're modeled on the kind of all-ages joint you might've gone to with your parents when you were a kid in the late 1980s or early 1990s where they'd have a beer. Not polished. Not perfect in any way, shape, or form. Just comfortable and accessible to everybody." At Dino's, the pizzas are available as whole pies or by the slice and come as a classic round or an addictively chewy, twice-baked Sicilian square, but the twenty-one-and-over Dino's is also a great place to grab a drink, whether it's a draft cocktail, a boozy slushy, or a beer and a shot. As with many bars, old-fashioneds and Negronis are among the most popular orders, but when I'm at Dino's, give me a Rainier, a Sicilian slice covered with crispy pepperoni cups, and a Mariners game on the overhead TV.

"As far back as can I remember, I always wanted to be a bartender," says Donohue, channeling the spirit of Ray Liotta's iconic line in *Goodfellas*. "I grew up in a medium-size college town, and bartenders were basically the coolest people around. I wanted to do that. I liked the controlled socialization of it. You always have the little distance between you, but you get to really interact and affect other people's days."

What do you love about being a bartender?

The thing I enjoy most is the ability to interact with your environment in a meaningful way every day. You can go to work and be having a terrible day, but if you go in and focus on doing a great job, you'll be rewarded for that. That immediate reinforcement of the idea that bringing positivity into the world will reflect positivity in the world. I love that.

What's the late-night vibe like at Dino's?

We have two waves. The first one is industry: people getting off their restaurant shifts who are done somewhere around midnight. They'll come through and have a slice and de-stress. Watch a little TV, bullshit a little bit, and have a couple of old-fashioneds or Negronis. The final push of

the night is everybody who's been out drinking elsewhere who maybe wants to get one last drink and a couple of slices in them. It's amusing. We could really easily be just a drunken mess of a place, but we police those who have been overserved elsewhere pretty heavily. We don't want to be that place. We don't mind that people are a little tipsy—that's the nature of being a bar. But when people get sloppy and argumentative, it's time to go.

Do you have any closing time rituals at Dino's?

When I'm behind the bar, I end with a four-song progression. The first song is Billy Joel's "Vienna." I think it perfectly encapsulates the sort of necessary optimism of being in a bar at last call. Second, it's almost impossible that whatever we were playing before is going to sound anything like "Vienna." It's going to be a bit jarring. The next one is "The Party's Over" by Willie Nelson. Then I yell out "last call!" and fire up "When Doves Cry" by Prince. And then it's "End of the Road" by Boyz II Men.

When everybody's out the door, my shift drink is usually a Rainier or a Miller High Life pony—something to wash the taste of the night away and to reset. I love being in the bar after everybody's left. There's something really wonderful about the transition. I'll usually sit there for a little while and just enjoy the space on its own. Let all the assholes or things that went wrong in the middle of the night wash away.

What is the last thing you'd want to drink before you die?

A perfectly made martini is a tunnel that you drive through to a new world of optimism and possibilities. A poorly made martini is a painting of a tunnel you drive at with enthusiasm.

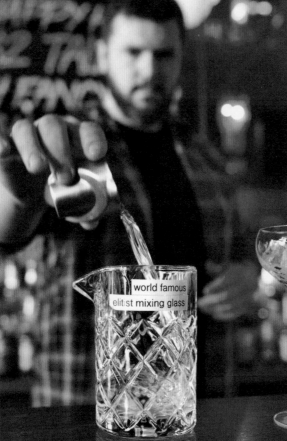
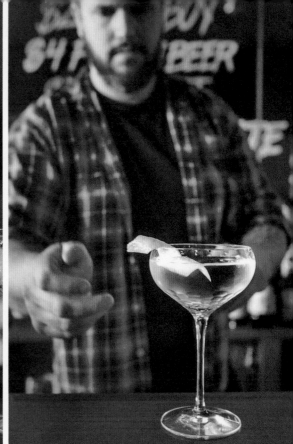

My grandfather's final drink before he died was a Gordon's martini on the rocks. He was pretty deep in dementia at that point, but it had always been his drink. And so the doctors allowed it, and we fixed one up for him just a couple of weeks before he passed. He definitely did his best to drink it. He got the martini and he lit right up. He definitely remembered what a martini was.

My final martini would be made with a London Dry–style gin with French dry vermouth and Regans' Orange Bitters, which is still, hands-down, the best orange bitters on the market. A martini is a drink of optimism and a little bit of excess. That's why I'm going for a four-ounce martini. It's crisp, it's refreshing, and it's that thing that sort of cleans you off and gets you ready to go wherever you're going next.

MARTINI (3:1) *Makes 1 Drink*

3 ounces Citadelle gin 1 ounce Dolin Dry Vermouth 2 dashes Regans' Orange Bitters No. 6 Garnish: lemon twist, 3 Castelvetrano olives	Combine the gin, vermouth, and bitters in a mixing glass filled with ice. Stir until chilled and strain into a chilled coupe glass. Garnish with the lemon twist and serve the olives on a plate on the side.

Mt. Royal Tavern. Baltimore, Maryland >>

SMUGGLER'S COVE

San Francisco, California | Martin Cate

"There's a port on a western bay
And it serves a hundred ships a day"
—Looking Glass, "Brandy (You're a Fine Girl)"

You can always transfer through SFO en route to a tropical island getaway, but a much easier, more direct route to escaping city life is available seven days a week at San Francisco's Smuggler's Cove. Opened in 2009 by Martin Cate and his wife, Rebecca, the goal of Smuggler's Cove, according to Cate, is "to give people that transformative escapist environment like a great tiki bar should—a journey that takes you out of San Francisco to somewhere else." In addition to serving both traditional and modern tiki-style cocktails, Cate and his team take the opportunity to tell a broader tale than just tiki at Smuggler's Cove, weaving in the three-hundred-year-old story of rum, including drinks inspired by colonial taverns and Royal Navy history, classic Prohibition-era Cuban drinks, and island-specific Caribbean specialties. "We put all of that together to create an immersive experience," says Cate. "Ideally, with each visit you can be surprised and delighted by something new."

The cozy clubhouse of the tiki bar takes up three floors, and the setting harkens to the maritime connection with rum (more than 750 rums are carried, including rare and vintage bottles), with a nod to San Francisco's history as a harbor town. A built-in waterfall runs along the wall, and the "motley junk-house collection of things," as Cate calls his design ethos, evokes the shiplap, barrels, cork floats, nets, and other materials salvaged from shipwrecks or bartered for over the years to decorate and reinforce the eponymous smugglers' hideout. "There's nothing fake in the bar," Cate says, adding, "well, okay, the anchor is fake. You can't put a two-thousand-pound anchor on a four-by-four and not expect it to fall to the ground." Cate built up the impressive collection found throughout the bar by trading with other tikiphiles and by tracking down and buying items from historic tiki bars. "All the artwork and carvings come from fallen tiki bars all over the world. Everything has a patina—the lamps, the World War I and World War II memorabilia, the puffer fish, the fishing gear—because it's old," says Cate. "This is actual historical art. Not a bunch of plastic junk from Party City."

Cate realizes that his bar may not be for everyone, especially when faced nightly with guests who are used to being able to order any drink of their liking no matter where they are. "There's a plate of standards that every bar should be able to do: but rum is why you're here, this is what makes this bar special and is why you selected it over any other. Just as you'd say to your friends, 'Let's go get Italian food,' tonight you said, 'Let's go drink Scorpion bowls and drink weird rums.'"

What does tiki mean to you?

I live and breathe tiki. I fell in love with tiki in 1994 at Trader Vic's in Washington, DC. I was blown away by the drinks, the food, the atmosphere, the music, everything.

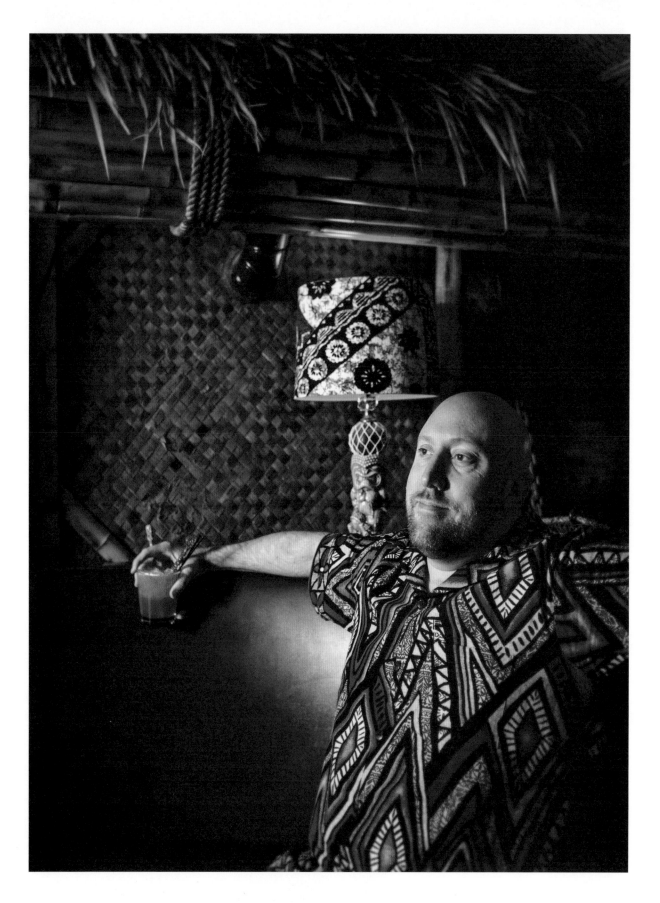

Martin Cate

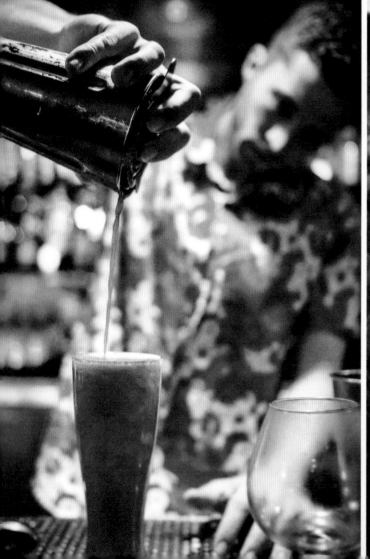

Tiki in and of itself incorporates arts, crafts, and design language that takes into account traditional Polynesian arts as well as crafts inspired by artists of Polynesia, and such things as nautical decor, maritime ephemera, and jungle plants and foliage. All these disparate elements come together to create this completely imagined and created world we call a tiki bar. The Smuggler's Cove vision is to be aesthetically a tiki bar, but also to tell a broader story. The tiki heyday represents just thirty years in the three-century history of rum. It's an important chapter in the story of rum, but it doesn't begin to scratch the surface of the spirit.

What do you love about rum?

Going into the incredibly complex and challenging history of rum takes you on this journey that I'm still constantly exploring. I've been to more than fifty distilleries in the Caribbean and I'm still learning. Rum comes from at least seventy countries; it's made on every continent except Antarctica. Exploring rum became a huge obsession for me and was the genesis of Smuggler's Cove. How can we do what we've been doing, putting the right rums and right mixes of rum in these cocktails, but also trying to get people excited about the spirit itself?

Do you have any last call rituals at Smuggler's Cove?

We close at 2:00 a.m., but last call is at 1:15 a.m., as some of the drinks are a bit more complicated. Both bartenders will bellow out "last call" really loudly and drawn out. Really lean back and let it out. In the upstairs bar, we have a big, brass ship's bell hanging way up in the rafters. We installed this semi-elaborate Swiss Family Robinson–style series of pulleys that goes across the ceiling and comes down and connects to the bar downstairs, so we can ring the bell from the main bar. If you really tug at it, you can hear it a block away. It's a serious bell. We do it gently so our neighbors don't freak out.

Usually people get kind of banged up by the drinks here. When 1:30 a.m. rolls around, people are sort of faded out, coming down a little bit. But they can be a bit loud, so our door staff spends a lot of time telling people to shush on their way out or while waiting for their Ubers.

What is the last thing you'd want to drink before you die?

It would probably be a Jet Pilot. It's this great drink that was served at Steve Crane's The Luau restaurant in Beverly Hills in the 1950s. It's basically a reproportioned and slightly tweaked Zombie. It has everything you want in an exotic cocktail. A blend of citrus. For the sweet, it's got a great mix of falernum and cinnamon syrup. For a bit of spice, it has Herbsaint and Angostura bitters. And then it's a blend of three rums. You can have a lot of fun and play with it when combining the rums. But what I fell in love with when I started mixing exotic cocktails is this journey you take inside your mouth. Here's a really interesting blend of fresh citrus. Here are all these great rums. Loud, pronounced, front and center—big, honest rums. And then in the background, here are these mysterious spices working their magic. These hints of clove and cinnamon add this layer, this little sense of mystery to the drink.

Back in the day, you were never told what was in the drink. All these drink names talked about adventure and danger and excitement. Shark's Tooth. Never Say Die. Missionary's Downfall. Jet Pilot. This was in the era of Yeager and the 1950s optimism that we could use technology to break down barriers. Jet pilots were heroes of the day. With classic exotic cocktails,

there's this perception that they were just a bunch of fruit juice to hide the booze and get you drunk. Or that they were syrupy sweet. But they're actually super intricate and super layered. And those drinks definitely did not hide the rum. They used well-made, characterful, heavy-bodied rums.

I think this final drink would be more celebratory for me in that it's a celebration of what I've had the good fortune of doing over the last quarter century, both my passion and my profession. I love what I do. The first time I had one of these drinks in 1994 kind of warped my worldview. It had this profound effect on me, with the drink being an agent of storytelling—a journey, a sense of adventure, a little exciting, a bit mysterious. These drinks beckon you in with a notion that you're about to go on an exciting trip somewhere. I guess you could even say that's it. If I'm breathing my last breath, I'd like to think I'm about to go on an exciting trip somewhere.

JET PILOT *Makes 1 Drink*

1 ounce black blended rum
 (preferably Coruba)
¾ ounce blended aged rum (preferably
 Appleton Estate Rare Blend 12-Year)
¾ ounce black blended overproof rum
 (preferably Hamilton 151 Demerara)
½ ounce fresh lime juice
½ ounce fresh grapefruit juice
½ ounce Cinnamon Syrup
 (recipe follows)
½ ounce John D. Taylor's
 Velvet falernum
1 dash Herbsaint
1 dash Angostura bitters

Combine all three rums, the lime juice, grapefruit juice, cinnamon syrup, falernum, Herbsaint, and bitters in a drink mixer tin. Add 1½ cups crushed ice and 4 to 6 small "agitator" cubes and flash blend. Pour into a chilled double old-fashioned glass.

CINNAMON SYRUP *Makes about 2 Cups*

1 cup water
2 (6-inch) cinnamon sticks, halved
2 cups sugar

Combine the water and cinnamon sticks in a saucepan over medium heat. At the first crack of a boil, add the sugar and rapidly stir with a whisk to dissolve (about 1 minute). Remove from the heat and let cool completely. Strain through a fine-mesh strainer into a jar and cap tightly. It will keep in the refrigerator for up to 1 month.

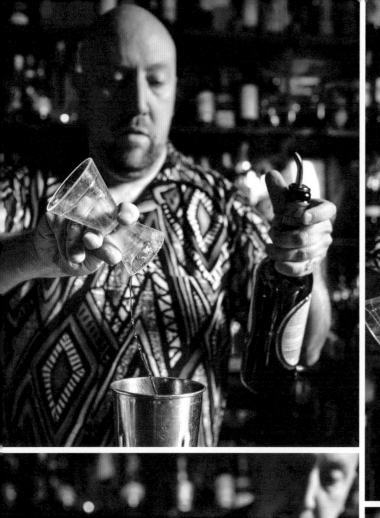

Matt Russell and Benjamin Hash

HORSE INN

Lancaster, Pennsylvania | Benjamin Hash, Matt Russell

"To the outside the dead leaves, they're on the lawn
Before they died, had trees to hang their hope"
—Band of Horses, "The Funeral"

"If you're going to keep coming through here, you might as well learn how to say it properly. It's *Lan-kiss-ter*, not *Lan-cast-er*." And with that friendly admonishment, Matt Russell handed me a cold can of Hamm's and welcomed me back to the Horse Inn, his historic south-central Pennsylvania tavern. Originally from Lancaster, Russell went to culinary school in Charleston, South Carolina, and worked as celebrated Southern chef Sean Brock's sous chef at McCrady's for five years. He fell in love with and married Starla Lane Russell and, following the birth of their son, moved back to Lancaster in 2013. "Charleston is one of those places where you can stay twenty-one for years. It was time to kind of grow up. I've always loved Lancaster," he says, displaying the Technicolor landscape of tattoos that cover both of his arms. Symbols of local Pennsylvania pride stand out as permanent tributes, including "Imported from Lancaster County" stamped over a tableau of Lancaster's historic Central Market, an Amish horse and buggy, a Philly cheesesteak with Cheez Whiz alongside a bag of Grandma Utz's potato chips, Philadelphia's city hall building, the Yuengling beer eagle, and road signs calling out the curiously named Lancaster County townships of Bird-in-Hand, Blue Ball, and Intercourse. "Lancaster is beautiful and I took it for granted, but becoming a chef made me realize the amazing things that are coming out of the ground here. It's a great place to grow up, and I thought it would be a great place for us to raise our son."

In January 2014, Russell and his wife became the fourth owners of the Horse Inn, which opened in 1920 but wasn't called by that name until 1935, making it the oldest continuously operating restaurant in Lancaster. The two-story building dates back to the early 1900s and was originally home to an excavating business owned by William Shaub. Shaub's horses and carriages were housed downstairs, while upstairs, where the current Horse Inn now stands, there was a hayloft that was converted to a speakeasy during Prohibition. The second floor eventually transformed to a legitimate restaurant and bar, with Shaub's wife Florence's tenderloin tips 'n toast becoming a popular dish that's still on the menu today.

Russell made some slight adjustments to the historic building with an eye to respecting its past, but many features, like the original 1800s wooden bar the Shaubs had purchased, remains. The original horse stalls were brought up from the stable downstairs and now serve as booths for diners, and the barstools are built from converted Conestoga wagon wheels. There's a jukebox, shuffleboard, and a foosball table, and the walls are adorned with dozens of vintage beer trays and neon and tin signs. Russell gave the old menu an overhaul, updating its classic tips 'n toast while adding new dishes, like Korean fried cauliflower and shrimp and grits, along with a killer house cheeseburger and spicy chicken wings. "I always loved Lancaster and the old corner bars and the history of the place. As soon as I looked at this place, I knew what it needed and a strong bar program would be key. People pay millions of dollars to have their place look like this."

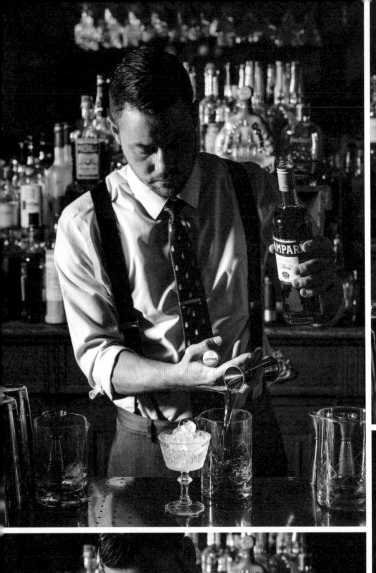
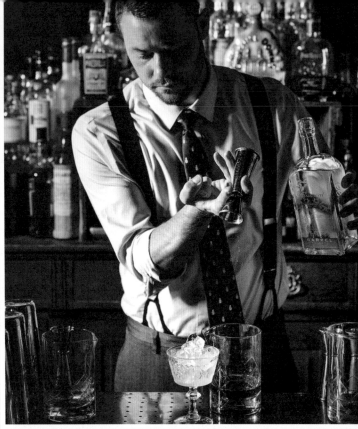
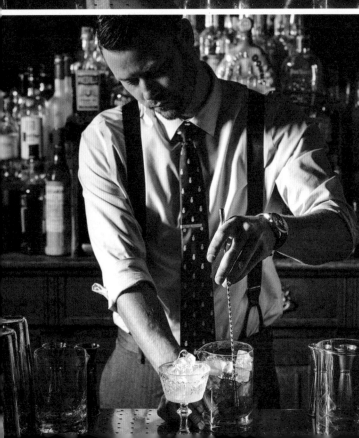
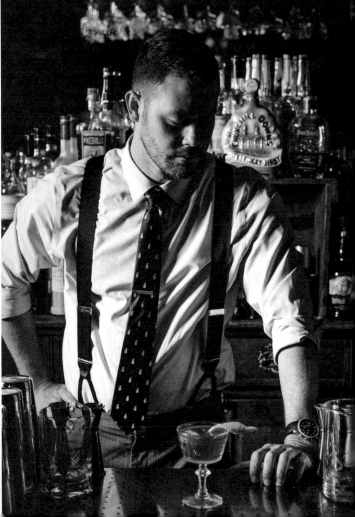

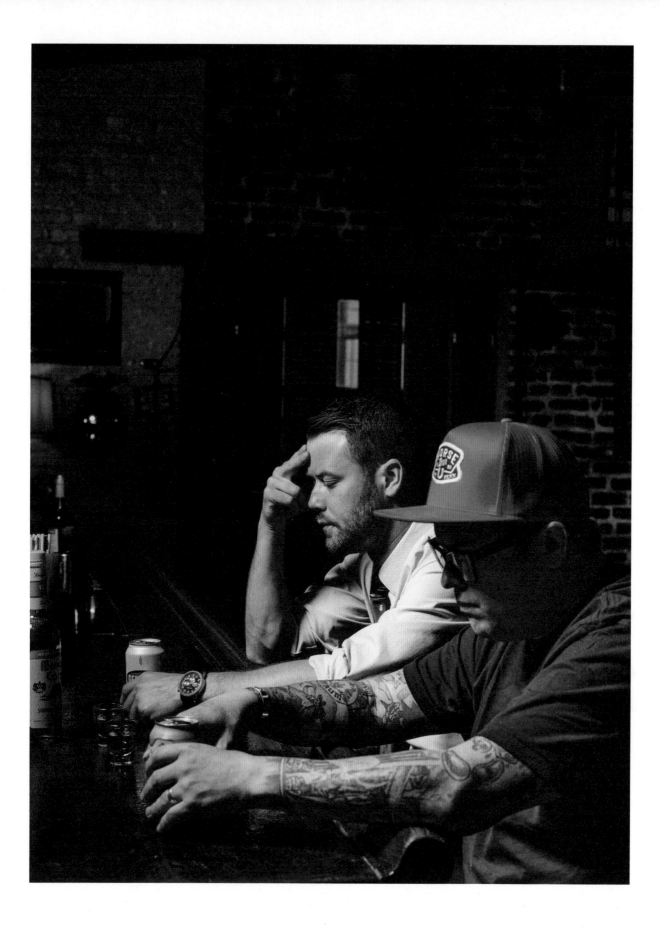

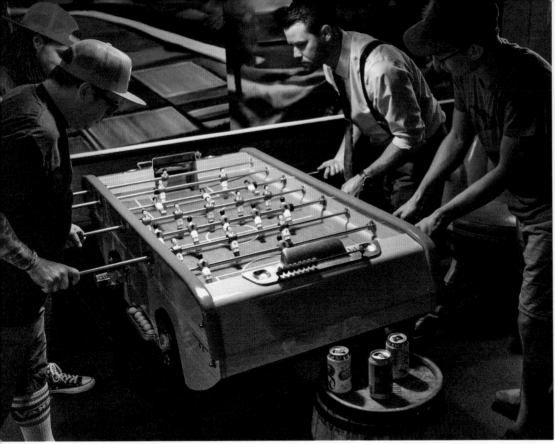

Enter Benjamin Hash, who as bar manager developed a cocktail menu that respected classics while leaving room for experimentation. And each night Hash steps behind the bar, he feels the ghosts of bartenders past working beside him. "My most favorite thing about this restaurant is the cigarette burns on the backbar," he says. "It shows you how many years of bartenders have stood back here. You see all these scars on the wood and think of the stories of all those old bartenders standing back there smoking."

Across from the foosball table (where the Horse Inn staff get into some pretty competitive matches after their shifts), near the smaller bar in the back and underneath a rare neon sign for Chesterfield Ale, sits an antique clawfoot tub filled with random cans of beer on ice. These "mystery beers" sell for $2 a can and are what the majority of people are drinking when they come in late at night. In a house signature style, after the cap is popped, each beer-can top gets an extra puncture with a church key to allow a smoother flow of beer. "People come in, they sit down, and they order their drinks and they talk. They socialize," says Hash.

When it's time to close up and Hash has let his postshift adrenaline run its course, he'll likely grab a drink at Valentino's, a nearby neighborhood bar that's been open for eighty-five years, to unwind before heading home. "I record all the Phillies games, then I can watch them at four in the morning at three times the speed," he says. "I've watched almost every Phillies game this year that way."

Hash is a thoughtful bartender who takes pride in his craft, and I when I ask him about his one final drink and what that might be, he looks off intensely and ponders the question, ultimately settling on his choice of a "burly badass" shift-shot-turned-cocktail he calls the Last

Man Standing. "It's clearly not for everybody," he says of the equal-parts drink made with gin, rye, Campari, and Fernet-Branca. "It is a simple cocktail, but it's strong and full of flavor and depth, really rich in character. It doesn't allow you to drink it without demanding your full attention. It forces contemplation, a moment of clarity. When I sit down at the end of the night, enjoying the company of others and preparing to head out the door together, we each have our own individual stories, and this moment seems like a parallel to the approach of our final rest. After each shift, somewhere a bartender doesn't make it home. As the bar closes down, somewhere a patron never makes it back to his bed. These are hard truths, and as we count down to our final shift, we must be grateful for our fortitude, yet careful and aware of our own fragility."

LAST MAN STANDING *Makes 1 Drink*

¾ ounce Campari
¾ ounce Fernet-Branca
¾ ounce gin (preferably Bluecoat Barrel Finished)
¾ ounce rye whiskey (preferably Rittenhouse)
2 orange twists
Garnish: orange twist

Combine the Campari, Fernet-Branca, gin, and whiskey in a mixing glass filled with ice. Express the orange twists over the mixing glass and discard. Stir until chilled and strain into a chilled coupe glass. Garnish with the orange twist.

John "Coonie" Spreafico

CITY GROCERY

Oxford, Mississippi | John "Coonie" Spreafico

"And where are you when the sun goes down
You're so far away from me"
—Dire Straits, "So Far Away"

I've had the good fortune of visiting Oxford many times over the past decade, and I can't recall a night on which I didn't wind up among friends at the upstairs bar at City Grocery. It has been a favorite watering hole in Oxford since first opening in 1992, and walking up the narrow staircase to the second-floor bar is both a familiar rite of passage and a sign that good times are ahead. When it's hopping, I'll grab whatever space I can find, even if that means leaning against the wall. But nothing beats sitting out on the balcony overlooking Oxford's central town square with a cold beer or old-fashioned in hand.

When I contacted chef John Currence, who owns City Grocery as well as local restaurants Big Bad Breakfast, Bouré, and Snackbar, he told me to check in with his bar manager, Coonie. "Just one name. Like Madonna or Cher." Coonie turned out to be John Spreafico, a charming host with a thick, dark beard whose distinctive south Louisiana drawl puts you immediately at ease. (His nickname, with which his friends branded him when he was younger, is a derivation of *coonass*, a common but admittedly controversial moniker often used to describe those from south Louisiana.) Coonie and his team move a lot of beer, but among cocktails, their house old-fashioned, free-poured to the rim of a rocks glass complete with muddled orange and cherry in the mix; Moscow Mule; and Hemingway Daiquiri are top sellers. During football season, most people are looking at a two-hour wait to get into a restaurant for dinner, but you can always grab a burger, muffuletta, pimento cheese and crackers, or shrimp and grits at the bar. "We get so busy during football games," says Coonie. "It's one in, one out, but once the crowd gets to a certain point, we cut the door off. You can make drinks only so fast. It's the only place in town where you can get in and people aren't elbowing you and you can still get a quick bite to eat."

Running along the bar are a series of small gold plaques in front of each barstool. On them are the names of longtime regulars and their preferred drink order, including John T. Edge (Bourbon), writer and director of the Southern Foodways Alliance; Jonny Miles (Budweiser), author and journalist; Jack Pendarvis (Old-Fashioned), author and Emmy Award–winning writer for *Adventure Time*; and Randy Yates (Whatever's Cold), owner of Oxford's Ajax Diner. The plaques in the middle row are tributes to patrons who've passed away, like local writer Larry Brown, whose inscription reads Best Friend City Grocery Ever Had / Git You Some Before You Die. "These are people who've come in for years," says Coonie. "We bestow it upon them. If you ask for one, you're never getting one. There's no price on it. It's just you being a friend of the bar and a friend of City Grocery."

Late night at City Grocery sees a wave of restaurant and service-industry regulars stopping in to have a drink at the end of their shifts. "It can get kind of loud and raucous, but we know most everybody, so it's easy to get it under control," Coonie says. "We've got people who know

how to act in a bar." The clientele at City Grocery are mostly professionals who live around town, including a mix of professors, doctors, and lawyers—a place where older people can come and get away from all the students. "We get a lot of grad students and law school students, but we're very strict on carding. If we catch a fake, we take it from you and you're not coming back," says Coonie. "Students are always looking for drink deals, and City Grocery is seen as a fancier bar in college students' eyes and one that's hard to get into." Coonie estimates 75 percent of the clientele at City Grocery are regular customers, people who come in three to four times a week or those who drive down from Memphis for the weekend during football season.

"Currence likes to say, We want to treat our locals like celebrities and treat celebrities like locals." While this is the sort of phrase you hear casually tossed around in the hospitality industry, I can attest that it's a genuine practice at City Grocery, which is one of the reasons it's often the first (and maybe last) stop for those visiting Oxford. "If we see one of our regulars coming up the stairs and they drink the same thing every time, we'll just go ahead and start making it and hand it to them when they sit down. That makes people feel special. That makes people feel important. That's what we try to do. Many regulars want to talk and engage, but some regulars come in and go outside and sit on the balcony and don't say much." Coonie looks out over the balcony, surveying the tail end of a passing summer thunderstorm. "Some people take years to get to know. Some people you know their life story the second time they're in here. It's the perk of the job for me. Knowing everybody and being able to make their experience enjoyable."

When Coonie considers his final drink on Earth, he turns to his go-to shift drink, a Budweiser and a shot of Jameson. "I've always drunk Budweiser and I love Jameson as well," he says. "I don't drink hard liquor very much, so it takes the edge off real quick. It's a sipper for me, but Jameson is kind of the universal shot for people around town in the service industry. It was Rumple Minze for a long time, but we all got a little bit older and wiser, I guess, after the wake of disaster that Rumple Minze left you with. People are creatures of habit, so I guess I'm no different. I'd like to think this would be celebratory. Most who know me know this is what I go to. When I'm on either side of the bar, I've noticed that consistency helps all involved. If eye contact can't be made, a simple nod lets the bartender or me know it's time for one more. That keeps you working ahead. And if you stay ahead, you'll never get behind."

FOX LIQUOR BAR

Raleigh, North Carolina | Travis Brown

"There ain't nobody here
Who can cause me pain or raise my fear 'cause I got only love to share"
—The Avett Brothers, "Ain't No Man"

If you're in Raleigh, North Carolina, it's a safe bet that you'll be dining at one or more of the restaurants owned by award-winning chef Ashley Christensen: Poole's Diner for elevated comfort food such as mac and cheese and tomato pie, Death & Taxes for a wood-fired hanger steak with a coal-roasted sweet potato, Chuck's for a double-decker burger with bourbon-Cheerwine BBQ sauce, or Beasley's Chicken + Honey for can't-miss fried chicken. Or you might be leaning more toward a cocktail, and if that's the case, there's Fox Liquor Bar, named in honor of Christensen's father's nickname and located on the basement level of the corner building that used to be a Piggly Wiggly.

"I had been traveling around the country quite a bit and I saw a lot of bars in many cities doing amazing drinks, but wrapping them in a package of exclusivity," says Christensen. "I wanted to open a bar that had incredible offerings, but in a place that felt much more welcoming and inclusive. Creating cocktails that are inventive and thoughtful and made with quality ingredients was the mission, and the cocktails would stand second only to hospitality."

Fox Liquor Bar was her first experience running a business whose focus wasn't her area of expertise as a chef, and while the bar was well received by the Raleigh community when it opened in 2011, over time she was disappointed in the direction the bar program was heading. "Like a lot of bars, I think we fell victim to being too serious," Christensen says. "I saw what was happening and it felt so foreign to me, so far away from why I named that place after my father. There came a point in time where it felt so off-mission for me that I had to ask myself, How do we fix this?" The couches that had previously been placed throughout the bar were removed in favor of booths and banquettes, which made the space comfortable for couples or large groups. The lighting was changed to be appropriately intimate but also to illuminate the energy of the bar. It was vital to Christensen that bar remained a welcoming space. "We just kind of reeled it back in and did a reset. We thought a bit more about how we really wanted to feel to the guest who comes in and enjoys the space. Now I'm so proud of the place. We've been really successful in turning it around."

Christensen brought in Travis Brown, an east–North Carolina native who moved back to his home state from New York, to take over running the bar program at Fox Liquor Bar. She requested he scrap the bar clean of any pretensions. "To me the smartest person in the room doesn't need anyone else to know it," says Christensen. Aside from a stint working the dish pit at a Buffalo Wild Wings, Brown has been a bartender for as long as he's been working and has never looked back.

"Fox is very much a bar," says Brown. "There are not a lot of bells and whistles. There are just two pictures on the wall. We're in a basement, so when you come down here, it's dark and it's a relaxed vibe. You can come and hang out and have an intimate conversation in the booths or hang out at the bar with the bartenders. Keeping true to building balanced cocktails that are

Travis Brown

based on the classics is important. That was a part of the original program and it's important to me to keep the soul of the original concept while lightening up the seriousness of it a little bit." As it's an Ashley Christensen bar, there's also going to be some killer snacks to nibble on when you're having your Coffee Vodka Soda on draft, including hot ham sliders on Hawaiian rolls with Swiss cheese, brown sugar, and mustard; taco-spiced pork rinds; her take on a NYC dirty-water dog spiked with kimchi relish and Kewpie mayo; and cheeseburger quesadillas.

"My favorite thing about being a bartender here is the flow of service," says Brown. "When things are going well, it's all about building those drinks, shaking them, getting them out perfect and on time. The interaction and the banter between guests and the back staff—it's the most satisfying thing." Near the end of the night, Brown looks forward to transitioning from the all-night push of "get me a drink, get me a drink" to the more relaxed atmosphere of the remaining guests, who tend to be an older, more responsible crowd. "I love taking time with the last guest at last call to have the kind of conversation that can only happen at that hour," says Brown. "There really is a magic hour that draws thoughtful conversation and the consideration of every moment of that shift. Once you've had your busy shift and you've locked the doors, the mood kind of changes and allows for your own introspection to spill out into conversation with others."

When it comes to Brown's last drink before he dies, he'd request a Kona Swizzle, a riff on a Queen's Park Swizzle, which is a refreshing Demerara rum–based, tiki-esque drink first served in the 1920s at the Queen's Park Hotel in Trinidad. "There are different interpretations of the drink's history, but the first one I had was at PKNY in New York, right before it closed down," he says, referencing the Lower East Side tiki bar that closed in July 2013. "We went into PKNY at about 3:00 a.m., and it was pretty empty. I didn't want to bother the bartender that late, but he was super gracious. I wanted something tiki and possibly with coffee and he made me that Kona Swizzle. He put love into it and it was fantastic, and he was so nice about serving us. I was really impressed. You don't get that a lot, especially when you have a crowd of drunk people rolling in five minutes to last call."

KONA SWIZZLE *Makes 1 Drink*

2 ounces rum (preferably an
 aged Martinique rhum
 agricole, like Clément)
1 ounce fresh lime juice
¾ ounce orgeat
8 to 10 fresh mint leaves
½ ounce coffee liqueur
 (preferably Caffé Lolita)
Garnish: fresh mint sprig

Combine the rum, lime juice, orgeat, and mint leaves in a cocktail shaker. Add about 5 pebbles of crushed ice and quickly whip shake until the ice has diluted to bring the temperature down without adding too much water. Pour the contents of the shaker into a chilled collins glass and fill the glass with crushed ice. Add more crushed ice just above the wash line of the glass to create a landing pad for the coffee liqueur. Gently top with a float of the coffee liqueur and garnish with the mint sprig.

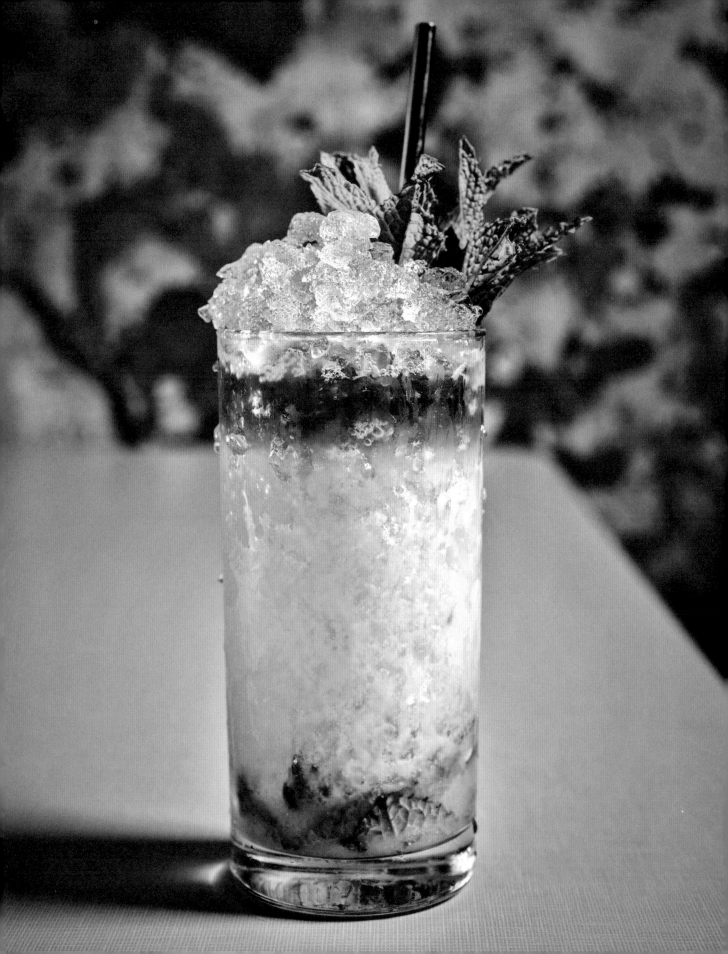

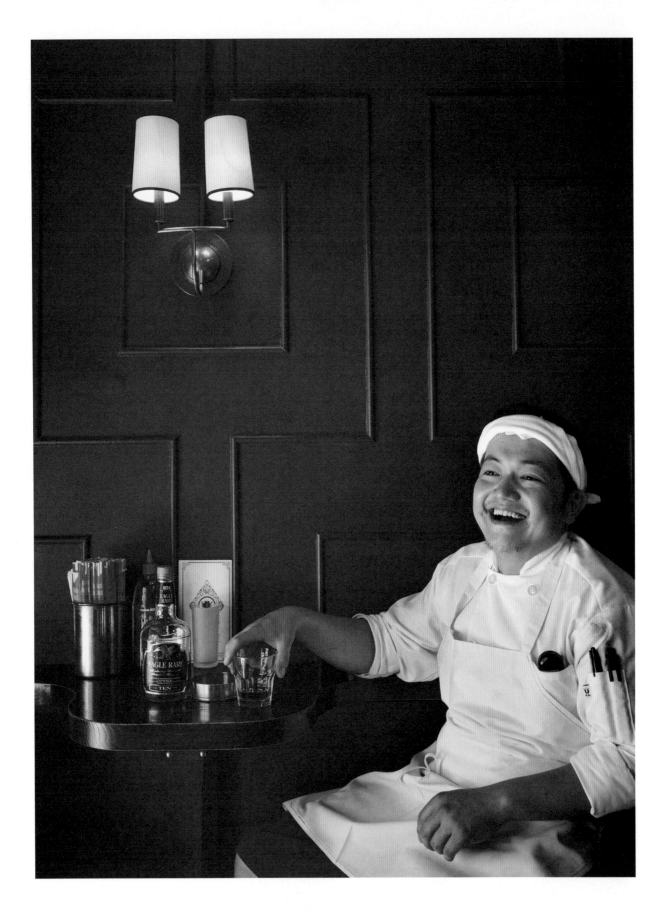

Devin Gong

COPYCAT CO.

Washington, DC | Devin Gong

"Some people like to go out dancing
And other people, (like us) they gotta work"
—The Velvet Underground, "Sweet Jane"

Devin Gong is a man of few words. When I ask the Swiss Army knife–like owner, bartender, and cook what his bar Copycat Co. is all about, he says with a laugh, "We're a bar that serves Chinese food and cocktails. I would say that sums it up." Noticing me soaking up the Chris Pyrate–commissioned first-floor mural featuring a colorful wreath of *maneki-neko* (Japanese "good luck" cats), he quickly adds, "And yes, I like cats." But the bar's name comes from a popular building on the Baltimore campus of the Maryland Institute College of Art where Gong and his fellow art students hung out.

Downstairs you can post up with a beer and grab a bite from the menu of pot stickers, steamed *bao*, and skewers of pork cheek, chicken, rib-eye, and lamb shoulder. Gong found it difficult to find a chef willing to cook straight through to 2:00 a.m., so he took matters into his own hands. "I decided to cook what I know. I come from the northeastern region of China. It's what I grew up eating, and that's all I really know how to make." Upstairs is a darker room with a bar devoted to cocktails. The extensive menu features a matrix of classic categories such as sours, fizzes, flips, rickeys, bucks, mules, and smashes. "We start with these categories, then break out from there. We also make a lot of tiki drinks, which is kind of the anticlassic, and original drinks based on the season. We switch it up every couple of months."

When it comes to regulars, Gong believes the key is fostering a relationship with those who come in and share the same amount of love for the bar that he does. "You can tell when someone walks in whether they're going to love or hate the bar." One guest who left an impression with Gong was cocktail legend Dale DeGroff, who popped in unannounced one night after bad weather delayed his trip back to New York. "So he stopped in and we made him a mai tai, which was was pretty cool," says Gong in his understated manner. "He loved it."

When I first met Gong that evening, he was filling in for a cook who was in the emergency room getting a cut stitched up, working behind the line prepping dough for the *bao* and in no mood to talk about hypothetical final drinks. He quickly directed me to the upstairs bar, then joined me a bit later, going behind the bar to bring out a bottle of Eagle Rare 101 bourbon, an expression that was discontinued in the early 1990s. He was able to track down a few bottles from Bill Thomas, proprietor of DC's foremost whiskey bar, Jack Rose. "When it first came out, it was trying to compete with Wild Turkey 101, but it really flopped and was discontinued," says Gong. "It's a special bourbon for me. It's a treat at the end of the night. I don't dip into it that often, but if I had a really good shift and I feel like celebrating, I'll pour some for myself and my staff." Gong thinks any good American should love bourbon and then admits that it's cheaper than scotch and the quickest way for him to get buzzed. But the fact that he can't get the Eagle Rare 101 anymore is a major part of its appeal.

When I ask him whether he thinks about his own mortality when it comes to last call, he laughs and says, "I don't know if I would go that far," before getting serious for a moment. "Last call, to me, has a sense of impermanence to it. The hours of 5:00 p.m. to 3:00 a.m. are reserved for the guest. And as soon as the last person leaves, it's our time to kind of clean up and talk about the day, have a drink, do what we need to do, and then go home. I love making people happy. To me the bar is about service, you know? At the end of the day, it's a place that's not your house, it's not a coffee shop, it's not the park. It's a place to go on dates, it's a place to hang out with friends, it's a place to have a good time. That's why I love the bar."

TOKYO RECORD BAR

New York, New York | Ariel Arce

"I am a D.J., I am what I play
I've got believers
Believing in me"
—David Bowie, "D.J."

"The only way you can really understand Tokyo Record Bar, and I hope this doesn't come off as pretentious, is to be in there," says owner Ariel Arce. "When you are in the room, it's not just the DJ who is setting the tone but also the bartender and the servers. Everybody is in it together, helping one another. And you feel that energy as a guest." Twice a night, the snug basement bar located beneath Air's Champagne Parlor on MacDougal Street in the heart of New York's Greenwich Village fills up with eighteen guests who are seated under a canopy of paper cherry blossoms for a two-hour, seven-course *izakaya*-inspired menu of small bites, washed down with sake, Japanese beer, and sake- and sochu-based cocktails.

As the first order of business, each guest flips through the Vinyl Jukebox menu and writes down his or her song selection on a slip of paper. Everyone gets one song, whether it's "Heart of Glass," "Dirty Work," "Can't You Hear Me Knocking," or "What a Fool Believes," and the DJ gets to work spinning a custom playlist for the evening. The music is loud, the servers are dancing with one another, and ordering another beer makes perfect sense as you grab a fistful of *togarashi* popcorn and wait for your song to drop. And as a cheeky middle finger to all those expensive, stuffy tasting menus that leave you hungry afterward, after the final course is cleared, chef Zach Fabian pulls two trays of Sicilian-style pizza out of the oven and everyone is served a hot square slice on a paper plate as "Born to Run" blasts over the speakers and the checks are dropped off at the tables.

What's the secret to the success of Tokyo Record Bar?

I never expected anyone to show up. I created it for my friends, and now my friends can't even get in anymore. It's turned into this kind of weird phenomenon. The reason this happened is that I truly believe people are kind of over traditional dining and traditional bar culture. They're looking for something experiential. They're looking for something that reminds them that they're in New York City and that they're doing something cool. And they get to have a memory that's not just about what dish they liked but also about an overall environment.

How do you curate your Vinyl Jukebox list?

It's set up like a wine list, and over time we've taken songs off or added songs. But our vinyl collection is growing all the time, and right now we have about 250 songs on the list organized by time period. The thing is there's a part of us that wants to be very petty and music focused. But there's another part of us that knows we're going to get four ladies in from Long Island celebrating four different things and someone is going to want to play Bruce Springsteen. And they're going to want to get up and dance and that's what makes us special. We don't take ourselves too seriously.

Ariel Arce

What's the most requested song from the Vinyl Jukebox menu?

I know what it is, but I don't answer that question because I vehemently believe that everybody needs to feel like their song is the most special song ever played. And when you start telling people that they're just like everybody else, it creates for a very strange dynamic. People care so much about selecting the music. When a song comes on, you know who picked it. You see them excited or moving around a little. Somebody's high-fiving their friend. They're dancing. Other people are quiet and more reserved. But I'll tell you, if you don't play someone's song, you're definitely going to hear about it.

Are there any songs on the Do Not Play list?

Some songs just don't work with our vibe. Take Meat Loaf. You won't hear "Paradise by the Dashboard Light" here. And no U2. I don't know why, really, but how many more times do we need to listen to "With or Without You" before we die?

Do you have any late-night, postwork rituals?

There's not really an end-of-night ritual, but there's generally a dance party. I'm not at a place anymore where I'm all amped up and have to go out and drink some more after work. I've got to get up and do it all over again tomorrow. I've got thirteen people I'm responsible for. So the adult answer is I have a slice of pizza. Anybody who knows me knows that there are a few things that I love, and two of those are Champagne and pizza. I always go to Ben's across the street.

What is the last thing you'd want to drink before you die?

I drank a tequila gimlet for the first time three years ago and I haven't looked back. I really used to like margaritas, but they could be too sweet, so I bumped out the triple sec and basically wound up with a gimlet. I'm late to embracing tequila. I didn't start drinking it until a few years ago, so it was a totally new adventure for me. My friend and I drank margaritas, and we rated them on a scale of one to ten. Basically, no margarita ever got above a five or six. Anytime I was with her, I would order one and it just never delivered. But once I graduated to the tequila gimlet, my orders were hitting more in the sevens and eights. I think the most consistent one I've tried is made at Fort Defiance in Red Hook, Brooklyn. It's just delicious. But if it's going to be my last one, it better be cold as hell and in a heavy rocks glass—like a beautifully cut Waterford crystal glass.

TEQUILA GIMLET *Makes 1 Drink (pictured on page 188)*

2 ounces blanco tequila 1 ounce fresh lime juice ¾ ounce simple syrup 　(1:1 sugar:water) Garnish: lime wheel	Combine the tequila, lime juice, and simple syrup in a cocktail shaker filled with ice. Shake until chilled and strain into a chilled old-fashioned glass filled with ice. Garnish with the lime wheel, or if you're Ariel, garnish with whatever citrus you have on hand.

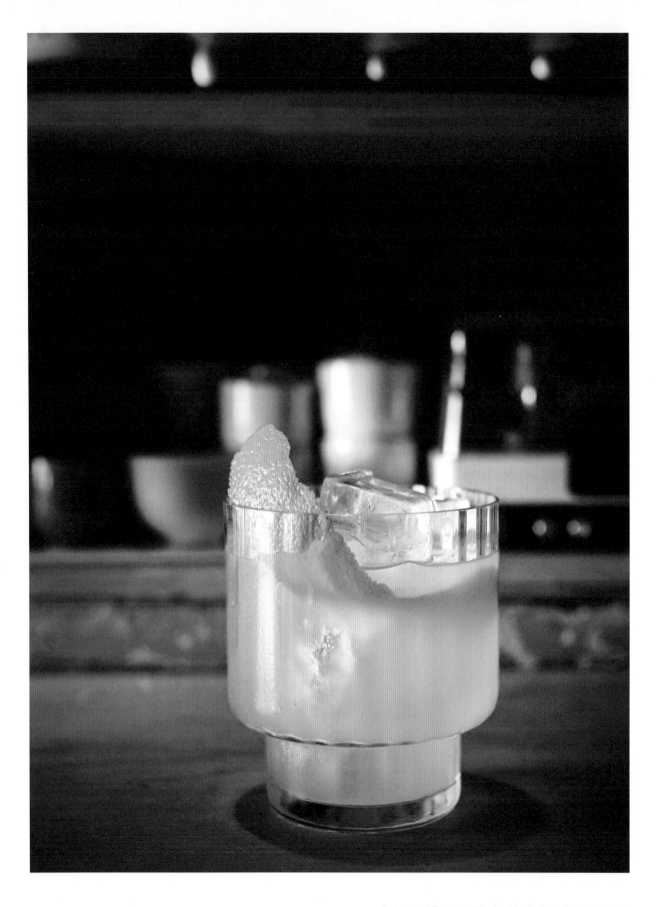

Robert's Western World. Nashville, Tennessee. »

EL PASO

STATE THEATRE
SPARTANBURG - S.C.
ON MARCH 8
OPRY

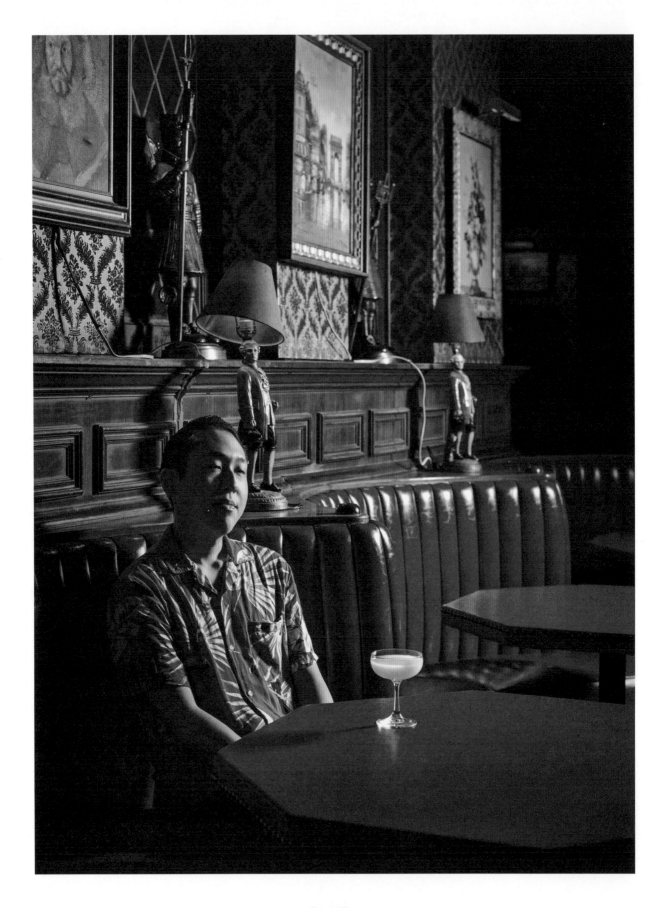

Ryan Kim

THE PRINCE

Los Angeles, California | Ryan Kim

"Yes I'd give my life
To lay my head tonight on a bed
Of California stars"
—Billy Bragg and Wilco, "California Stars"

Los Angeles is a city where many historic bars are still available to visit for a crisp martini, but you'll be hard-pressed to find one more cinematic than The Prince. When you walk down the stairs to the main bar, located on the ground level of a Tudor Revival–style apartment building in Koreatown, across the street from the site of the former Ambassador Hotel where Robert F. Kennedy was gunned down by an assassin in 1968, you instantly feel like you've walked onto a film set for a Rat Pack–era, midcentury steakhouse. The street-level windows are blocked out, and as your eyes adjust to the dark, you notice a red glow is cast over the room, amplified by the rich crimson booths, leather tables, and lush banquettes that snake along the walls, each appointed with a buzzer to alert your server when you're ready to order. Oil paintings of fruit bowls, pastoral landscapes, and dead presidents hang on the walls; miniature armored knights stand at attention throughout the restaurant; and pools of light spill out from a battalion of lamps cast in the likeness of American Revolution–era British officers in their signature red coats. A baby grand piano sits in one corner of the front room, and an elegant horseshoe bar with stained-glass panels running along the ceiling above anchors the space. If you poke around in the back on your way to the restroom, you'll uncover a spacious private dining room, which, for some reason, is adorned with Christmas decorations 365 days a year. The bank of TVs wrapped around the bar showing the Dodgers game is a modern concession, but it doesn't completely break the man-out-of-time illusion of the room.

The Prince first opened as the Windsor Inn in 1927, and benefited from its proximity to other famous Los Angeles haunts of Hollywood's elite, including the Ambassador Hotel's nightclub, the Cocoanut Grove, and the original Brown Derby restaurant, whose iconic building was designed to look like a giant version of its namesake chapeau. In 1949, California restaurateur Ben Dimsdale, who also ran the Secret Harbor, now home to the nautical-themed dive bar HMS Bounty up the block at the Gaylord, rebranded it as a steak house called The Windsor Restaurant. It changed ownership once again in 1991, with the decor remaining in the newly named The Prince, but the house specialty switching from porterhouse steaks to Korean fried chicken.

The Prince has long been a popular location for television and film shoots. It was featured in *Chinatown* (the curved, stand-alone booth where Jack Nicholson and Faye Dunaway filmed their scene is now known as "the *Chinatown* booth" and is one of the most requested tables in the house), stood in for a 1960s New York steakhouse in several episodes of *Mad Men*, and was the location for the neighborhood bar on *New Girl* (they filmed at the actual bar for the first season, but then built a reproduction of the bar in a studio for the rest of the show's run). Bar manager Ryan Kim was seated at the *Chinatown* booth on his first time at The Prince but didn't realize

its significance. "I always liked that booth. It is smack in the middle of the room," he says. "But I've never actually seen the movie. I was in a film noir class, and of the sixteen classes, the one I missed was when *Chinatown* was shown." Kim thinks location scouts are drawn to The Prince not only for its timelessness but also for the mix of aesthetics all in one place, from its slightly oddball decor to the Korean food to the menus of classic cocktails.

"Many of the classic LA bars didn't have a strong cocktail program because most people were having three-martini lunches," says Kim. "A lot of shaken, bone-dry gin martinis. That's what was expected. Each day I'm trying to figure out a way to go back a little into the past while keeping it somewhat modern as well." The Prince's cocktail menu serves as a tribute of sorts to the four eras of ownership of the restaurant, which happen to fall under four distinct periods of drinking culture, each with its own section: Windsor Inn (1927), Martinez, Sazerac; The Windsor Restaurant (1949), El Presidente, mai tai; The Prince (1991), Midori sour, cosmopolitan; The Prince (2017), Toronto, Jungle Bird. There are also classics in honor of two historic former neighbors, the Brown Derby and the Cocoanut Grove, and some concessions, like a margarita for twelve for $105.

"The crowd here is a little scattered for sure," says Kim. "We have the old Korean clientele who will always drink a pitcher of beer, some soju, and have some chicken, which is beautiful. We also have a lot of young film and art people from the neighborhood. And we have the tourist crowd who come in the hope of reliving whatever film was shot here they want to remember." In addition to skipping *Chinatown*, Kim says he's actually never watched any movie or TV show filmed at The Prince. It is not out of lack of interest; he just doesn't watch much television. You'll forgive him then when he tells you he once carded actor, writer, and musician Donald Glover. Kim was noticing that other restaurant guests kept approaching his booth to say hello and ask

for a selfie when one of his servers came up to him and said, "Dude, you just carded Childish Gambino." He explained to Kim that Glover was famous, like *really* famous, as in, one of the most talented people in Hollywood famous. "He was totally chill about it," says Kim. "I feel like a lot of LA celebrities would appreciate being carded if they're that big. They get to remember what it's like to be a regular human being." If Glover had hung out until last call, he might have caught Kim putting on the traditional closing time song, Queen's "Bohemian Rhapsody," and perhaps would have joined the crew for a round of mezcal shots.

Kim is in his early twenties and perhaps a bit too invincible to go all-in on the commitment to his one final drink, but he tells me if he had to choose, it would be the aptly named Death in the Afternoon. "I was thinking what spirit would make me happy if it was my last drink and that would have to be absinthe," he says. "Sometimes during a shift, I'll take a little sip and it just makes everything better." But further thoughts on mortality will have to wait because game four of the World Series is about to start, the Dodgers are playing the Red Sox, and Kim, after all, knows his priorities.

DEATH IN THE AFTERNOON *Makes 1 Drink*

1 ounce absinthe **Champagne or sparkling wine** **Garnish: lemon twist**	Pour the absinthe into a chilled coupe or flute glass. Slowly top with Champagne. Garnish with the lemon twist.

SERVICE BAR

Washington, DC | Chad Spangler

"Whatever gets you thru the night
It's all right, it's all right"
—John Lennon, "Whatever Gets You Thru the Night"

Service Bar is a fitting name for the kind of neighborhood hangout that, first and foremost, prioritizes the comfort of its guests. Whether that's through an affordable, easy-to-navigate menu that ranges from classic cocktails to a Pop & Pony—a seven-ounce Miller High Life partnered with a shot of Wild Turkey or Cynar—or hanging out with friends while taking down a basket of lemon-brined fried chicken with honey and hot sauce, the top priority at Service Bar is having a good time. The U Street neighborhood bar also features something you don't see in many bars, a tiny bar within the bar called the Snug Room. According to co-owner Chad Spangler, it is modeled after the tradition of screened-off rooms in Irish pubs where women, who historically weren't allowed in pubs, or "people who didn't want to be seen" could drink in privacy. The cozy, reservations-only bunker seats up to eight around a small table, with a dedicated bartender serving drinks through a small window.

Opened in 2016 by veteran bartenders Chad Spangler and Glendon Hartley, Service Bar is my favorite kind of bar: a high-low mix of serious cocktails with inventive takes on classics (and plenty of beer) from a strong bar team in a room where you're immediately put at ease. "It can get a little rowdy in here," says Spangler. "It's a lot of friends coming in from around the city who work in other restaurants and bars. We get a huge hit of that industry crowd almost every late night. It gets fun. People will be drinking beer and shooting back daiquiris. There will be singing. We'll do a round of shots with whoever is left here at the end of the night." The last time I was there, I crashed a raucous private party hosted by three best friends all named Alex. The "Alexes," as they were collectively known, made sure I had a drink in my hand along with a slice of birthday cake. It's the kind of place where you'll never be mistaken for a stranger.

Why did you decide to open Service Bar?

My partner, Glendon Hartley, and I always knew what we wanted to do, but the thesis and emphasis of what we wanted the bar to become was to open a place that we would both want to go and hang out. We had worked in the craft cocktail world and loved cocktails, but we really didn't love going out to cocktail bars. You would have to wait a long time for drinks; sometimes they'd be good and sometimes they wouldn't. You'd often get this nose-turned-up sort of attitude, and they were abhorrently expensive most of the time. And they were too quiet. Most of the bars doing craft cocktails at the time fit that mold one way or the other, and we weren't huge fans of that. Whenever we'd go hang out, we'd go to a dive bar and try to dissect the reasons why we like, for instance, an Irish pub. You can get whatever you want without an attitude. The drinks are reasonably priced. There are usually warm wood colors that make you feel welcome. Maybe it's a little bit kitschy. A dive bar also usually had fun music playing that wasn't jazz from the 1920s and it would be loud.

Chad Spangler

Our goal was to become a neighborhood bar that just happened to do great craft cocktails. That's just what we do. We're a neighborhood bar first. Service is always first. A key element of what we do is to make people feel welcome, to feel at home. And we offer things at a price point where you can come back five times a week and you're not breaking the bank.

What's the hardest part of being a bartender?

I just wish everyone understood in full before going into the industry what it actually means not to have a life outside of it. You don't get sick leave; you don't get paid vacations; if you get injured, you don't get injury time or health insurance; no benefits; no 401K. It's a fun life and awesome job security. You can move anywhere and always be employed and make great money. And it's an intrinsically rewarding job. You can grow yourself and your talent and talk to people all the time. But it's difficult to live a normal life and have friends outside of the restaurant industry. I think that's why it's such a close-knit life. The community that develops among bartenders and restaurant workers is really special and something that can never be discounted. And it's a double-edged sword to be around alcohol all the time. You have to have a pretty strong mind-set, and it's easy for people to take on a lifestyle that's not necessarily sustainable. I know plenty of people I've worked alongside or know through the industry who've had a hard time staying sober. You have a few drinks and they lead to a few more. When you work five nights in a row week after week, that can easily slip into an unhealthy lifestyle.

What is the last thing you'd want to drink before you die?

I wouldn't necessarily have this at the end of my shift because at the end of the day you're done and you can really only pop open a beer. But our Grilled Apricot Iced Tea would be my deathbed cocktail, if you will. It's not that intricate or mind-blowing. It's just something I found that I drink most often here, and I'm excited whenever it comes back on the menu. It speaks to a lot of different things I really like put into one drink. We incorporate the apricots two different ways: First we'll grill them over charcoal and wood and then smoke and cook them for a little while, flip them over, and cook them a little more. We then use some of the grilled apricots to make a syrup and infuse the rest in Teeling small-batch Irish whiskey.

It's not the most popular drink on our menu, but it's my favorite. It's a strong drink but doesn't taste like one at all, which I suppose no well-made cocktail really does. This one in particular drinks like a refreshing glass of iced tea with a really nice smoky, charred flavor that has a cool backbone of fruit. It's not sweet, but it packs a really awesome stone-fruit flavor that pairs really well with everything else that's in it.

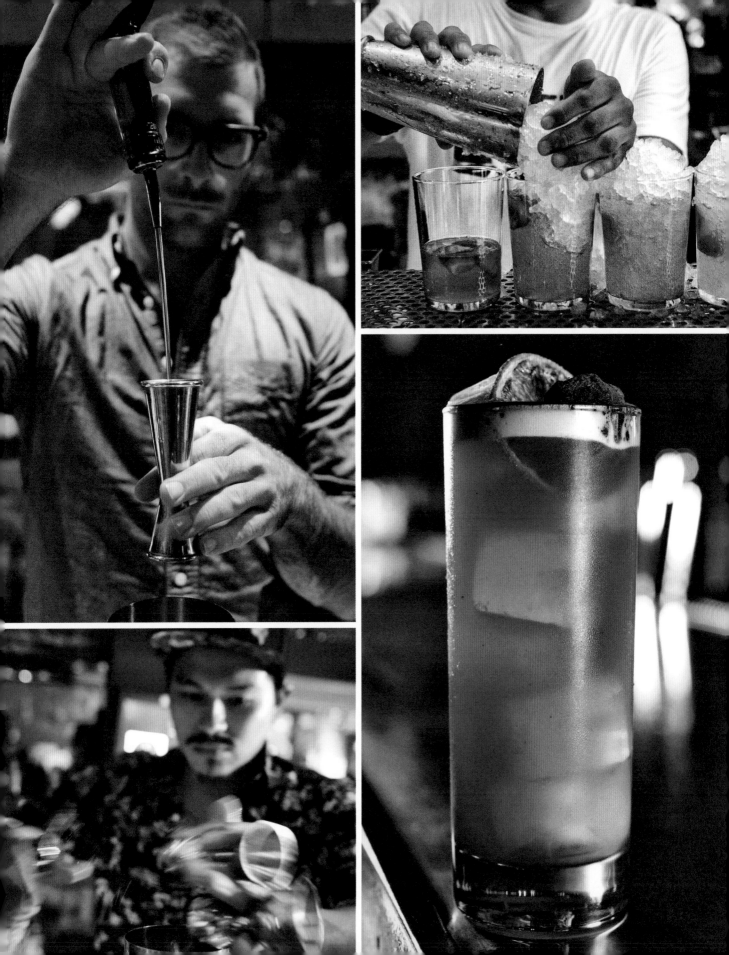

GRILLED APRICOT ICED TEA *Makes 1 Drink*

2 ounces Grilled Apricot–Infused
Irish Whiskey (recipe follows)
2 ounces Cold-Steeped Black Tea
(facing page)
¾ ounce Grilled Apricot Syrup
(facing page)
¾ ounce fresh lemon juice
Garnish: Dehydrated Lemon Slices
(facing page) or fresh lemon twist

Combine the whiskey, tea, apricot syrup,
and lemon juice in a cocktail shaker filled
with ice. Shake until chilled and strain
into a collins glass filled with ice. Garnish
with the dehydrated lemon slice or fresh
lemon twist.

GRILLED APRICOT–INFUSED IRISH WHISKEY *Makes about 3 Cups*

4 to 6 Grilled Apricot Halves
(facing page)
1 (750-milliliter) bottle Irish
whiskey (preferably Teeling
small batch)

Put the apricots into a container with a sealable
lid. Pour in the whiskey and cap tightly. Allow to
infuse at room temperature for 72 hours. Strain
through a fine-mesh strainer into the empty
whiskey bottle and cap tightly. It will keep in the
refrigerator for up to 3 months.

COLD-STEEPED BLACK TEA *Makes 4 Cups*

3 tablespoons second flush Darjeeling loose leaf black tea 4 cups water	Put the tea and water in a glass container and let steep for 24 hours. Strain through a fine-mesh strainer into a clean container with a sealable lid. It will keep in the refrigerator for up to 1 week. You can use the spent tea leaves again to make hot tea.

GRILLED APRICOT SYRUP *Makes 4 Cups*

4 to 6 Grilled Apricot Halves (recipe follows) 4 cups sugar 4 cups filtered water	Put the apricots into a container with a sealable lid. Cover the apricots with the sugar and cap tightly. Allow to infuse at room temperature for 24 hours. Add the water and stir until the sugar dissolves. Strain the syrup though a fine-mesh strainer into a clean container with a sealable lid. It will keep in the refrigerator for up to 1 month.

DEHYDRATED LEMON SLICES

5 to 6 lemons, thinly sliced	Arrange the lemons in a single layer on a dehydrator tray. Dehydrate on medium-low for 36 to 48 hours, until the sugars have caramelized and the flesh has darkened but the skin remains yellow. Store in an airtight container at room temperature for up to 1 month.

GRILLED APRICOT HALVES

Prepare a low-heat fire with both wood and charcoal. Place 8 to 12 apricots, unpeeled, halved and pitted (or substitute another in-season stone fruit or figs), flesh-side down, on the grill grate and grill for 15 to 20 minutes, then flip the halves and grill until the fruit is nicely charred on both sides but has not dried out.

Separate the apricot halves into two equal portions to use for infusing the whiskey and making the syrup.

SPORTSMAN'S CLUB

Chicago, Illinois | Laura Kelton

"These days I seem to think about
How all the changes came about my ways"
—Nico, "These Days"

Sportsman's Club, a cash-only tavern in the Ukrainian Village neighborhood of Chicago, takes its name from an earlier bar that served as a watering hole for local Polish immigrants. Many of the original fixtures are still in place, such as the oak bar and the barstools. But among the renovations and updates that arrived with the new owners in 2013 are deep wooden booths with tweed padding; a custom house blend of amaro, sherry, and fortified wine; and a forest of taxidermied woodland creatures placed throughout the space that create a clubby vibe modeled after the Musée de la Chasse et de la Nature in Paris (if you're looking for the ATM, it's in the back with a wild boar perched on top). Old-time regulars from the more divey iterations of the bar, including the grandson of the previous owner, still stop in and offer their nod of approval for keeping the spirit of the seventy-year-old bar alive and well.

While you can always count on being served a well-made classic cocktail at Sportsman's Club, what you won't find is a fixed menu. Each night the opening bartender determines the four daily specials—typically a long drink, a shaken drink, a stirred drink, and something seasonal, like a hot toddy in winter—spelling them out in block letters on the black letter board hanging above the reel-to-reel machine that's bordered by a tableau of stuffed fowl. That reel-to-reel machine works like a charm and is usually the source of the soundtrack of the night, ranging from high-energy hip-hop to funk to country to punk rock. The bar hosts regular Reel to Reel Sessions, where they record a set from one of their vinyl DJs, archiving the night's playlist on the back of the tape can. Sportsman's Club is also one of a handful of Chicago bars that still operates with a package license, allowing it to sell retail goods to guests who might want to grab a six-pack of Miller High Life, Hamm's, or Pabst Blue Ribbon, or maybe a 200-milliliter flask of Wild Turkey 101 or a bottle of wine to take home.

"Regulars keep the lights on here," says general manager Laura Kelton, "especially in the winter months. They bring a sense of consistency you don't often find in a business that's built around the great unknown. You have no idea what's going to happen at the start of each shift."

What's it like to work at Sportsman's Club?

This bar is very indicative of my cocktail-making style. We change it up a lot and we can do some weird stuff, but at the end of the day, we're making really simple drinks that make people happy. What I love in particular about running this bar is that it's not really a cocktail bar. We're staffed with a lot of great veteran bartenders, and you can get a great drink here, but it's really a beer-and-shot bar. We are the number-one Miller High Life account in the city of Chicago. High Life and a shot of whiskey are what you are going to see being sold here the most. You really get to be just a bartender and get to know the people who sit across from you on a very regular basis. We're very

Laura Kelton

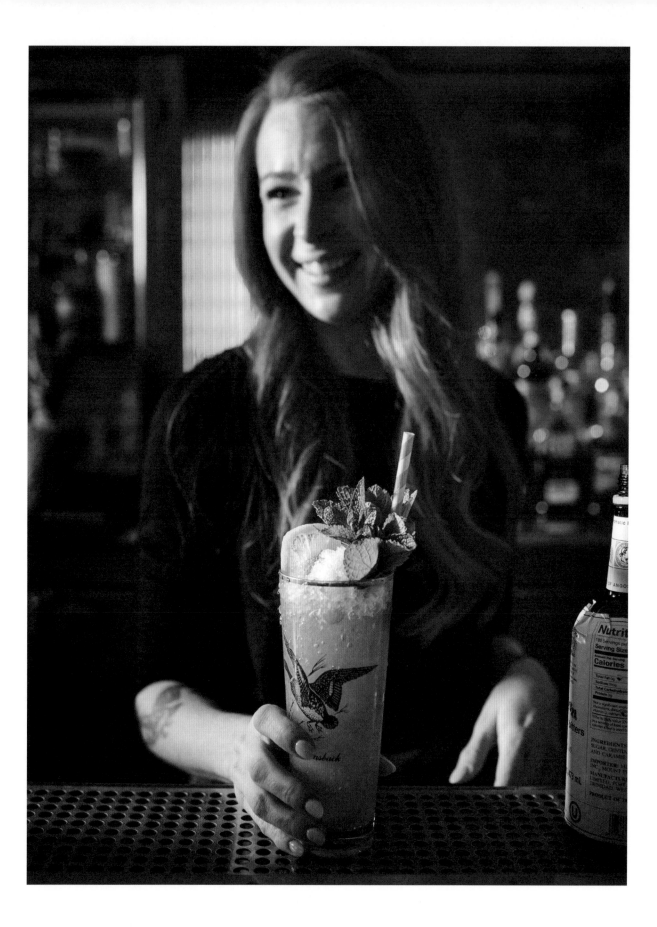

much a neighborhood spot, with a huge industry crowd of regulars. But I like making drinks to make people happy, not because I think cocktails are the coolest thing in the entire world. Being here is very reflective of that.

What do you love about bartending?

Every bar should be a place where people feel welcome. This bar has a warm and welcoming presence to it. People come here on their good days and their bad days. It's a respite for people. The satisfaction I get from getting to know people and hopefully making their day better is what drives me in this industry. I love people and taking care of people, and that goes hand in hand with the pitfalls. We lost a very dear friend and regular to suicide a few years ago. I had seen him in here on a bender a couple of weeks before, and that was the first time I really realized how emotionally and mentally taxing our jobs are. That opened my eyes to what a slippery slope we can create with what we do for a living. We are supplying people with alcohol for a living. It made me so aware.

What's last call like at the bar?

We're known for our last call at Sportsman's, and you can pretty much guarantee that if I'm closing, this is how it's going to go down. And I can't take credit for it. The original bar manager started this tradition. I don't necessarily want to scream at last call, so at 1:30 a.m. there's a quiet turning down of the music, then I start a wave of audible shushing until everyone is silent. If we're very busy, I will enlist friends at the bar to help with the shushing. When everyone has stopped to listen, I can speak to them in a civilized tone about wrapping things up, ordering one more drink, using the bathroom, settling your tab, calling your Uber. Now is the time for all of that. Then I thank everyone for spending the evening with us. Fifteen minutes later, the music is off and what I like to call the ugly lights are up. If it's still packed at that point, I have to start yelling at people. When you give a lot of yourself to everyone every day at service, the chance to let it out can be very satisfying. Once the money's been counted and we're all cleaned up, we'll finish with a group shot. I love bartending, but last call is my favorite time of night.

What is the last thing you'd want to drink before you die?

I honestly don't know if there's a cocktail I love more than a sherry cobbler. Any iteration. I just think it's insanely delicious and I love sherry. If I'm thinking my one final drink, I may not need a hardcore 100-proof whiskey. I like the fact that it's definitely a lower ABV spirit, but it has such a wide range. All the different expressions bring something to the table. It can be rich, it's nutty, it's fun, it's got a cool history. I make mine with Stiggins' Fancy pineapple rum. Pineapple rum was one of my first vices—maybe before I should've been drinking it—and the pineapple is a symbol of hospitality. Sherry cobblers also became a big tradition for me when I was in New Orleans as part of CAP [Cocktail Apprentice Program] offered through the Tales of the Cocktail Foundation. Going to Cane and Table [the rum-centric, Caribbean-inspired bar in New Orleans's French Quarter] and having a sherry cobbler is something I make a point of doing whenever I'm there. There's a lot of history and nostalgia to the drink for me. It's full of so many great memories around the people that I've shared the drink with and the people that I've made it for.

STIGGINS' SHERRY COBBLER *Makes 1 Drink*

½ ounce Demerara simple syrup
 (1:1 Demerara sugar:water)
1 large orange wheel
2 large lemon wheels
2 ounces Lustau amontillado sherry
½ ounce Lustau PX sherry
½ ounce Plantation Stiggins' Fancy
 Pineapple Rum
Pinch of salt
Garnish: lemon wheel, orange
 wheel, fresh mint sprig,
 Angostura bitters

Combine the simple syrup, large orange wheel, and large lemon wheels in a cocktail shaker and lightly muddle to incorporate the ingredients. Add both sherries, the rum, salt, and 1 ice cube and quickly whip shake until the ice has diluted to bring the temperature down without adding too much water. Fine-strain into a chilled collins glass filled with crushed ice. Add more crushed ice to top off if needed. Garnish with the lemon and orange wheels and the mint sprig. Douse the mint with 2 or 3 dashes of bitters.

Miles Macquarrie

KIMBALL HOUSE

Decatur, Georgia | Miles Macquarrie

"He's leavin' (leavin')
On that midnight train to Georgia"
—Gladys Knight, "Midnight Train to Georgia"

I meet up with Miles Macquarrie on a hot summer Saturday night at the bar at Kimball House in Decatur, Georgia, just outside of Atlanta. He'd been running frantically between Kimball House and his new place, Watchman's, but when he finally sits down to join me, he still looks as elegant as ever, with a narrow mustache that evokes a dashing World War I ace pilot. "Are you hungry?" he asks, but my answer doesn't matter because soon iced platters of oysters, shrimp cocktail, and steak tartare cover the bar. Before I've had a sip of my French 75, he asks the bartender to make me the signature Kimball House Cocktail, a martini variation made with gin, dry vermouth, Cocchi Americano, and orange bitters.

Macquarrie and his business partners, Bryan Rackley, Matthew Christison, and Jesse Smith, opened Kimball House in a former 1891 train depot in September 2013, turning to old hotels for inspiration, especially Atlanta's historic Kimball House Hotel (the original 1870 hotel was destroyed in a fire in 1883; the second iteration was rebuilt in 1885 and later razed in 1959). "We wanted to have something that was doing drinks at a high level but also felt classic and timeless," says Macquarrie. "One part neighborhood bar, one part dining destination. I feel like we did that."

Although many bars punch up a go-to last call song of the night on their playlist, the tradition at Kimball House is a bit more interactive. A half hour before closing time, a bartender scampers up a tall wooden ladder behind the bar to retrieve an antique toy xylophone that was acquired with the sheet music to the "How Dry I Am" refrain from Irving Berlin's "The Near Future." This woe-is-me lullaby was sung by the town drunk on the first-season *Twilight Zone* episode "Mr. Denton on Doomsday," as well as in the 1939 Chuck Jones cartoon short *Naughty but Mice*, where Sniffles the mouse catches a mean buzz from some over-the-counter cold medicine and bursts into song. The bar staff gathers around the accompanist on xylophone and together sing their closing-time anthem, "How dry I am / How dry I am / Nobody knows / How dry I am," as the regulars join in and new customers look on in curiosity. "We want last call to be a joyous occasion. We want it to be fun," says Macquarrie. "So many places can be, like, get the fuck out. We're not that kind of place. We want it to be something where everyone can sing along with us—not to mention, it's the bartenders singing the song, so there's an element of sympathy toward them. Those motherfuckers haven't had a drink all night. We've had times where we've sung our last call song to an empty restaurant, but we've never skipped it."

When all the guests have gone and the lights come up, the bartenders take control of the playlist and Macquarrie steps behind the bar to make us a Brooklyn, his choice for his deathbed drink. Amer Picon isn't legally available Stateside, but that doesn't stop Macquarrie from pulling down a bottle off the shelf. He tells me about a trip to Europe with his wife just after they were

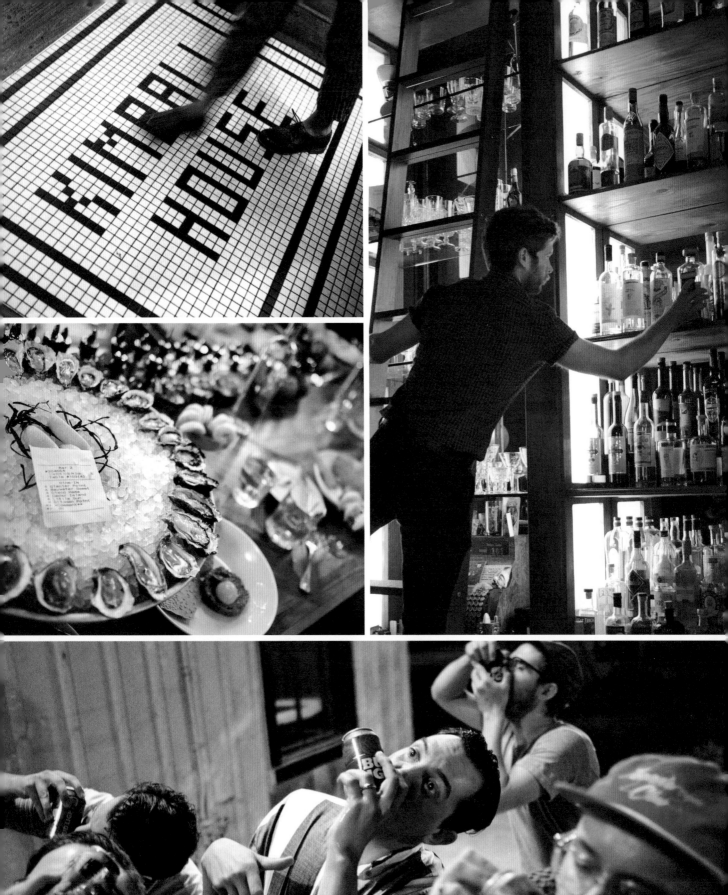

engaged. "We were in Paris for only four days, but I bought a case of Picon, twelve liters of it. I had to buy a new suitcase, which I lugged around from Brussels to Antwerp to Amsterdam." The bottles he shipped home never made it, but the four bottles he packed in his suitcase did, and when his wife asked him what he was going to do with them, he said, "We're going to make proper Brooklyns with them and they're going to be fucking good." Now Macquarrie kindly requests that anyone he knows traveling abroad mule home some bottles for him, offering Kimball House gift cards for their service. "We only use those bottles to make Brooklyns," he says. "I think what a Brooklyn says about me is that I love obscure history and classic cocktails. There are some really amazing popular classic cocktails that I love very much, but something about this one and the fact that it has a pretty unobtainable French aperitif as a key component really speaks to me. The drink is stiff yet elegant and shows a good bit of restraint." Macquarrie takes a sip and admits he doesn't think about mortality often enough, but imagines when the time comes he wouldn't be able to plan a final drink around it. "That being said, picking your favorite drink to enjoy one last time before the final good-bye sounds pretty nice."

Our reverie is interrupted when we notice the staff huddling around the back patio waiting for us to wrap up our conversation. "That's right," says Macquarrie, "it's Shotgun Saturday. Come on." We step outside into the muggy Georgia night as cans of Bud Light are tossed around to everyone gathered. Macquarrie makes a brief toast and then there's a final group exhale of a staff marking the close of another busy Saturday night as the crew punctures holes in the sides of the aluminum cans with their wine keys and the snapping of beer caps fills the air.

BROOKLYN *Makes 1 Drink*

2 ounces rye whiskey (preferably Michter's, Rittenhouse, or High West Rendezvous)
¾ ounce Dolin Dry Vermouth
¼ ounce Amer Picon (or Bigallet China-China Amer Liqueur)
¼ ounce Luxardo maraschino liqueur
1 lemon twist
Garnish: cocktail cherry (preferably Tillen Farms Bada Bing)

Combine the whiskey, vermouth, Amer Picon, and maraschino liqueur in a cocktail glass filled with ice. Stir until chilled and strain into a chilled coupe glass. Express the lemon twist over the surface of the drink and discard. Garnish with the cocktail cherry.

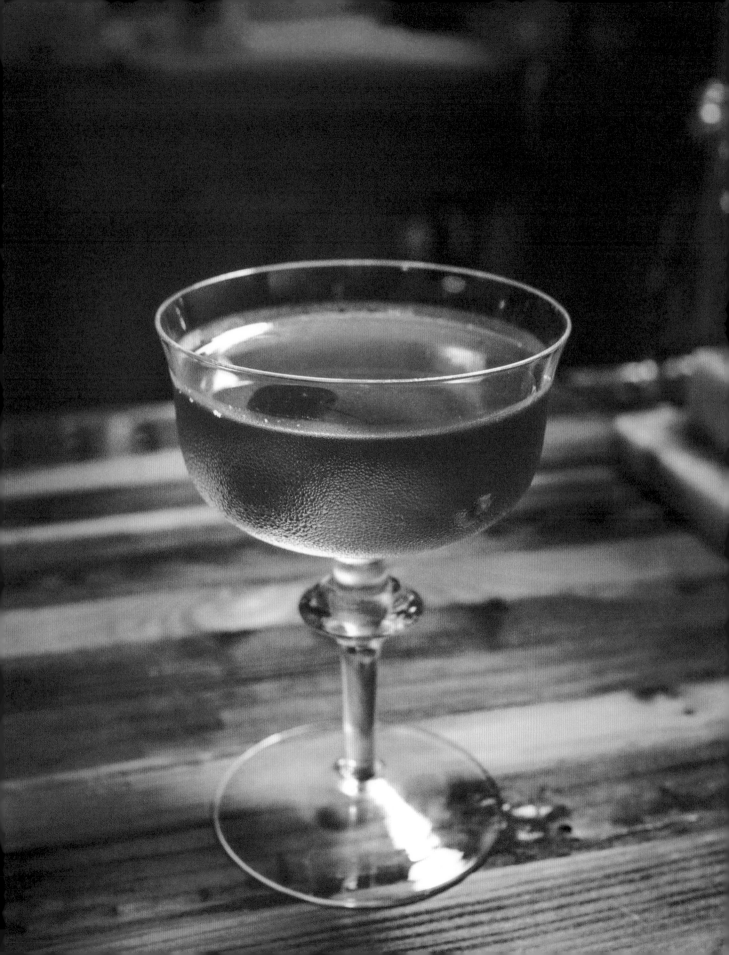

Joey Dykes

BASTION

Nashville, Tennessee | Joey Dykes

"Friends say it's fine
Friends say it's good
Everybody says it's just like rock and roll"
—T. Rex, "20th Century Boy"

Located in a high-ceilinged, warehouse-like venue that was previously home to the American Syrup and Preserve Company in the Wedgewood-Houston section of Nashville, Bastion is actually two venues in one. If you walk in and head right, you'll find a twenty-four-seat restaurant from former Catbird Seat chef Josh Habiger where diners can sample a five-course, choose-your-own-adventure style à la carte menu or larger parties can go all-in for a family-style "feast." Hang left and you'll be in the bar side of Bastion, a laid-back room with an all-vinyl soundtrack and drinks ranging from beers and boilermakers to such inventive cocktails as the Sherwood Forest Fire (Cognac, banana, maple, and smoke). Against the white brick wall in the back are built-in bleachers that sit beneath a black-and-white photo mural populated by a nightmarish Easter bunny peeking out from a doorframe and a bare-backside view of a posse of nudists reaching up to the sky. The walls are adorned with an eclectic gallery of artwork featuring cats, owls, toucans, hippos, and motorcycles. And if you're too exhausted from a heated match of bubble hockey, you can settle into one of the lounge areas outfitted with midcentury chairs and benches.

Bastion bartender Joey Dykes moved to Nashville to play music but also supported himself making pizzas, washing dishes, scooping ice cream, flipping burgers, and pulling espresso shots before he started at The Patterson House, where he worked his way up from host to barback to bartender. "We have a very devoted cast of regulars at Bastion. Sometimes when we open up and look around, we know every single person wrapped around the bar. They might not know one another, but I see all these people every day. Nashville can be very touristy. In the bar, it's very much a community."

And whether you've had dinner next door or are just popping in for a beer and a shot, don't miss out on the only food served at the bar, a tray of nachos that has a more elevated pedigree than your average bar snack. The kitchen makes its own beer queso, smokes the pork butts in-house for the pulled pork, and even makes a from-scratch "chorizo" with cauliflower, black beans, and sun-dried tomatoes for vegetarians. All of that is topped with cilantro, crumbly Mexican Cotija cheese, pickled red onions, jalapeños, and radishes. "They're kind of simple but complex at the same time and really, really delicious," says Dykes.

What's the bar program at Bastion all about?

We're essentially kind of a dive bar, but we just happen to have an amazing craft cocktail program. House-made syrups, fresh juices, daily punches, the works. You can get a PBR draft for $3 or a shot and a beer for $6. It's all across the board. That's why I love this bar. You can come in and see a $13 cocktail and might think it's pretentious, but you can also get a High Life pony for $2.50. It's fun and it's a party place. Bastion is very much a neighborhood bar.

What's the vibe like at last call?

It can go either way—very chill or very rowdy. I've seen both. It's usually a bit more relaxed, but it really depends. Since we shut down a little early, people usually make their move to ride that last call wave to barhop to the next place. Folks say that Nashville is very much a drinking town with a music problem. But sometimes you look around at the bar scene and are like, man do you people work? Does anybody in here have a job? Every day and every night people are out drinking everywhere. It just doesn't stop.

Do you go out after your shift?

I'll have a shift beer with the crew. It's changed over time, but we're in Hamm's season right now. We keep them in the walk-in cooler to chill, and Blake [Lanham, fellow Bastion bartender] started a tradition of throwing the Hamm's over the bar at the closing bartenders as hard as he can to get a really nice foam that ensures the first gulp is a really good one.

After work, yeah, I'm going out. It's celebratory. We've just worked twelve hours, and if we can make it to another bar before last call, it's a victory in our mind. Attaboy goes until 3:00 a.m., but if you want a little more lowbrow, which is what we do usually, we will go to Dino's for cheeseburgers, fries, and shots. Or we go to 308, a dark and vibey cocktail bar where I'll get a tallboy of Bell's Two Hearted Ale. We call it Dino8 because they're so close to each other.

What's the hardest part of being a bartender?

The hours. I feel like I've aged a decade in five years. It's hard to coordinate a schedule with people who don't work late nights. My sleep schedule is completely fucked. Recently my body has really been speaking to me. I've got a bunion situation. I've thrown out my back. And substance abuse is a very slippery slope.

What is the last thing you'd want to drink before you die?

Rum was a big hurdle in spirits for me when I first started bartending. The first time I ever got sick off of liquor was from Malibu rum—Malibu and Diet Coke at Myrtle Beach during senior week when I was eighteen. It was like puking up sunscreen. I never drank rum after that. Then when I was working at Patterson House I had my first real rum cocktail. I had no idea that rum didn't taste like sunscreen. It instantly went from being my absolutely least favorite spirit to my favorite spirit. I especially love the funk of Jamaican rum and the complexity in the heat that the overproof and Navy strength brings.

It's representative of how my career has changed and how I think about drinks. To take something I once hated and turn it into something I love. The daiquiri is such a beautiful, simple sour cocktail that expresses the rum very easily. I'm probably going to order a shaken citrusy drink over a stirred cocktail nine times out of ten, so why not have one for my final drink? It's simple. Super delicious. Crushable. And it's going to get the job done.

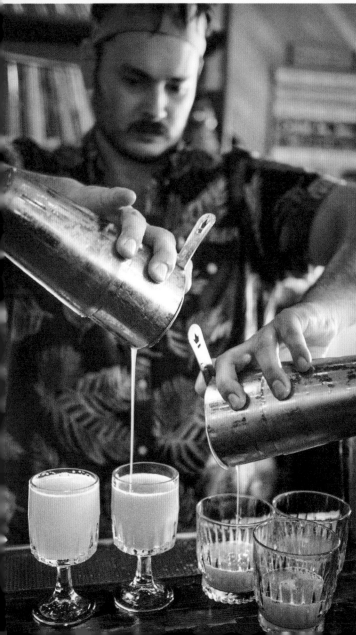
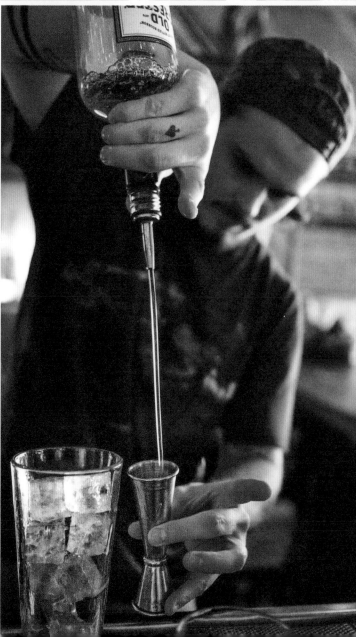

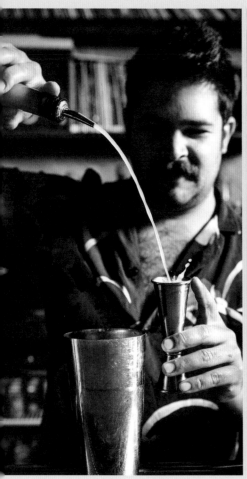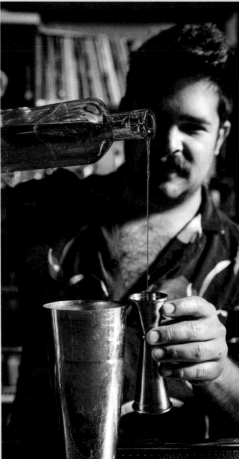

WRAY & NEPHEW DAIQUIRI *Makes 1 Drink*

2 ounces Wray & Nephew
 White Overproof Rum
1 ounce fresh lime juice
½ ounce rich simple syrup
 (2:1 sugar:water)

Combine the rum, lime juice, and rich simple syrup in a cocktail shaker filled with ice. Shake until chilled and strain into a chilled coupe glass.

CANLIS

Seattle, Washington | James MacWilliams

"Now
The mist across the window hides the lines
But nothing hides the color of the lights that shine"
—Joe Jackson, "Steppin' Out"

Canlis, one of Seattle's most iconic restaurants, sits atop Queen Anne Hill in a midcentury modern building with stunning views of Lake Union and the Cascade mountains. I lived in Seattle for over a decade, in the same neighborhood as Canlis, yet had dinner there only once as a guest of my then-girlfriend's parents, who were passing through on their way to Vancouver. I regret that I had that experience only once, but Canlis's standing as a destination for special-occasion fine dining, not to mention the tab for dinner, kept me away. Its reputation for hospitality is legendary, and one thing I'll never forget was when, just a few moments after I suggested my hosts stop by Fran's Chocolates to pick up some of the Seattle chocolatier's famed salted caramels, a manager walked by the table and, with little fanfare, presented a box of those very salted caramels tied in a ribbon. "Thought I'd save you a trip," he said before discreetly walking away.

If only I had been savvy enough to consider the Canlis bar and lounge as a more regular destination, where that level of service and overall experience is on display each night. It's a lesson I've since learned and will be sure to amend whenever I'm back in town.

The landmark restaurant was founded in 1950 by Peter Canlis and is now owned by his grandsons, Brian and Mark Canlis. They took over the family business from their parents, Chris and Alice Canlis, who ran Canlis for thirty years following the death of Peter in 1977. I stopped by Canlis before service to meet with their head bartender, James MacWilliams. I was early and waited by the bar, and when he rolled in, he was wearing a casual hooded sweatshirt adorned with a trio of howling wolves and carrying a motorcycle helmet under his arm. He excused himself to change and moments later reemerged in a sharp dark suit and crisp white shirt, instantly transformed into a dashing bartender from a black-and-white movie (but not before Brian Canlis passed by and briefly broke the illusion by leaning in to quickly adjust MacWilliams's tie).

"I started bartending the day I turned twenty-one and have been doing it for twenty years," says MacWilliams. "I was at the original Duke's on Queen Anne [the first location of Duke's Bar & Grill on First Avenue West and Thomas, near the Seattle Center, which spawned a series of Duke's Seafood & Chowder locations in Washington]. The lead bartender at that time was dealing cocaine over the bar. The bar manager was waiting for me to turn twenty-one so he could fire the guy, and my first shift was on a Tuesday night during a Sonics game making $2 Long Island Iced Teas." MacWilliams had been bartending at clubs, dive bars, and fast-casual joints and never aspired to work in fine dining, but a friend who had worked at Canlis told him about the job opening. He came by for a group interview with the chef, managers, and directors at the restaurant and fielded questions about his experience. After a couple of hours of intense queries, the final question came from Brian and Mark's mother, Alice, who played a pivotal role in shaping

James MacWilliams

the restaurant's famed level of hospitality. With all the technical questions out of the way, she asked MacWilliams about his mother. "She was more concerned with who I am than what I could do," recalls MacWilliams. "Her questions about family and what my passions were outside of work caught me off guard." Six weeks later he was offered the job and has been at Canlis for over a decade.

MacWilliams took me through the restaurant, starting at the entryway where an enormous, three-hundred-year-old Japanese *kura* door stands near the entrance. "The whole idea of Canlis starts right here at the front door. Years ago this *kura* door would have been put in front of a vault to protect the treasures within. We operate in the same way, in that we are guarding people's treasures, their most special moments. We are a place where people come for their most special occasions—anniversaries, birthdays, retirements—the big events. We invite people into our home and we guard that and keep it safe." From there it was to the rooftop where a pair of Adirondack chairs, a stack of field blankets, and a keg of rosé on tap was set up as an aerie for guests to have an after-dinner drink with a view, and then to the basement wine cellar where he presented an impromptu tasting of a quartet of vintage bottles of amaro. On our way back to the bar I noticed the restaurant's James Beard medal, which would have been framed and prominently displayed at most restaurants, hanging unadorned on a simple hook in a hallway on the way to the restroom.

After spending a few hours with MacWilliams, he invited me to come by for a drink later. "You have to see this view at night from the bar to understand what we're all about," he said, gesturing to the bank of windows overlooking Lake Union. I hadn't exactly packed for fine dining and motioning to my untucked, wrinkled oxford he assured me, "Not to worry, I'll see you later tonight."

Back after sundown with courtside seats at the intimate bar, I had a glorious view of the summer night sky changing hues and the lounge's piano player seamlessly transitioning from Gershwin to Radiohead. I'm in awe of the understated yet highly choreographed flow of the room, and MacWilliams tells me that members of the Pacific Northwest Ballet had once visited the restaurant to offer tips on movement, poise, and body language. He makes me one of his most popular drinks, what he calls the Almost Perfect Cocktail, a fragrant sipper made of pineapple rum, Averna, Cocchi Americano, maraschino, and bitters served over a big rock.

"The biggest change to the bar in our 2015 renovation wasn't anything physical, but a philosophical shift in how we curate our spirits," he says. "Before that we kind of tried to have everything for everyone. And that didn't feel very much like inviting someone into our home. Most people at home don't have everything, just their favorite things. So if you look at our backbar, there's not a whole lot there. My wells are all single barrels. I don't have to offer everything when I'm starting off with something exquisite that they can't get anywhere else." But I did notice that MacWilliams, with the ease of a seasoned magician, would slide through a small door behind the bar from time to time and then reappear as if he'd been there all along. "I'm not supposed to talk about this, but I will. People see me coming in and out of this cubby all the time. It's just where we store extra liquor and the ice machine, but lots of great conversations happen back there. It's a place for me to get out of the fishbowl for a few minutes." With that he asks if I'm hungry. What he promises will be just a little snack to go with my cocktail turns out to be a four-course tasting menu at the bar.

While Canlis counts some of Seattle's biggest names as frequent dinner guests (the kind of people who have streets named after them), MacWilliams notes that some of their best regulars are the people who come by the lounge. "We don't have last call, per se," says MacWilliams.

"Basically, one of the bartenders stays here until the last guest has left the building." After the piano player packs up and leaves for the night, it seems like a good time to ask him what his one final drink on Earth would be. His answer of a margarita and a beer ("doesn't matter where it comes from as long as it's Pacifico") surprises me, but once he tells me why it makes perfect sense.

"My wife and I got together twelve years ago. We were living in a condo on the other side of Queen Anne, really close to a Mexican restaurant called La Palma. Over the years it became our second living room. It's where we celebrated our son's first birthday, our anniversaries, and, embarrassingly enough, a couple of Valentine's Days. It was the place where we would go to just celebrate. And when we were celebrating we wanted Mexican food, a cold beer, and a margarita." The lounge is empty and he leans back against the bar to finish his story. "And dying kind of sounds like something worth celebrating, or at least marking as a special occasion. I have this glorified idea of going out like I'm in a Clint Eastwood spaghetti western, so I'd probably be thirsty at the end. Don't get me wrong, I love whiskey, especially great whiskey, but if I'm shot and dying, it's the last thing I'd want. I'd be lying there and it just sounds like it's going to be dusty. I just want something refreshing and maybe to take a moment to celebrate my passing a little bit. If I saved the town and died in a gunfight, I'd want to go out refreshed."

With the restaurant empty, MacWilliams and the beverage team have one last card up their sleeve. I suspected there might be some amaro to close out our time together, but I didn't expect they would be cracking the seal of a 1970s bottle of Brancamenta, a favorite amaro of the staff. I stand up and the guys come around from the other side of the bar and we raise our glasses together as they send me off into the Seattle night to the refrain of their team toast: "Early and often. Maximum effort. Luxury."

MARGARITA *Makes 1 Drink*

Lime wedge (for rimming)
Kosher salt (for rimming)
2 ounces blanco tequila (preferably
 Arette Artesanal Suave)
¾ ounce curaçao (preferably
 Pierre Ferrand)
1 ounce fresh lime juice
½ ounce simple syrup
 (1:1 sugar:water)
Garnish: lime wedge

Cut a small notch in the center of the lime wedge and run it around the rim of a chilled margarita glass, gently squeezing the lime as you go. Pour a small pile of kosher salt onto a plate just wider than the diameter of the glass. Tip the lime-slicked glass on its side, parallel to the plate, and gently roll the outside edge of half of the glass in the salt, coating it. Fill the glass with ice.

Combine the tequila, curaçao, lime juice, and simple syrup in a cocktail shaker filled with ice. Shake until chilled and strain into the salt-rimmed margarita glass. Garnish with the lime wedge.

ALMOST PERFECT COCKTAIL *Makes 1 Drink (pictured at left)*

4 dashes Angostura bitters
½ ounce grenadine
¼ ounce Luxardo maraschino liqueur
¾ ounce Cocchi Americano
¾ ounce Averna
1½ ounces Plantation Stiggins'
 Fancy Pineapple Rum
Garnish: lemon twist, edible flower

Combine the bitters, grenadine, maraschino liqueur, Cocchi Americano, Averna, and rum over a large ice cube in a double old-fashioned glass. Stir gently to incorporate the ingredients. Garnish with the lemon twist and the edible flower.

At Canlis, MacWilliams keeps the Averna and Cocchi Americano chilled in a refrigerator. He builds the drink over a single cube rather than chilling the glass in order to maintain the potency of flavors. In addition, even if the Canlis guest doesn't notice, he's drawn to the visual appeal of the liquids of varying colors and viscosity cascading over the sides of the large ice cube.

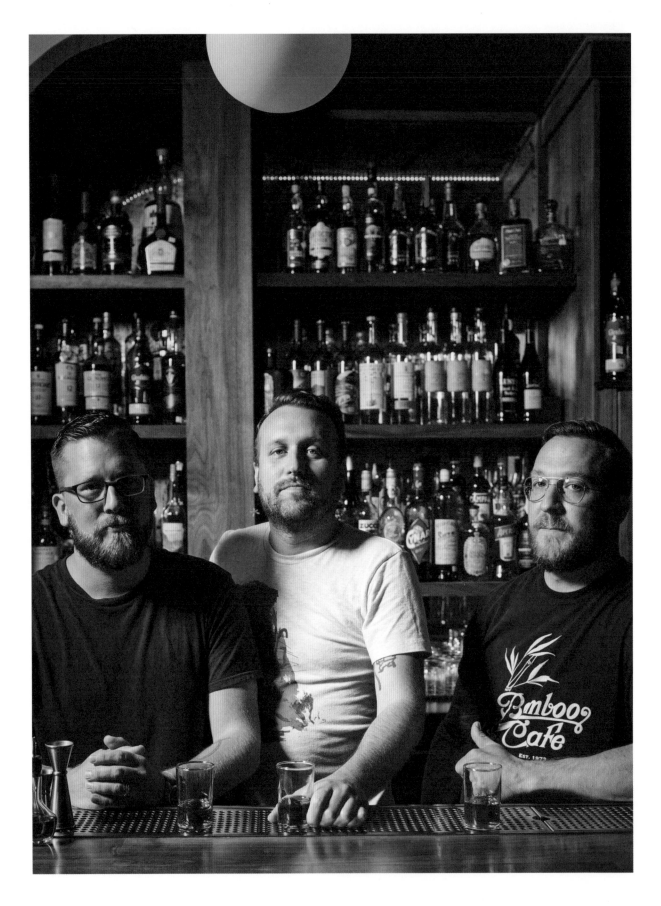

Mattias Hägglund, Brandon Peck, and Thomas Leggett

THE JASPER

Richmond, Virginia | Mattias Hägglund, Thomas Leggett, Brandon Peck

"East bound and down, loaded up and truckin',
We're gonna do what they say can't be done"
—Jerry Reed, "East Bound and Down"

Located among a strip of retail shops in the Carytown neighborhood of Richmond, Virginia, sits The Jasper, a neighborhood bar run by a crew with an esteemed pedigree in the local bar scene. The Jasper promises "Full Pours & Honest Prices" but delivers much more, making it a beloved destination for cocktail enthusiasts and industry regulars alike.

There was the element of a DC-Marvel crossover when two of Richmond's most buzzed-about bartenders, Mattias Hägglund of Heritage and Thomas Leggett of The Roosevelt, joined forces, partnering with restaurateur Kevin Liu, to open The Jasper. "I remember meeting Mattias and thinking, this guy can be my competition at this point or he can be my best buddy," says Leggett. "And I've always found it better to go the friendship route, which he made very easy for me. We had a lot of the same ideas about what we wanted to do." Leggett brought aboard Brandon Peck as bar manager to round out the dream team, and they've been hosting one of the best spots in the area to grab a drink ever since. "If Richmond is any one thing, it's ambitious," says Hägglund. "There are a lot of people who are diving headfirst into cocktails and trying to learn everything, from our next-door neighbor making a really rad clarified milk punch to people trying to set up tiki bars to a strong whiskey culture. The hospitality side of things had to catch up to the quality of the beverage side, but it's finally leveling out a little bit. And it's only getting better everyday."

The Jasper is located in a former carpet store, which is hard to picture, as it feels like the bar has been there for years. It is named in tribute of Jasper Crouch, a freed slave who oversaw the bar and catering at Richmond's Quoit Club in the early 1800s; Crouch's Quoit Club Punch, made with Jamaican rum, brandy, and Madeira, is proudly featured on the front page of the bar menu ("It's our little way to connect to what he was doing and was known for, and the fact that he never got what he deserved," says Leggett). Along with house cocktails there are some inventive takes on classics, including Zombies on draft, an $8 nitro bourbon and ginger (the mix of nitrogen and carbon dioxide from the on-tap cocktail imparts a thicker, foamy texture and subtle sweetness), and a tequila and chile liqueur–spiked Jungle Bird riff called the Caribbean Kween.

When I was walking through the bar I noticed a small Chartreuse logo painted on the floor, which turns out to be the guys' version of the X on a treasure map. Hägglund scrolls through his phone until he brings up a photo of where I'm standing with a bottle of green Chartreuse resting beneath the floorboards. They tucked it away time capsule–style to mark the opening of the bar. It's clear that this crew are friends beyond their business relationship, and these "big cats," as they call themselves, made this "wildcat" feel at home, even calling me over to the service bar near the end of the night to join the team in a sherry toast to celebrate the close of another Friday night (which, when there's sherry involved, is dubbed Fortified Friday).

How did your team moniker, "big cats," come about?

Peck: The big cats thing started somewhat organically because several friends gifted us some ceramic cats for our backbar. Then we gradually accumulated a bunch of cool wall art of big cats, and the name just kind of stuck. It's a funny little thing that has kind of made us all feel a little more like a family, which is such a wonderful feeling when you're at work.

What was your vision when creating The Jasper?

Hägglund: Our ambition has always been to be the best version of a neighborhood bar that we can possibly be. We're in a busy shopping district with a lot of foot traffic, so we needed to have something for everyone. We needed to be reasonably priced and we needed to be attainable, but excellent at the same time. We want everything to excite and thrill.

Peck: This bar is the perfect cross section between the two worlds I've lived in: late-night, divey party bars and casual fine-dining restaurants with very specialized cocktail menus. We set out to be a cocktail bar, but not exclusionary to anyone. If you don't want to drink cocktails, you definitely don't have to. Our house beer is Old Speckled Hen. It's this classic beer that nobody really cares about that's so delicious.

Do you have any favorite shift drink traditions?

Leggett: I'd love to have a last call ritual, but we're still new, so it's a little early for that. But when it comes to shift drinks, I love alliteration. I think it started off as Smith and Cross Saturdays. That happened only one time, and we quickly figured out that was not a good idea. Sherry Saturdays is a thing. It's low ABV, and we were introducing staff and servers to different styles of sherry that we use a lot in cocktails but that maybe they've never really had by themselves. You've never had a nice oloroso sherry? Let's all drink one. Then we forced that into Fino Fridays or Fortified Fridays.

Peck: And our mini Zombies on draft. When a group of friends come in and you don't have time to make them a round to say hello because you're too busy, you can just pour a handful of baby Zombie shots. And, of course, there's Coors Banquet and Plantation dark rum. It's the easiest thing to drink that you don't have to think about. Coors is the best cheap beer.

Leggett: I think once we called them Colorado Kool-Aids, everybody is like, yeah, that's what we want.

Hägglund: I grew up with my dad drinking it. It smells like football to me.

What is the last drink you guys would want to have before you died?

Peck: Sherry has become a sign of camaraderie around here, a rally call to the staff on busy nights, and a moment to breathe deep in the midst of chaos. We shoot sherry as a team every Friday and Saturday midshift because it brings us back down to earth. Sherry is the great unifier at The Jasper. We're proud to carry a good chunk of the Lustau lineup. As a staff, I think we all veer more toward fino, manzanilla, amontillado, and oloroso, but we celebrate all styles.

I'm constantly aware of my own mortality, and I thank my lucky stars for each day I get to spend in this mortal coil. This life is just a lottery, a random draw, so I think it's important to find the things you love and enjoy doing (and drinking) them until you don't have the time to do them anymore. It's the coward's way out to numb yourself when death comes knocking. But when the end comes, I want to taste something I love and greet the darkness with my eyes wide open.

Bamonte's. Brooklyn, New York. »

Kaddy Feast

MONTERO BAR & GRILL

Brooklyn, New York | Kaddy Feast

"Ride captain ride upon your mystery ship
On your way to a world that others might have missed"
—Blues Image, "Ride Captain Ride"

I've walked past Montero, which sits on the far west side of Atlantic Avenue a couple of blocks from the the Brooklyn waterfront, hundreds of times, but it took me, I'm embarrassed to say, almost a decade to set foot in the door. I long admired the old neon sign hanging over the entrance, but ultimately, it's the bar itself and the people who occupy the seats that has made Montero a port of call for generations.

Leaning on its roots as a longshoreman's bar, I figured Montero was still a little rough around the edges. I remembered on early-morning trips to JFK before the sun was up witnessing a hive of activity buzzing at the bar through the windows or a gaggle of patrons smoking out on the sidewalk as I sat at the light waiting to merge onto the on-ramp of the Brooklyn Queens Expressway. But then one summer evening when I was standing on the sidewalk in front of the bar taking a photo of the setting sun illuminating the Montero sign, a red-haired woman dressed in black with a Patti Scialfa vibe came out from the bar to say hello. She went on to tell me about the hundreds of photos she's taken of that very sign, even giving me tips on the best angle. "I think you probably have enough pictures by now," she said, heading back inside. "Why don't you come in and see what we're all about."

The bartender, Kaddy Feast, introduced me to the sole customer, a beloved regular who was a daily fixture at the bar. She then pulled the cap off a PBR bottle (Montero is one of the few bars in New York where you can find Pabst Blue Ribbon in a bottle) and, like a museum docent, proceeded to give me a guided tour through the countless nautical knickknacks, artifacts, framed newspaper clippings, and faded photographs covering the walls, shelves, and every corner of the bar. Orange life preservers from ships that had docked in the Brooklyn piers hung above us, and model airplanes suspended from fishing line were on a perpetual strafing run dive-bombing any patrons below. There was a working dumbwaiter that delivers cases of beer from the basement, a calendar that's off by a decade tacked up behind the bar, and two midcentury wooden phone booths with working sliding doors (the phones themselves are another story).

Feast told me the story of Joseph Montero, a merchant marine from Galicia, Spain, who was the chief engineer on a ship making regular runs delivering goods to Brooklyn. He opened Montero in 1938 with his wife, Pilar. It was originally located across the street but was set to be razed due to Robert Moses and his plans for building the expressway through the neighborhood. Montero moved the bar to its current location on the site of a former German delicatessen and reopened on July 4, 1947. Now, Montero is run by his son Pepe and Pepe's wife, Linda. "Over the years when you got adopted into the Montero family, whether you were an employee or a patron, Joe and Pilar would take care of you, make sure you were safe and fed," says Feast, who experienced that tradition firsthand the first time she walked through the door.

Like me, Feast had passed Montero a million times without stopping in. "I thought it was an old-man bar," she says, "where there are five old dudes sitting one stool away from each other because they hate each other. And then when you would walk in, they would all turn to look at you and growl." She was at an admitted low point in her life, having just quit a job under difficult circumstances and given notice on her apartment. She met a friend at Montero on St. Patrick's Day, and after updating her friend about her current situation, a woman down the bar "too drunk for her own good" got a little nasty with Linda Montero. When Linda called back to Pepe to have him hustle her out the door, Feast sprang to attention, put her hands on her hips like Wonder Woman, and stood between Linda and the inebriated patron. After things returned to normal, Linda came over and said she wanted to talk to Feast. They headed to the back, near the pool table, where Linda asked her about her schedule. "I don't have one. I'm unemployed," said Feast. "She told me to come by Monday at 5:00 p.m., and I've been here ever since." Although she had only a couple of years' experience tending bar, the job suited her. "We all judge people so quickly, especially in America. But these snap judgments are not who people are. What you do and how you look is not who you are. Being behind the bar allows me to witness people revealing themselves every day."

That lost-in-time reverie at Montero can easily shift into a rowdier scene as the hours tick past, especially on weekends when there's karaoke. The first hour of karaoke is all about breaking the ice: An older woman with dark Crystal Gayle hair hanging to her waist opens with the 1978 disco ballad "Native New Yorker" ("Where did all those yesterdays go? / When you still believed / Love could really be like a Broadway show") followed by a mix of tipsy regulars who can't keep up with the lyrics on the teleprompter or whose song choices feature extended instrumental sections that just drag out their uncomfortable moments in the spotlight. After a rousing rendition of Neil Diamond's "I Am . . . I Said" followed by Billy Idol's "Hot in the City," the room starts to skew toward a house party vibe, with hipsters and bros rolling in with boxes of pizza from Table 87 up the block. Everyone sings along at full volume, and there's a scrum for the minigolf pencils to fill out their song requests as the house MC, Amethyst Valentino, breaks the news that their turn at the mic won't come up for at least another hour.

Bartenders don't drink behind the bar at Montero, so Feast takes the time to savor her shift drink once the bar is locked up and she's alone, rather than head out to another bar. "A lot of bartenders use that as an excuse," she says, "but I will tell you right now, starting to drink at 3:00 a.m. or 4:00 a.m. to catch up with people drinking since 10:00 p.m. is never a good idea." Instead, she cranks up Janis Joplin and has her own solo karaoke show at the bar, singing along at the top of her lungs. She has a special place in her heart for Early Times bourbon, which she tells me would be the last thing she'd want to drink at the end.

"My grandparents had a nightly tradition of having a predinner drink, and when I was old enough, I was allowed to pour the booze, which was always Early Times bourbon, into the glass over ice," says Feast. "They would call dinner, face off to each other with glasses in their hands, and would say, 'I love you, Nellie . . . I love you, Warren . . . ,' then clink glasses and kiss each other." After her grandmother passed away, Feast would have a toast in her honor whenever she found a bar that carried Early Times, and she continues that tradition whenever someone she knows dies. "I raise a glass and say, 'Granny, go meet this one and bring them a drink and tell them it's going to be okay.'" Early Times is harder to find in New York these days, but Feast saw

WELCOME TO MONTEROS
WE'RE ALL HERE
BECAUSE
WE'RE NOT ALL THERE

TELEPHONE

NOT RESPONSIBLE FOR
PERSONAL PROPERTY

a bottle at Montero when she started work there and it felt like a sign. It was the only bottle of Early Times at the bar, and she told Pepe not to worry about replacing it once it was gone. But knowing the story about her grandmother, Pepe makes sure there's a new bottle on the shelf whenever it runs out.

"I think of Montero like the building in *Ghostbusters,*" says Feast. "It's got this nexus of energy from all of the people that have come before. I think a lot of bars have that, but this place is special. It's the ghosts of people in their rawest form. You drink, you lose inhibitions, there's sometimes conflict, but mostly it is people coming together." She sits at her favorite seat at the corner of the bar and takes a sip of Early Times as she gazes over the old photographs on the wall. "Every night I have a shift at Montero it's a five-act play, just like Shakespeare," says Feast. "And every time I think there's only going to be four acts that evening, somebody walks in the door and something happens. Some nights it's a tragedy, but mostly it's a comedy. But you just never know."

REDBIRD

Los Angeles, California | Tobin Shea

"And it's something quite peculiar
Something shimmering and white"
—The Church, "Under the Milky Way"

If the soaring ceilings of Redbird, which include a retractable roof that opens to reveal the nighttime sky, evoke the soaring drama of visiting a historic cathedral, there's a good reason. The setting of the downtown LA restaurant was once the rectory for the Cathedral of Saint Vibiana, the second Roman Catholic church in Los Angeles and the seat of the local archdiocese. After being marked for demolition following extensive damage suffered in the 1994 Northridge earthquake, the 1876 cathedral was spared, and the cathedral and its garden were transformed into an event space by chef Neal Fraser and his wife and business partner, Amy Knoll Fraser, who opened their restaurant Redbird on January 7, 2015, next door in the former home of the cardinal.

The full-circle bar, which is split between the two dining rooms, is run by bar director Tobin Shea, who was part of the opening team and is known around the city for his inventive cocktail program and its inspired themed menus based more on concepts, such as the Silk Road, horse racing, and vintage seed catalogues, than on the seasons. With his pressed apron, ready smile, and slicked-back salt-and-pepper hair, Shea downplays his role at Redbird, insisting he's in service of making everything and everyone else in the restaurant shine. But if you're sitting at the bar, he has that much-talked-about quality of celebrities and other magnetic personalities to make you feel like you're the only person in the room (and that's saying a lot in such an expansive room). "One of my biggest strengths as a bartender happens when someone sits down in front of me. I love talking to people—finding out where they're from, and if I know something related to that area, I try to always make those connections instantly. If you're from Binghamton, let's talk about spiedies. Rochester? Then you know I'm going to bring up Genny Cream Ale."

How would you describe your bartending style?

I love to build off the shelf—respecting the bottles, the brands, and the stories behind those spirits. Someone spent their life trying to figure this out and make this the best they possibly could, and now you're going to spend ten minutes infusing it with something or barrel aging it and think you can make it better? I really take that to heart. Everyone always talks about seasonal menus, but one of my main components of being a bartender is that distilling and making liqueurs is essentially capturing the season and the spices of the season. That's one thing that I've always stood behind. We obviously use fresh ingredients as much as possible, but we build off the shelf more than we do the farmers' market. That being said, we do have a garden in the back that we do incorporate ingredients from on a regular basis. We have a beehive on the roof with honey. But we don't build around seasons and plan that into the menu. I still do all those other things, but deep down the root of me is building off the shelf and respecting the way distillers and producers have been able to capture those flavors.

Tobin Shea

What drink are you best known for?

The one I got the most love for was the Little Tokyo, which is essentially a sake Negroni with a little yuzu in it. We had it on the opening menu, but no one was really ordering it. It was a great drink—I loved it. But the drink wasn't selling, and I took it off the menu. A week later, Jonathan Gold comes out with his bar issue in the *Times* and it was one of the twenty-five cocktails you have to have in Los Angeles. And I had taken it off the menu the week before! I remember the flush feeling I got on my face when someone called me up to read the article to me. The bar program got a ton of credibility after that. He didn't sit at the bar when he ordered it, but a year and a half later, I had the chance to meet him and shake his hand and thank him. To this day, I remember the feeling I got reading his story. I had to sit down.

What's your favorite memory at the bar?

It didn't happen here at Redbird, but at HMS Bounty in Koreatown, a bar I love. I was there with my girlfriend and my sister having drinks, just standing there passing the time drinking Cutty [Sark, an old-school blended scotch with a distinctive yellow label illustrated with its namesake clipper ship] and soda. I put $20 down on the video Keno. I'm watching the numbers, trying to pay attention, but also trying to stay involved in the conversation. And then I was like, I have six numbers right now and eight out of eight is the big payout. I figured that I would probably pay for dinner that night. So I go up to the bartender and say, "I think I won, but I don't know how much. Can you scan this ticket?" She scans it and then in this bar full of drunks she shouts as loud as she fucking could, "You just won $35,000! Holy shit." Everyone cheered and she said, "You're definitely buying a round of drinks for everyone."

What is the last thing you'd want to drink before you die?

My drink before I die is going to be some version of an old-fashioned. The sugar, the bitters, the whiskey—you have the whole spectrum. The reason it's one of the most popular drinks is because it works. I like to try to find that sweet spot where the bitters are highlighted a little bit. It's so easy to make anywhere. You can make it in a hotel room or on a plane. It's always there when you need it.

Every year at Redbird, we have a Kentucky Derby party, and in the month leading up to it, we have a horse racing menu with drinks such as the mint julep, Belmont Breeze, and Black-Eyed Susan. One of the drinks we put on the list is the Kentucky Colonel, which is essentially a B&B. I'm from Pennsylvania, which is a control state, and there were places in state liquor stores where you couldn't find a bottle of Bénédictine but you could buy a bottle of B&B. Bénédictine can be too sweet, so I knocked back the sugar, but it's my interpretation of a B&B in the form of a brandy old-fashioned.

My girlfriend's father is a huge brandy drinker and kind of turned me on to brandy. I love the regional aspect of brandy. Northern Indiana people make their Manhattans with brandy. You go to Wisconsin and they're making their old-fashioneds with brandy. After hanging out with him, I grew an appreciation for brandy. Not to mention they're fairly priced. Some of these brandies are ten to twenty years old, and they're cheaper than an eight-year-old whiskey or bourbon. My first old-fashioned was definitely one made in the Wisconsin style. Going back twenty-five years, that's what everyone made. It sort of ties it all together for me. It's so funny

how things have changed. I absolutely love what I do. I'm older, but I can still do a double standing on my head. This will probably be my career until the day that I die—which might be the reason why I die at the same time, too.

BRANDY OLD-FASHIONED *Makes 1 Drink*

2 ounces brandy (preferably Bertoux) ½ ounce Bénédictine 4 or 5 dashes Angostura bitters Garnish: orange twist	Combine the brandy, Bénédictine, and bitters in a mixing glass filled with ice. Stir until chilled and strain into a double old-fashioned glass over a large ice cube. Garnish with the orange twist.

LITTLE TOKYO *Makes 1 Drink*

1½ ounces nigori sake (preferably Momokawa) ¾ ounce Cappelletti Aperitivo Americano Rosso ¾ ounce Dolin Vermouth Rouge ¼ ounce yuzu juice Garnish: orange twist	Combine the sake, Cappelletti Aperitivo, vermouth, and yuzu juice in a mixing glass filled with ice. Stir until chilled and strain into a double old-fashioned glass over a large ice cube. Garnish with the orange twist.

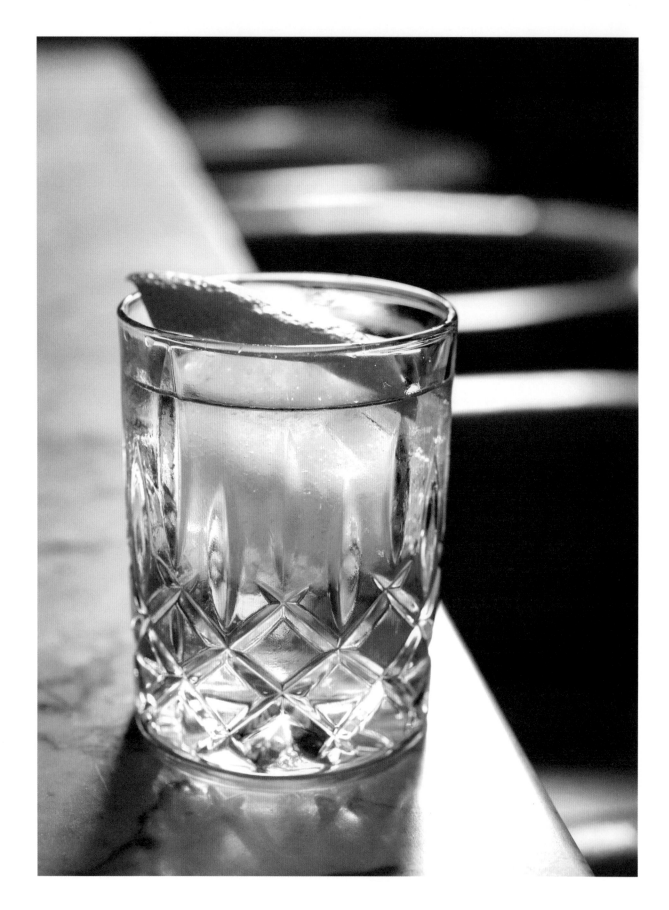

Brandy Old-Fashioned

Little Tokyo

Jason Kraft

ROBERTA'S

Brooklyn, New York | Jason Kraft

"Now, let me get some action from the back section
We need body rockin' not perfection"
—Beastie Boys, "Body Movin'"

People flock to Roberta's in Bushwick, Brooklyn, for its eclectic take on pizza, but they also come to party. The venue itself is set up like the set of *M*A*S*H,* with a hodgepodge of indoor and outdoor seating crammed with communal tables, canvas tents, and shipping crates. It is also home to a radio station, rooftop garden, bakery, take-out counter, and Blanca, an award-winning tasting-menu-only restaurant where diners are invited to spin vinyl from the house record collection. Head bartender Jason Kraft is the spirited ringmaster of the controlled chaos in this lively setting, energetically hopping between their first come, first serve seven-seat bar and the even more raucous tiki bar outside.

Whenever I'm at Roberta's and Kraft is behind the stick, there's usually a dreamy sense of lost time, especially in the tiki bar, a tented space where packs of friends and couples on dates are passing around pizza in take-out boxes and drinking a little more than they probably should. You may leave a little worse for wear from a few too many shots of Fernet-Branca, but you're guaranteed to exit through the outdoor garden and into the night riding a rainbow-colored comet's tail of good vibes. The last time I was there, I stopped in for dinner around 6:00 p.m., and the next thing I recall was hearing "last call!" before Kraft cued up his ritual closing songs: "Purple Rain" at full volume followed by Michael Jackson's "Man in the Mirror." "Music sets the energy for any situation," says Kraft. "With Roberta's, it's always been more of the rock-and-roll and hip-hop department, with the only rule of thumb being that Pearl Jam was never allowed to be put up."

Do you remember what first got you into making drinks?

I'm originally from a super-mellow, small beach town in Orange County, California. Growing up, my dad's best buddies were three Hawaiian brothers and cousins. I'm talking massive, beached-out Hawaiian guys, bro. Cooking steaks, speaking pidgin to one another. My dad's got bamboo shit on the walls, surf records all over the place, and the backyard is filled with tiki statues. He's even got a Jacuzzi out back, and he still has a rattan bar with built-in shelving from the 1940s. This inspired my warm-weather California vibe. When I was, like, seven, he taught how to make a Fuzzy Navel, and I'd bartend his parties shirtless in a little bow tie. I've been drawn to these brightly colored, fresh-juice cocktails ever since. Anyone who knows me knows I'm a fan of the garnish. I love overly garnished, fun, big, bright, beautiful drinks. Load it up. Man, don't give me a sprig; I want a fucking tree. I want to bury my face in that drink and smell it. I love that.

What do you love about being a bartender?

They say bartenders are like rock stars without instruments. I've always seen bartending as like being on a stage. And it is. You're up here performing. I'm also a musician, and bartending is just another extension of being on stage—like being the front man of a band. Not that I'm big and flair-y, but I tend to have a little more showmanship when I'm making cocktails. It's just part of who I am. That translates to me being a big front man—loud and dancing and having a good time. Theoretically, it's my job behind the bar to know more than the average Joe, but that knowledge we have as bartenders is not to be, "Oh, look at me I'm so smart," but to give guests a good experience. Give them a good journey and never have them feel like they're being taken for a ride.

How would you describe the scene at Roberta's?

You need to experience the place in person to properly understand it. You just have to. We do pizza. We play fun rock and roll and hip-hop. We have an incredible two-Michelin-star chef doing seasonally driven Italian food. That's the greatest thing about Roberta's. Anytime I tell someone about it they go, "Okay." Then I bring them through the front door and they go, "Oh shit, that's what you meant." It's like seeing live theater. The energy physically hits your chest. You walk in the front door and get fucking smacked with a unique palpable energy that can only exist in this space. This is why I love working there.

What's closing time like at Roberta's?

Last call at the compound itself is midnight. We're kind of done when the last table bounces. We have two-hundred-plus employees on the payroll, so I'm the hub for the shift drinks, usually

a beer or a nice shift-size pour of wine. We switched up from Bud draft to a twenty-five-ounce can of Bud Ice. If you're going to get a Bud, why not get two? We'll let loose and have a little dance party when we're cleaning up. In the warmer months, we congregate outside by the little hut out back, commonly known as the But Hut. It's got two photos of Eddie Murphy up on the wall, so we go out there and party with Eddie. My best way to come down is when everybody starts going away, when the staff drinks are all set. Once the staff splits or takes off to do their own thing, I love sitting in that backyard when it's dead quiet and the stars are out. Out there with my cig and a glass of wine just decompressing for five minutes is so legit relaxing.

What is the last thing you'd want to drink before you die?

If I had the chance to put one last drink to my lips, I think it would have to be a Vieux Carré. I drink a lot of good wine because it's accessible, and I'm a wine person in my day-to-day, but I'm a psychopath for a great stirred medicinal cocktail. The Vieux Carré is the absolute embodiment of what a fucking cocktail is supposed to be: stirred and spirit-forward. There's nice spice from the rye, and you get the richness and the woodiness from Cognac and that velvety texture from sweet vermouth. It's absolutely everything. It's rich without being too rich. It's simple in its primal form. But it's overtly complex.

I'd stick with pretty classic specs. I wouldn't want to riff on it; it's so good as it is. I dig it up, or down in a chilled rocks glass with a little expressed lemon. That's my desert island cocktail. When I think of last call, and I take that not as a bartending term, there's so much finality behind it. It's beautifully morbid. Dude, if I was to kick the bucket and know I can have one more fucking drink, this is it.

VIEUX CARRÉ *Makes 1 Drink*

¾ ounce overproof rye (preferably
 Rittenhouse or Pikesville)

¾ ounce Cognac

¾ ounce sweet vermouth

¼ ounce Bénédictine

3 dashes Peychaud's Bitters

3 dashes Angostura bitters

Garnish: lemon twist

Combine the rye, Cognac, vermouth,
Bénédictine, and both bitters in a mixing glass
filled with ice. Stir until chilled and strain into
a chilled double old-fashioned glass over a large
ice cube. Garnish with the lemon twist.

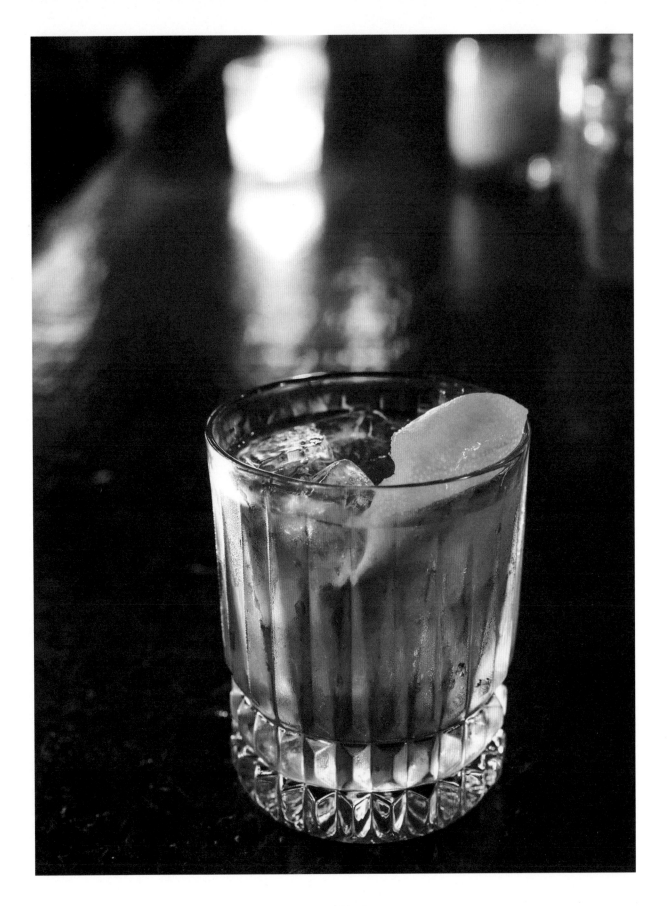

Vieux Carré

Karen Brownlee

EARNESTINE & HAZEL'S

Memphis, Tennessee | Karen Brownlee

"I met a gin-soaked, bar-room queen in Memphis
She tried to take me upstairs for a ride"
—The Rolling Stones, "Honky Tonk Women"

The last time I walked into Earnestine & Hazel's I stepped headfirst into a gathering of a dozen people standing in a circle. I thought I had stumbled upon a church group caught mid-prayer or maybe an anonymous meeting of some sort, but it turns out this was just one of the many local ghost tours making the rounds at Earnestine & Hazel's, one of Memphis's most historic dive bars, and also the most haunted.

The unassuming two-story building on the corner of South Main Street and GE Patterson Avenue that eventually became Earnestine & Hazel's was built in the late 1800s and sits kitty-corner from the retro neon-decorated façade of the Arcade, where Elvis Presley's favorite booth remains a popular tourist attraction. "If you look at it from the outside, and if someone didn't tell you about this place or you didn't read about it, you're not going to come in here on this corner," says Karen Brownlee, who has been tending bar at Earnestine & Hazel's for over seventeen years. "It looks like an old dump. You probably wouldn't walk in the door. This place is pretty much word of mouth. If you're outside looking in, you're not coming in here."

The building was first used as a church, and in the late 1930s, it became a sundry store and a pharmacy run by Abe Plough, who would go on to build a national corporation, acquiring St. Joseph baby aspirin, Coppertone suntan lotion, and Maybelline cosmetics. In the mid-1950s, Plough sold the building to two black sisters, Earnestine Mitchell and Hazel Jones, who were beauticians at the beauty parlor on the second floor. Plough had partnered with Mitchell's husband, who went by the name Sunbeam, to open Club Paradise, a nearby music venue that became a popular stop for such black musicians as Sam Cooke, Aretha Franklin, Tina Turner, B.B. King, Ray Charles, and Jackie Wilson traveling through the segregated South. The sisters turned the pharmacy into Earnestine & Hazel's, a soul food café with live music downstairs and a brothel upstairs, with the eight second-floor rooms rented out to prostitutes.

"The musicians would play Club Paradise, then come here and eat and then stay upstairs for a while before going to the Lorraine Motel," says Brownlee, motioning toward the location of the former motel two blocks away where Martin Luther King Jr. was assassinated and where the National Civil Rights Museum now stands. After a two-decade run, Club Paradise was boarded up in the 1970s, and Earnestine & Hazel's lingered on through the 1980s. But as the sisters grew older, the spark behind the popular café dimmed.

Enter Russell George, who took over Earnestine & Hazel's in 1992 and whose imprint on the venue is still felt by the hundreds of weekly visitors to the bar. George's first claim to fame was at age ten, when he was the only white kid who entered a James Brown dance contest at the Memphis Mid-South Coliseum. It was judged by James Brown himself, and George took home the first prize. At age fifteen, he ran a speakeasy out of an apartment and then moved on to gigs

as a restaurateur, music promoter, and a backup dancer for the Icebreakers. A friend convinced him to put in an offer on the space, and with the sisters' blessing, he turned Earnestine & Hazel's into a full-time bar. "The brothel upstairs was long gone, but there were still women hanging around in here that he had to run out. He made this place what it is today," says Brownlee.

I met Russell George on my first visit to Earnestine & Hazel's around 2010. He greeted me as he had thousands of visitors before, and as my Soul Burger sizzled away on the flattop, he talked about the history of the bar, pointing out his favorite photographs and memorabilia on the walls, the original pharmacy drawers and cupboards, the handwritten menus of the café listing daily specials of hog maw, neck bones, and fried chicken and fish, and the various TV shows, movies, and music videos that had used the bar as a filming location.

The Soul Burger was George's invention and is the only food served at Earnestine & Hazel's. He experimented with multiple toppings until he settled on the simple formula of bun, burger, American cheese, mustard, mayonnaise, pickles, sautéed onions, and "soul sauce" (don't even think about getting any answers about what's in the squeeze bottle) served on a waxed paper–lined red plastic basket accompanied by a snack-size bag of Golden Flake Thin & Crispy potato chips. On weekends, the place typically sells up to three hundred burgers, which take eight minutes to cook per order, between the hours of midnight and 3:00 a.m.

The former brothel upstairs has a long association with paranormal activity and continues to draw ghost hunters from around the world. The fuse box at the base of the crooked stairway leading upstairs still displays the house rules, written out in George's all-caps script: NO DOPE SMOKEN, NO CURSIN, NO FREE LODEN, E.H. (Brownlee laughs, noting that Russell was never much of a good speller.) The entire bar is a little smoky, dusty, and sticky in spots, but when you head to the second floor, the slanted and enchanted stairway leads to a dark corridor with peeling paint and scabs of hanging plaster and eight numbered rooms running along the right-hand side. There's a small eight-seat bar with an upright piano in the corner room at the end of the hallway that's open on weekends. The bar-within-a-bar is run by Nate, a seventy-four-year-old retiree from Budweiser who plays records on the stereo and serves up simple mixed drinks to a devoted crowd of regulars. "Nothing fancy. Booze with club soda and tonic and throw a lime in it," says Brownlee, noting that where the bar now stands is the room where "Ray Charles used to pop heroin and do prostitutes."

As for the supernatural elements reportedly at play, Brownlee points out that, "It's not like things flying around in the air or anything, but some weird stuff happens in here." The encounters are typically sightings of floating orbs of light or transparent figures, and sometimes strange faces will appear on developed film. There are times when Brownlee is alone at the bar and she will hear the piano keys tinkling and people moving chairs around upstairs. "It's hard to explain," she says. "I don't feel that there's anything negative with the spirits here. If you don't respect this place and take care of it, then you might have a negative experience. I've never had that. But one of my cooks got freaked out up there one night and he ran down them steps, through the bar, out the door, and all the way home. And he would no longer go upstairs by himself."

I count myself as one of those who has experienced something—if not paranormal, then downright eerie—upstairs at Earnestine & Hazel's. It was around 1:00 a.m. and I was there with the bar team from the Gray Canary, a nearby restaurant run by my friends Mike Hudman and

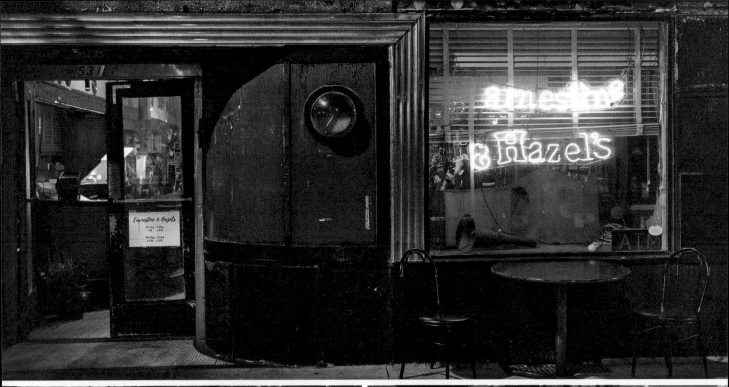

Andy Ticer. We were ordering rounds of beer at the time and the Soul Burgers were stacking up on the bar, and as people started dancing, I wandered upstairs by myself. Being alone up there at that hour was unsettling enough, but made even more so as each creaky footstep was amplified like I was in a horror movie. I was about to turn around and head back downstairs when I noticed one of the hallway doors was slightly ajar and a beam of light was shining through the opening. I peered in and saw the back of a man's head. He was in a chair punching numbers into an adding machine and speaking to someone on the phone, but his words were muffled. Assuming I was interrupting someone burning the midnight oil, I went back downstairs. Brownlee was our bartender that night, and I mentioned to her that I didn't know someone was working upstairs and hoped I hadn't bothered him. "There's no one up there, baby," she said, sliding a beer across the bar. When I later slipped back upstairs to check, there was now a padlock snapped shut on the office door. The sommelier from our crew overheard my conversation. "I wouldn't go up there if you put a gun to my head," he said. "You don't mess around with ghosts. You don't want to bring that shit back home with you."

You'll find only bottled beer and burgers at Earnestine & Hazel's, with the exception of a bottle of Fireball kept behind the bar for the occasional shot. Brownlee is hard to miss with her red hair, and while I've caught her smiling on occasion, she often has a melancholic look on her face, a slight weariness of being witness to so much over so many nights behind the bar. Working in a bar that's seen its fair share of deaths and hosts a cast of mournful spirits roaming the creaky upstairs hallway, you'll forgive her for not wanting to pontificate on the finer details of the last drink she'd want to have before she died. She's dealing with the dead every night she sets foot in the bar. But I have to ask, and without looking up from tending to a Soul Burger she says, "I just like cold beer. Bud Light is my go-to choice. That's just me." And in this case, that's good enough for me.

The jukebox at Earnestine & Hazel's is famous for its deep selection of soul, rhythm and blues, and funk, with some concessions to more contemporary musicians. But it's also known for playing a song at random when no money has been put into the slot. The song that pops up is often eerily in sync with the mood of the room. Brownlee tells me about Tammy Wynette's "D-I-V-O-R-C-E" coming on out of nowhere when a woman stopped in to celebrate signing her divorce papers. Or the time she was talking with her fellow bartender about the death of James Brown and "I Feel Good" screamed from the speakers. "It's due to come on here shortly," says Brownlee, a hint of a smile on her face.

Near the end of our time together, I asked Brownlee about the circumstances of Russell George's death, who on September 8, 2013, retired to his upstairs office and sometime around 5:00 a.m. shot himself, becoming the thirteenth person to die at Earnestine & Hazel's. She says that the paranormal activity has died down since his death, but it's far from settled.

"Russell loved this place. It was his heart. His soul. His life. Everything. He got really sick where he was fixing to go anyway, so he just figured he'd do it here where he could stay here, I guess. I don't have answers. I never saw that one coming." Just as Brownlee says this, the jukebox came to life. It was Little Anthony and the Imperials singing "I'm on the Outside (Looking In)."

"I'm on the outside looking in
I don't wanna be, I don't wanna be left on the outside all alone
Well, I guess I've had my day and you left me go my way
Now it's me who has to pay"

"What did I tell you?" she says, taking a sip of her Bud Light. "If these walls could talk. If these walls could talk."

Screwdriver Bar. Seattle, Washington. >>

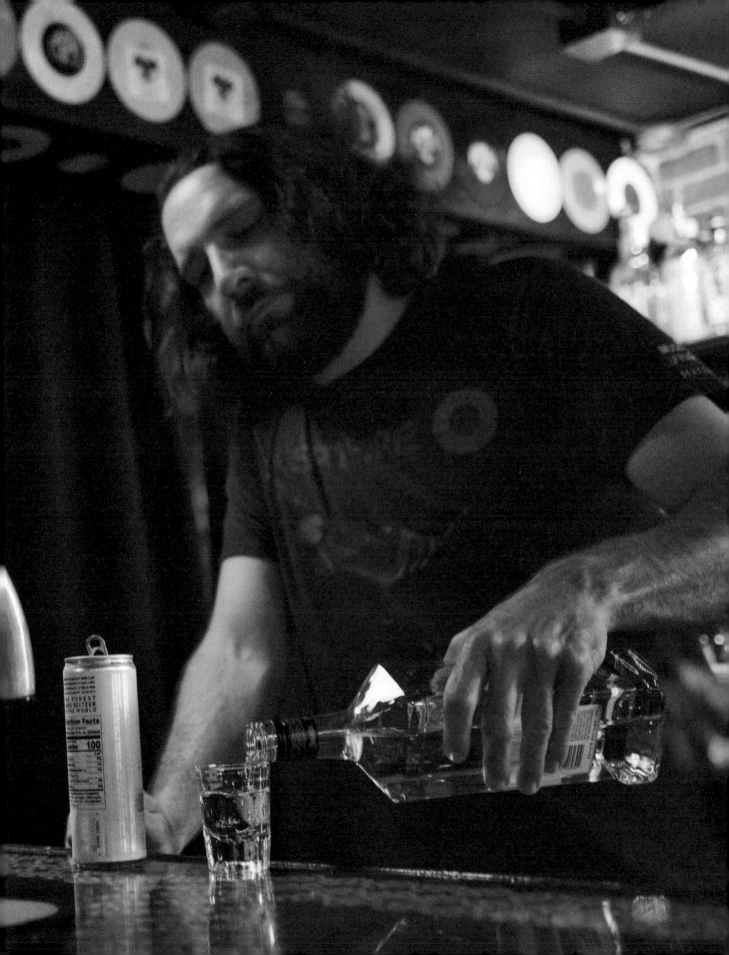

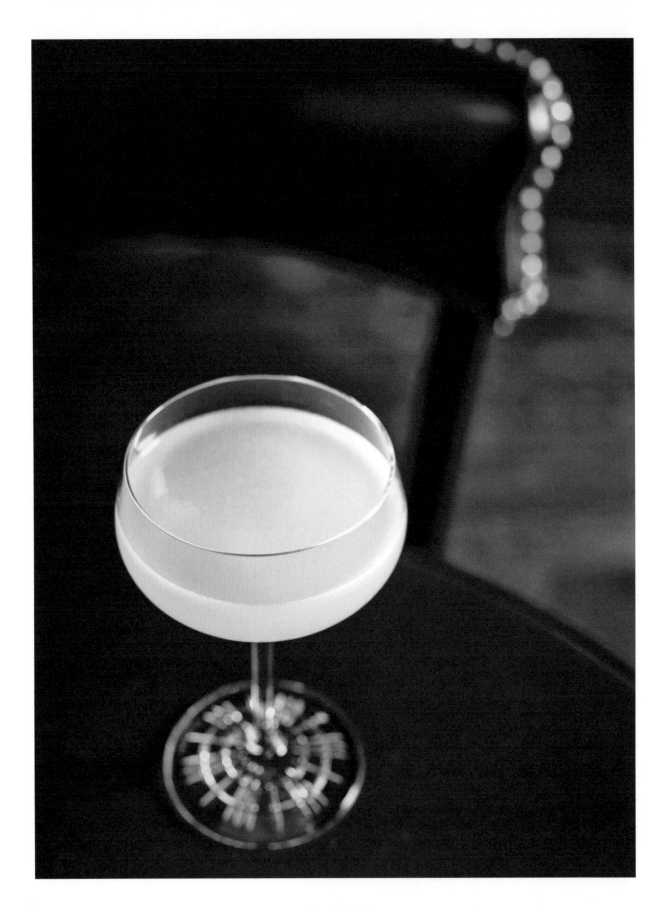

Last Word

EPILOGUE:
A LAST WORD WITH MURRAY STENSON

Seattle, Washington

"Wow, have love
Whoa baby will travel"
—The Sonics, "Have Love, Will Travel"

I lived in Seattle for just over a decade, and it was where my twin passions for cocktail culture and writing first intersected. It was a time when the spark of the modern cocktail movement in America was spreading from New York and San Francisco, and I was able to witness the evolution of the Seattle scene firsthand. There was Canadian bartender and blogger Jamie Boudreau, who went from tending bar at Tini Bigs, a martini bar (where multitudes of drinks ending in "-tini" were served in ten-ounce cocktail glasses) in Lower Queen Anne, to running the influential bar Vessel, which a cast of rising local bartenders called home, to eventually opening his own bar, the internationally acclaimed Canon. I still have early sample bottles of bartender Miles Thomas's homemade bitters, which went on to become Scrappy's Bitters, a brand now featured in bars around the world. Writers such as Robert Hess (cofounder of the Museum of the American Cocktail) and Paul Clarke (editor in chief of *Imbibe* magazine) were geeking out about spirits, cocktails, and old drinks books in online forums, chronicling what was happening in the Pacific Northwest as the area's drink scene took hold. And I picked up knowledge about spirits and bartending by spending countless hours sitting across from such bartenders as Andrew Bohrer, Anu Apte, Jim Romdall, Anna Wallace, Andrew Friedman, Casey Robison, and Rocky Yeh. But the North Star for anybody interested in cocktails in Seattle was Murray Stenson, a veteran bartender who remains one of the city's most beloved barmen.

Stenson moved to Seattle from suburban Spokane in 1961 and has been tending bar since 1976. "I got into bartending totally by accident," Stenson says. "It's a long, convoluted story, but I was living outside of Seattle and taking the summer off after I had been working and saving up. I took a place in an apartment complex and had the swimming pool all to myself during the day since everybody else had day jobs. The only two guys who hung out with me at the pool were the apartment complex owner's sons, and they offered me a job as a bartender and were willing to train me." After being a bit of a journeyman bartender in the 1970s and 1980s, Stenson settled in at Il Bistro, an intimate Italian trattoria tucked away under Seattle's Pike Place Market beneath the red neon glow of the market sign and clock. He worked there from 1990 until a fateful Valentine's Day in 2002. "I had a couple that came in four or five nights a week. They were great regulars, and we always had a good time," says Stenson. "They came in on Valentine's Day to have a glass of Champagne to celebrate their one-year anniversary of coming to Il Bistro, but the owner wouldn't let them hang at the bar because every seat was filled for Valentine's Day. I couldn't get over it—turning away weekly regulars like that—and quit at the end of my shift." Stenson later made up with the owner and even meets him for lunch from time to time, but after that night

Stenson became a valuable free agent. Ben Dougherty and Kacy Fitch quickly scooped him up for their bar Zig Zag Café, where Stenson would soon introduce to the menu a long-forgotten cocktail whose pale-green glow would be illuminated on menus across America and the world.

Stenson describes the cocktail list at Zig Zag Café in 2003 as "pretty generic," with the Aviation taking flight with adventurous drinkers thanks to the reintroduction of crème de violette. But when Stenson noticed a new bar in Pioneer Square had straight-up copied the Zig Zag menu, he encouraged Dougherty and Fitch to let him take advantage of the expansive collection of obscure spirits and liqueurs they had built up behind the backbar, which was quite a feat in what was then still a control state. Stenson turned to his collection of old cocktail books for inspiration, and it was in *Bottoms Up*, a 1951 book by Ted Saucier, that he came across the Last Word, an equal-parts cocktail composed of gin, green Chartreuse, maraschino liqueur, and lime juice. The pre-Prohibition drink is credited to the Detroit Athletic Club, where it appeared on a dinner menu in 1916, and it's a bold, bracing, slightly sour, herbaceous drink that's more than the sum of its seemingly disparate parts.

Both Chartreuse and maraschino were hard-to-come-by bottles in Seattle at the time, and Stenson's customers were quick to try it. "Most people loved it," says Stenson, "but it's not for everybody. I was selling it for two years in Seattle before it really hit in New York." In its early renaissance, calling for a Last Word at a bar was a secret handshake of sorts and tipped a bartender off, but it went on to become a rediscovered cult classic and a mainstay on cocktail lists the world over, spawning countless variations. Having Murray Stenson make you a Last Word at Zig Zag Café became something to check off your to-do list when visiting Seattle, and after Stenson won Best Bartender in America at Tales of the Cocktail in 2010, the media spotlight around him and Zig Zag increased until its relentless glare became too much. "It got to a point where after the Tales award and all the press, we had turned into a place with a line of people a block long every night at 5:00 p.m.," says Stenson. "We just got crushed every night, and I got burned out."

Stenson left Zig Zag in 2011 and briefly picked up shifts at Canon before he was sidelined with a heart condition in 2012. The Seattle bartending community rallied around him, raising funds via Murray Aid to help with the costs of his heart surgery. He later popped up from time to time working at local bars, but plans to possibly open his own place were put on hold when a second heart operation was required in 2018. When I ask him about Murr the Blur, the nickname he picked up thanks to his fast and efficient style behind the bar, he tells me that went out about fifteen years ago. "That was a long time ago," he says. "Younger bartenders have to take care of themselves physically. I know I've slowed down. I'm trying to figure it out right now."

Stenson has been on an extended break from bartending per his doctor's orders, but hopes to step back behind the bar at Il Bistro. "When I first started, I was an incredible introvert and now I can talk to anyone about anything," he says. "My style as a bartender hasn't changed over the last forty years. I'm most comfortable in a neighborhood atmosphere with a lot of regulars. I like the predictably of regulars." And at Il Bistro, are patrons seeking him out to make a Last Word? "Nah, that was ten to twelve years ago," says Stenson. "That's ancient history to these kids coming in there now."

When Stenson considers his one final drink, he turns to Champagne. "If I had to give up all my vices, the last one to go would be Champagne," he says, in particular a glass of Billecart-Salmon brut rosé, which he describes as "smooth, mellow, with just the right amount of effervescence." Whether it's popping a bottle to mark life's grand moments or a little gesture, Champagne is about celebrating life for Stenson, and it confounds him when that's not the case. He shared a story about having lunch with a friend, unaware that it would be the last time he saw her. "I remember she was drinking Champagne and then two weeks later she was gone," he says. "It still mystifies me how anyone could be drinking Champagne and then two weeks later kill herself." When I ask Stenson whether, after two heart surgeries, he contemplates his own mortality, he laughs then says, "Of course I do. I'm sixty-nine years old. I've got an older cat named Lucy, and I look over at her every night and we kind of size each other up. I often wonder which one of us is going to kick first," he says, with a sly laugh. "I think we're both going to check out at the same time."

LAST WORD *Makes 1 Drink (pictured on page 258)*

¾ ounce gin	Combine the gin, Chartreuse, maraschino liqueur,
¾ ounce green Chartreuse	and lime juice in a cocktail shaker filled with ice and
¾ ounce maraschino liqueur	shake until chilled. Strain into a chilled coupe glass.
¾ ounce fresh lime juice	

DIRECTORY OF FEATURED BARS

CALIFORNIA

HARVARD & STONE
5221 Hollywood Boulevard
Los Angeles, CA 90027
(747) 231-0699
harvardandstone.com
@harvardandstone

THE MUSSO & FRANK GRILL
6667 Hollywood Boulevard
Los Angeles, CA 90028
(323) 467-7788
mussoandfrank.com
@mussoandfrankgrill

THE PRINCE
3198 7th Street
Los Angeles, CA 90005
(213) 389-1586
@theprincela

PRIZEFIGHTER
6702 Hollis Street
Emeryville, CA 94608
(510) 428-1470
prizefighterbar.com
@prizefighterbar

REDBIRD
114 East 2nd Street
Los Angeles, CA 90012
(213) 788-1191
redbird.la
@redbirdla

SMUGGLER'S COVE
650 Gough Street
San Francisco, CA 94102
(415) 869-1900
smugglerscovesf.com
@smugglerscovesf

TRICK DOG
3010 20th Street
San Francisco, CA 94110
(415) 471-2999
trickdogbar.com
@trickdogbar

GEORGIA

KIMBALL HOUSE
303 East Howard Avenue
Decatur, GA 30030
(404) 378-3502
kimball-house.com
@kimballhouse

TICONDEROGA CLUB
Krog Street Market
99 Krog Street NE W
Atlanta, GA 30307
(404) 458-4534
ticonderogaclub.com
@ticonderogaclub

ILLINOIS

LOST LAKE
3154 West Diversity Avenue
Chicago, IL 60647
(773) 293-6048
lostlaketiki.com
@lostlaketiki

SPORTSMAN'S CLUB

948 North Western Avenue

Chicago, IL 60622

(872) 206-8054

drinkingandgathering.com

@drinkandgather

MAINE

PORTLAND HUNT + ALPINE CLUB

75 Market Street

Portland, ME 04101

(207) 747-4754

huntandalpineclub.com

@huntandalpine

MARYLAND

IDLE HOUR

201 East Fort Avenue

Baltimore, MD 21230

(410) 989-3405

@idlehourbaltimore

MASSACHUSETTS

DRINK

348 Congress Street

Boston, MA 02210

(617) 695-1806

drinkfortpoint.com

@drinkfortpoint

MISSISSIPPI

CITY GROCERY

152 Courthouse Square

Oxford, MS 38655

(662) 232-8080

citygroceryonline.com

@citygroceryoxford

SAINT LEO

1101 East Jackson Avenue

Oxford, MS 38655

(662) 380-5141

eatsaintleo.com

@eat_saint_leo

NEW YORK

BAR SARDINE

183 West 10th Street

New York, NY 10014

(646) 360-3705

barsardinenyc.com

@barsardinenyc

GRAND ARMY

336 State Street

Brooklyn, NY 11217

(718) 643-1503

grandarmybar.com

@grandarmybar

THE LONG ISLAND BAR

110 Atlantic Avenue

Brooklyn, NY 11201

(718) 625-8908

thelongislandbar.com

@longislandbar

MAISON PREMIERE
298 Bedford Avenue
Brooklyn, NY 11249
(347) 335-0446
maisonpremiere.com
@maisonpremiere

MONTERO BAR & GRILL
73 Atlantic Avenue
Brooklyn, NY 11201
(646) 729-4129
@themonterobar

NITECAP
151 Rivington Street
New York, NY 10002
(212) 466-3361
nitecapnyc.com
@nitecapnyc

ROBERTA'S
261 Moore Street
Brooklyn, NY 11206
(718) 417-1118
robertaspizza.com
@robertaspizza

NORTH CAROLINA

THE CRUNKLETON
320 West Franklin Street
Chapel Hill, NC 27516
(919) 969-1125
thecrunkleton.com
@thecrunkleton

FOX LIQUOR BAR
237 South Wilmington Street
Raleigh, NC 27601
(919) 322-0128
ac-restaurants.com/fox
@foxliquorbar

OREGON

CLYDE COMMON
1014 SW Harvey Milk Street
Portland, OR 97205
(503) 228-3333
clydecommon.com
@clydecommon

PÉPÉ LE MOKO
407 SW 10th Avenue
Portland, OR 97205
(503) 546-8537
pepelemokopdx.com
@pepelemokopdx

PENNSYLVANIA

FRIDAY SATURDAY SUNDAY
261 South 21st Street
Philadelphia, PA 19103
(215) 546-4232
fridaysaturdaysunday.com
@friday.saturday.sunday

HORSE INN
540 East Fulton Street
Lancaster, PA 17602
(717) 392-5528
horseinnlancaster.com
@horseinn

PALIZZI SOCIAL CLUB

1408 South 12th Street

Philadelphia, PA 19147

palizzisocial.com

@palizzisc

TENNESSEE

BASTION

434 Houston Street

Nashville, TN 37203

(615) 490-8434

bastionnashville.com

@bastionnashville

EARNESTINE & HAZEL'S

531 South Main Street

Memphis, TN 38103

(901) 523-9754

earnestineandhazelsjukejoint.com

@earnestinehazels

VIRGINIA

THE JASPER

3113 West Cary Street

Richmond, VA 23221

jasperbarrva.com

@jasperbarrva

WASHINGTON

CANLIS

2576 Aurora Avenue North

Seattle, WA 98109

(206) 283-3313

canlis.com

@canlisrestaurant

DINO'S TOMATO PIE

1524 East Olive Way

Seattle, WA 98122

(206) 403-1742

dinostomatopie.com

@dinosseattle

NEW LUCK TOY

5905 California Avenue SW

Seattle, WA 98136

newlucktoy.bar

@newlucktoy.seattle

ROB ROY

2332 2nd Avenue

Seattle, WA 98121

(206) 956-8423

robroyseattle.com

@robroyseattle

WASHINGTON, DC

COPYCAT CO.

1110 H Street NE

Washington, DC 20002

(202) 241-1952

copycatcompany.com

@copycatco

SERVICE BAR

926-928 U Street NW

Washington, DC 20001

(202) 462-7232

servicebardc.com

@servicebardc_

ACKNOWLEDGMENTS

Emily Timberlake has been my editor since my first book, *Bitters*, and she remains a force of nature as a first reader and editor, and, more important, as a trusted friend. After editing *Distillery Cats,* she and her husband adopted two cats, Otto and Siouxsie. I'm eager to see what *Last Call* might inspire.

I can't say enough about my frequent collaborator, Ed Anderson, who photographed and helped design *Bitters*, *Amaro*, and *Last Call*. This was our most ambitious project yet, and we spent weeks together on the road in trains, planes, and rental cars, experiencing the highs and lows of chronicling the late-night stories of bars across America. And lived (barely) to tell the story.

I've known Aaron Wehner, the executive vice president at Crown Publishing, for over a decade, and it's an honor to be published by such a smart and savvy friend. Here's to many more drinks, dinners, and books together. And I'm thankful for the hard work, passion, and dedication from the talented team at Ten Speed Press, especially Windy Dorrestyn, Mari Gill, Lorena Jones, Lauren Kretzschmar, Annie Marino, Dan Myers, Ashley Pierce, Allison Renzulli, and Betsy Stromberg, as well as Mikayla Butchart, Ken Della Penta, and Sharon Silva.

A million thank-yous to my agent David Black, who continues to inspire me to be my best in life, while always being generous with his advice, advocacy, acumen, and so much more. And thank you to Matt Belford at the David Black Literary Agency.

Much love to all the bartenders, bar managers, chefs, and restaurateurs who took the time to sit with me for interviews, and for sharing their insights and personal stories. And to all the bars and restaurants for their hospitality, going out of their way to accommodate us for on-location photo shoots, often during service, and for mixing up countless drinks and making us feel welcome.

An endless debt of gratitude to the following for their continued friendship, support, goodwill, and generosity: Nick Anderer, Alex Bachman, Talia Baiocchi, Susan Baldaserini, Brian Bartels, Anne Bartholmew, Scott Blackwell, Damon Boelte, Andrew Bohrer, Chris Brucia, Dave Callanan, Joe Campanale, Frank Castronovo, Toby Cecchini, Peter Cohen, Steve Cook, Daniel Cosme, Gary Crunkleton, Chris DeCrosta, Tom Douglas, Daphne Durham, Billy Durney, John T. Edge, Renee Erickson, Frank Falcinelli, Kristin Ford, Jon Foro, Ethan Forrest, Jeff Galli, Brooke Gilbert, Jessica Gilo, Lori Glazer, Marty Gosser, Benjamin Haas, Marci DeLozier Haas, Charlie Hall, Mike Harrigan, Mike Hudman, Mark Iacono, Shai Kessler, Ali Klooster, Kate Kraft, David Lebovitz, Matt Lee, Ted Lee, Mari Malcolm, Ann Marshall, Rux Martin, Taylor Mason, Jayce McConnell, Jim Meehan, Peter Meehan, Danny Meyer, Tom Nissley, Katie Parla, Chris Petescia, Robert Simonson, Mike Solomonov, Nick Talarico, Eric Tanaka, Joe Tarasco, Andy Ticer, Amy Weinstein, Crasta Yo, and Dan Zeiders.

And to Laurie Brown, whose wisdom and beautiful spirit continue to inspire.

To my family for their love and support: Vicki, Bob, and Jack Adams; Gary Murphy; Gary and Mary Ellen Murphy; and Ryan and Kassie Murphy. And in loving memory of my father, Herbert "Bert" Parsons, my mother, Joanne Murphy, and my brother, Scott Parsons.

And, of course, to Louis.

INDEX

Continued >>

Library of Congress Cataloging-in-Publication Data

Names: Parsons, Brad Thomas, author.
Title: Last call : bartenders on their one final drink and the late-night
 wisdom and rituals of closing time / by Brad Thomas Parsons.
Description: First edition. | New York : Ten Speed Press, an imprint of
 Random House, a division of Penguin Random House LLC, [2019]
Identifiers: LCCN 2019013317| ISBN 9780399582769 (hardcover) | ISBN 9780399582776 (ebook)
Subjects: LCSH: Bars (Drinking establishments)—United States. |
 Bartenders—United States—Biography. | Cocktails.
Classification: LCC TX950.56 .P37 2019 | DDC 647.9573—dc23 LC
 record available at https://lccn.loc.gov/2019013317

Hardcover ISBN: 978-0-399-58276-9
eBook ISBN: 978-0-399-58277-6

Printed in China

Design by Ed Anderson

10 9 8 7 6 5 4 3 2 1

First Edition

"This book is a delight. *Last Call* shows us the sense of community evoked by bartenders across the country, whose wisdom and tenderness are captured here both in words and beautiful photographs. It made me—an erstwhile bartender and faithful customer—happy to remember that we all have nights when we unexpectedly hear the words 'last call,' and that noble and fascinating bartenders are out there waiting to share it with us."
—Alan Cumming

"Brad Thomas Parsons brilliantly takes us behind the scenes in this insider's visit with bartenders across the country, who disclose what they'd choose as their last libation. Not only do they share their thoughts, they also give us a taste of their favorite cocktails with a host of inspiring recipes that anyone can shake or stir up at home. You'll savor every sip of this spirited look at what goes on behind the bar—from small-town dives to big-city speakeasies—when closing time finally arrives."
—David Lebovitz, author of *My Paris Kitchen* and *French Drinks*

"This book is brimming with great recipes, but *Last Call* reminds us, with intimacy and warmth, that stories and the people who tell them are the very best portion of bar life."
—Rosie Schaap, author of *Drinking with Men*

"With the constant companionship of bartenders along the way, Brad Thomas Parsons takes us on a tour of some of the country's finest establishments in a somber yet seductive celebration of that hard-earned final moment of reflection, often paired with the perfect tune and a flawlessly poured drink in hand."
—Charlie Hall, drummer, The War on Drugs

"Brad Thomas Parsons' *Last Call* is a glorious multi-tool of a book. Its profusion of smart cocktail recipes makes it invaluable behind the bar—or tucked into your suitcase, as it's also a supreme travel guide to some of the finest saloons in America, a treasure map for late-night explorers. It's also, sublimely, a gravelly disquisition on life, death, pleasure, and what it all means. Parsons has become our preeminent thinker-drinker—our best surveyor of that heady, complex zone where liquid spirits meet the human spirit."
—Jonathan Miles, author of *Dear American Airlines* and *Anatomy of a Miracle*